THE SQUARE HALO
AND OTHER
MYSTERIES OF
WESTERN
ART

෴

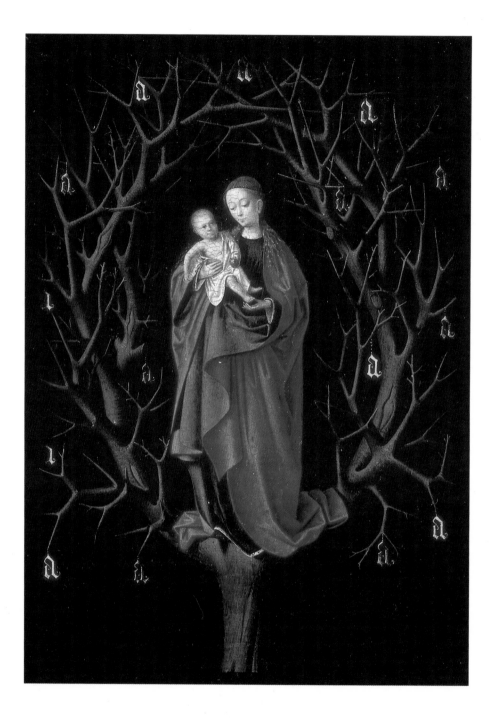

THE SQUARE HALO AND OTHER MYSTERIES OF WESTERN ART

❧

IMAGES AND THE STORIES THAT INSPIRED THEM

❧

SALLY FISHER

HARRY N. ABRAMS, INC.,
PUBLISHERS

Editor: Harriet Whelchel
Designers: Katy Homans and Deborah Zeidenberg
Photo editor: Roxana Marcoci

Library of Congress Cataloging-in-Publication Data
Fisher, Sally, 1939–
The square halo and other mysteries of Western art:
images and the stories that inspired them / Sally Fisher.
p. cm.
Includes bibliographical references and index.
ISBN 0-8109-4463-4
1. Christian art and symbolism. 2. Mythology,
Classical, in art. 3. Art appreciation. I. Title.
N8010.F57
704.9'482—dc20 94-48284

The author and publisher wish to thank the libraries, museums, galleries, and private collectors named in the picture captions for permitting the reproduction of works of art in their collections and for supplying the necessary photographs. Other photograph credits are listed below by page number.

Alinari, Florence: 39, 103, 108, 133; Jörg P. Anders/Bildarchiv Preussischer Kulturbesitz, Berlin: 48 above, 117; J. Feuillie/© CNMHS/SPADEM, Paris: 15; Cameraphoto, Venice: 49; Canali Photobank, Italy: 16, 17, 18, 20, 30, 32 left, 33, 34, 36–37, 41, 43, 45, 46, 47, 50, 55, 60, 67, 72, 75, 86, 98, 119, 120, 124, 139, 146, 155 right; Giraudon, Paris: 166; Giraudon/Art Resource, New York: 52; IRPA, Brussels: 89; All rights reserved, by The Metropolitan Museum of Art: 163 (1975); 88, 106, 149 (1979); 14, 23, 74, 90, 141 (1981); 71, 102, 112 (1983); 62, 82 (1984); 38, 160 (1985); 92 (1986); 150 (1988); 21, 44 (1989); 95, 126, 136 (1993); 19, 85, 137 (1994); Geoffrey Clements/© by The Metropolitan Museum of Art: 28 (1982); Schecter Lee/© by The Metropolitan Museum of Art: 165 (1986); Malcolm Varon/© by The Metropolitan Museum of Art: 58, 130 (1988); 48 below (1991); MNAC Photographic Service (Calveras/Sagristà): 76, 91; © 1994 Board of Trustees, National Gallery of Art, Washington: 25, 54, 61, 70, 113, 114, 122, 156, 162; Richard Carafelli/© 1994 Board of Trustees, National Gallery of Art, Washington: 25, 113, 122, 156, 162; Oronoz, Madrid: 42, 53, 101, 110, 123; Quattrone, Florence: 10, 66; Photo RMN: 87, 129, 152; Rheinisches Bildarchiv, Cologne: 64, 144; Scala/Art Resource, New York: 73 above, 93 (left, center, right), 116, 134

Illustration copyrights: Ars, New York/J. Feuillie/© CNMHS/SPADEM, Paris: 15

Frontispiece:
Petrus Christus. Our Lady of the Barren Tree. *c. 1450.*
Oil on canvas, 6⅞ x 4⅞".
Fundación Colección Thyssen-Bornemisza, Madrid (see page 33)

CONTENTS

INTRODUCTION

· 7 ·

THE OLD TESTAMENT

· II ·

Saint Michael · The Creation of Eve · Beguiling Serpents and Hairless Bodies · The Creation and the Fall
The Mystic Mill · Noah's Drunkenness · Abraham Entertains the Angels · Hagar and Ishmael
The Sacrifice of Isaac · Horns, Hats, and Anti-Semitism · Moses Striking the Rock · Joseph in Egypt
Judith and Holofernes · Susannah and the Elders · Tobias, the Angel, the Dog, and the Fish

THE VIRGIN MARY

· 31 ·

Where Did the Virgin Come From? · Mary's Conception · Joachim and Anna, Mary's Parents
Mary's Childhood · The Marriage of the Virgin · The Annunciation · Why Paint in Black-and-White?
The Visitation · The Pregnant Mary · The Death of Mary · The Madonna

THE LIFE OF JESUS

· 55 ·

The Birth of Jesus · The Three Kings · The Massacre of the Innocents · The Flight into Egypt
The Tree of Jesse · Holy Kinship · The Presentation in the Temple · The Baptism of Christ
The Temptation in the Wilderness · The Marriage Feast at Cana · The Transfiguration
The Entry into Jerusalem · The Last Supper · The Kiss of Judas · The Crucifixion
The Descent from the Cross · The Harrowing of Hell · The Supper at Emmaus
Doubting Thomas · Veronica's Napkin

EARTH AND HEAVEN

· 83 ·

The Hand of God · Pentecost · The Trinity · Heaven and Hell · Last Things
The Four Beasts of the Evangelists · Christ Pantocrator · Model Buildings · The Halo
Subliminal Halos · Variations on the Halo · Relics · The Invention of the Cross
Demons and Monsters · Wild Persons · Snake Oil · Love of Allegory and Allegory of Love
Fashion Fads and Healthy Jewelry · Death and Dying · The Vanitas Still Life
How Not to Die · How to Live · The Garden of Love

SAINTS
· 111 ·

Saint John the Baptist · Mary Magdalen · Saint Peter
Saint Luke, the Painter · Saint George, the Dragon, and the Princess
Cosmas and Damian, the Doctor Twins · Saint Sebastian
Saint Anthony of the Desert · Saint Jerome and the Lion · The Temptation of Saints
Saint Francis Takes His Clothes Off · Saint Francis and the Wolf
Saint Francis and the Stigmata · Saint Christopher and the Baby
Saint Margaret and the Dragon · Ursula and the Eleven Thousand Virgins
Saint Lucy · Saint Nicholas of Bari · Nicholas of Tolentino Revives the Birds
Saint Eustace and the Stag · Disaster Undone · The *Ex-Voto* · A Sacred Conversation
Saint Catherine of Alexandria · Saint Barbara · The Further Abuse of Saints
Knowing the Players without a Program

ROME REVISED
· 147 ·

What Is a Triumph? · Phyllis and Aristotle · Venus and Mars
Augustus and the Sibyl · Jupiter and Io · Europa · Leda and the Swan
Apollo and Daphne · Apollo and Marsyas · General Mayhem · The Judgment of Paris
Laocoön · Drinking · Emblems and Mottoes · Prudence · The Three Graces

SUGGESTED READING
· 168 ·

INDEX
· 169 ·

ACKNOWLEDGMENTS
· 176 ·

INTRODUCTION

There is a Gothic portico here, which I am beginning to think admirable, the porch of St. Trophime. But it is so cruel, so monstrous, like a Chinese nightmare.
VINCENT VAN GOGH TO HIS BROTHER, THEO, FROM ARLES

Sometimes I like to imagine myself a Marco Polo, a truly foreign visitor of the kind that does not exist anymore. Then I look around. What can one make of cannonballs piled up like fruit in a public park? Or an Easter rabbit? Football uniforms. Birth announcements on which large birds seem to abduct babies. Even "Thank God it's Friday" is meaningless if one is not familiar with the five-day work week.

To many educated persons, a museum visit is equally mystifying. There is Aristotle—we know who *he* is—but why is he crawling on all fours with a woman named Phyllis on his back? There is a group of gorgeously dressed persons. Each holds an object: keys, a sword, a small dragon on a leash, a little tower, a pair of eyes on a plate. They gaze into space. No one says a word. The title is *Sacred Conversation*. What can it mean?

Wall labels sometimes solve these puzzles, but more often than not they have other very basic information to convey; the question of who really painted the picture, for example. And after all, a wall caption cannot be too long. You did not come to the museum to read.

There was a time when even illiterate people had no trouble with Phyllis and Aristotle and the Sacred Conversation.

They would have automatically absorbed the necessary emblems, stories, and attitudes just as we have come to know football and Easter rabbits.

Questions of meaning are bound to arise when a once familiar story has lost its currency, or when symbols, attitudes, ideas, and customs have so faded into the past that they are now almost impenetrable. Even an artist of Van Gogh's stature found some Western traditions unfamiliar enough to be called "Chinese"— his, and others', term for the truly foreign. (When Louis Armstrong first heard bebop, he said it sounded like Chinese music.) But the Romanesque (not Gothic) church at Arles from which Van Gogh felt so estranged is not Chinese, it is part of his past, and our own.

Visual symbols were crucial to the vocabulary of Christianity when literacy was anything but universal, and as the centuries progressed a love of symbols for their own sake fed and nourished what became a rich tradition of signs, gestures, and subjects that had the ability to convey complex meanings. Iconography, the study of such visual signals, is a field generally unfamiliar to those outside the discipline of art history. It can clear up many mysteries.

For many connoisseurs, the subject matter, if any, of a work of art is no more

important than the melodies in a symphony or a jazz improvisation; it is the treatment that counts. They respond so fully to light, color, form, composition, and to technique, to the uses of materials and tools, that subject matter is secondary. Besides, they already know it.

Art historians and connoisseurs also have the remarkable ability to *forget* the entire history of art that has come *after* the creating of a certain work. As they look at a painting, they relive the drama of the artist working in his actual time; building on, codifying, or turning away from earlier ideas and practices, even his or her own. At their most successful, the attentions of the art historian and the connoisseur lead to an understanding of quality, an apprehension of greatness, that is its own reward.

This book is written for you if the nagging question, What's going on? falls like a log in your path. The sweetness of enjoying art should not be barred by obstacles so easily cleared. And the "subject matter" behind much Western art can be as interesting as the pictures.

The subjects included were chosen according to the frequency with which they are encountered in Western museums and churches, and their relative mysteriousness to most modern viewers. Very familiar subjects are included, however, when there is something interesting or surprising to say about them.

History itself I have treated rather cavalierly. Periods are not carefully separated, and, when a tradition persisted from the Middle Ages through the Renaissance, no dates whatever are mentioned. Social issues are almost ignored; the actual condition of women and peasants is not discussed. (The often oppressive effects of the cult of the Virgin upon girls and women, for example, remains entirely invisible.) The historian J. Huizinga said, "The plastic arts do not lament." His generalization holds true enough for the time span covered here. Until the era of William Hogarth and Honoré Daumier, the social picture we find in works of art is mostly cheerful, Pieter Brueghel being the notable exception.

There will be certain problems of anachronism. We look at art with modern eyes. We cannot help it. Some things will seem quaint or comical or even politically significant to us that did not seem so in their time. This is nothing to lament unless we begin to think of ourselves as historians. Important as it is to *study* a work with eyes of the past, it is more important to *admire* it with our own. The famous, often-reproduced section of the Sistine ceiling, in which God's hand reaches toward Adam's, has a crack in it. I find that crack an eloquent and moving part of the picture: perhaps it is lightning, or perhaps it signals catastrophe; perhaps even as the sky is coming apart, the hands come together. I suspect, personally, that the deep appeal of the image of those two hands lies partly in that crack.

A word, finally, about belief. To look at art sympathetically, it is best to consider all stories true. Paradoxically, certain modern readers will have less trouble believing that Helen hatched from an egg

than that Mary conceived a child without the assistance of a man. This is partly because Christianity is still a living religion, and nonbelievers remain a bit on the defensive. At the same time, some professing Christians will be pained by the equal status given to "pagan" and Christian stories, and some will wish that more careful distinction had been made between canonical Christian stories and those outside the pale. Then too, I will refer to some medieval beliefs in the past tense as if they are no longer held, when in fact they are vital to some Christians today, though not to others.

None of these issues can be settled to everyone's satisfaction. Any good story has a way of being *believed.* How many people who "should know better" have visited Hamlet's castle, Juliet's house in Verona, and know the addresses of Sherlock Holmes and Leopold Bloom? As far as we are concerned, the work, once it is created by the artist, becomes reality. Artists know how much truth there is in this: created objects take on their own life. To some this is plain idolatry. It is what Herman Melville sensed with horror on beholding the monuments of ancient Egypt in the nineteenth century. The idea that something we create ourselves could attain divine authority appalled him. On the other hand, Dante called art God's grandchild (humanity being the child). A popular medieval legend provides the metaphor I would invoke: Once, an artist, who had just finished painting the Virgin on the wall of a church, fell from his scaffolding. She reached out and caught him in her arms.

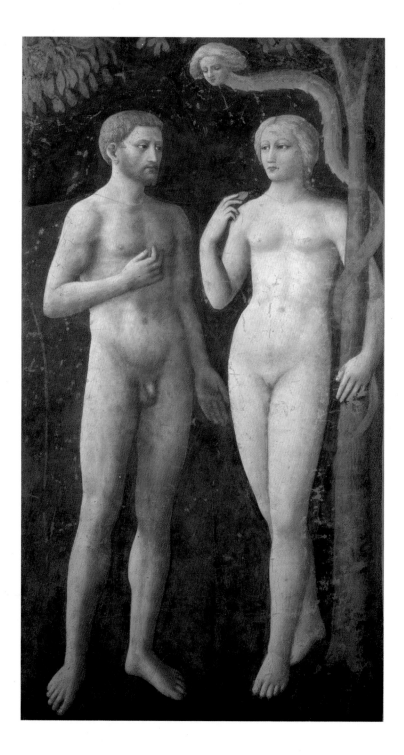

THE OLD TESTAMENT

SAINT MICHAEL

Michael is not a saint. He is an angel. The word *saint* came into English from the Latin *sanctus*, meaning "holy." It was not then used exclusively as a title, like "Doctor," but simply as an adjective. Saint Michael is the only common example of this usage in modern English.

Michael is not an ordinary angel but one of the three archangels who have important dealings in both worlds, Heaven and Earth. Here he performs his most momentous task, squashing the life out of Satan. Trouble did not begin on Earth. Satan, who was once an angel named Lucifer (Light), rebelled against God and fell from Heaven, and from light to darkness, turning as he did so into a repulsive creature—with wings, to remind us how he started. They may once have been feathered and multicolored, like Michael's, not the rubbery bat's wings we see here. Crivelli's is a fully imagined Satan, with snake skin, a red tongue, horns, whiskers, and strange, long ears. Yet he looks like a real being. One imagines the artist turning his panel upside down in order to achieve such a persuasive portrait.

It would be a mistake to underestimate the importance of Satan through all of the Middle Ages and into the Renaissance. He was a cause not only of sin,

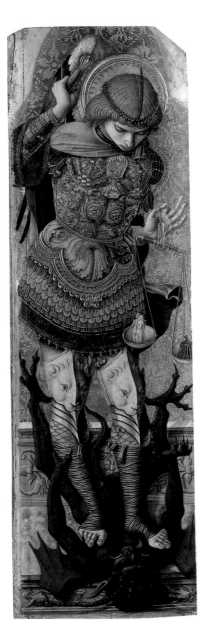

but of misfortune as well. Freud said there are no accidents. This is not a new idea. If a baby fell from a crib, if a wall fell on you, especially the wall of a church you were trying to build, it was no accident. Satan promoted evil every chance he got.

Satan will be defeated, but not until the last day. On that day, Michael will also weigh our souls to see who is worthy of Paradise. Crivelli's tiny human souls are lighter than the counterweight in the scale's other pan, but painters were never in agreement as to whether light souls were better than heavy ones or vice versa, so we must remain in suspense about the fate of the little naked couple.

Lion's-head kneecaps are only one feature of this truly splendid suit of armor. As the captain of the hosts in Heaven, Michael is often armed. We don't know how the armor accommodates wings.

The artist's hard edges and metallic colors, shallow but intense as those of an insect's wing, are enough to identify him fairly easily as a Crivelli, though you may not always know Carlo from Vittorio, who was probably Carlo's younger brother. Once you imagine these colors in a dark church, lit by candles, they need no explanation.

The other two important archangels are Gabriel and Raphael. (In the Jewish tradition there are four additional archangels. The best known of those, Uriel, appears in the poetry of John Milton and William Blake but almost never in works of art.) Archangels, and most of the other angels we meet in European art, come from the Old Testament, though their physical appearance evolved in a Christian context.

All the archangels are male, as all angels in the Old Testament seem to be. In the Christian tradition there is no universal agreement on the gender of angels. Some say they are neither one sex nor the other. In the seventeenth century, Milton decided that some angels were male and some female. On the next question—whether they ever make love—he said yes, but not in the way of humans. It seems they merge, like clouds.

THE CREATION OF EVE
એ

Woman has not always been celebrated in the Western tradition, but at least in this painting her creation seems to be the occasion for unqualified delight. She has not yet made her fatal mistake, and for the moment we can rejoice. Angels provide the music, Adam sleeps through a painless operation, and Eve bursts forth from the rib that God has deftly slipped from Adam's body. The foliage protects Eve's modesty (though she should not need modesty yet), and it also seems to add to the wonder of the moment, like the magician's puff of smoke.

When Athena springs from the forehead of Zeus, we respect this strange occurrence as part of "mythology." When God makes Eve out of one of Adam's ribs, many are scornful. Yet what we have in Eve's creation is an etiological myth that explains why things are the way they are

between women and men. Male and female were once one being, one flesh. They were pulled apart. As Genesis tells us, "Therefore shall a man leave his father and his mother, and shall cleave unto his wife: and they shall be one flesh." It explains that hollow, incomplete feeling that causes us to seek more than just sex, but also to fall in love in order to become whole again. Plato described a similar event in pagan mythology: Zeus split the originally androgynous humans in two, which explains why they now feel like half beings, "like flat fish," and why they are always "throwing their arms about one another, entwined in mutual embraces, longing to grow into one."

But here we are far from the Greek spirit in the attitude toward nudity. The dim, blank vagueness of Adam's genital area is matched today by the design of most dolls for children.

BEGUILING SERPENTS AND HAIRLESS BODIES
⁊

The Bible tells us that the serpent who tempted Eve was "beautiful." Artists have been hard-pressed to depict a snake that would be beautiful to most humans—given our irrational fear of these exquisite creatures (page 10). As a result, you will see woman-faced serpents, baby-faced serpents, and even women that terminate in serpenticity—*almost* mermaids—leaning out of the tree of the knowledge of good and evil, insinuating their irresistible logic.

Master Bertram. The Creation of Eve, *from the* Saint Peter Altarpiece. *1379.* *Oil and some gold on oak, 33 ½ x 22 ½".* *Kunsthalle, Hamburg*

As nudity became more and more acceptable in art, Renaissance artists nonetheless resisted depicting body hair of any kind. They based this preference on the example of classical sculpture. Greek and Roman female nude bodies are always hairless, and males often so, or relatively so. Whether this reflects artistic convention or the custom of depilation is not really known.

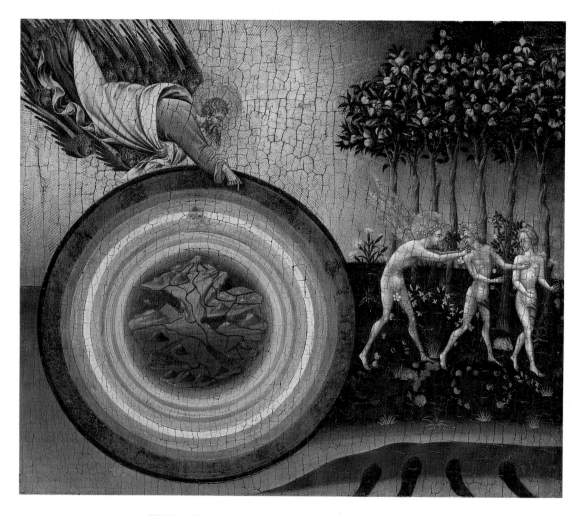

THE CREATION AND
THE FALL

ɘↄ

No, God is not rolling the globe toward Adam and Eve, but this is the moment of their reckoning. The archangel Michael is expelling them from Paradise.

In one glance, here are the entire universe, God its Creator, and the first humans being sent forth out of the perfect little world that was theirs for a short while. Within the celestial spheres, to which the sun, moon, and planets are attached, is the Earth, a sorry, brown place compared to the fragrant Garden of Eden, where the roses do not even have thorns.

Eden is not outside the universe. The right portion of the painting is an "enlargement" of the mountaintop, down on Earth, from which four rivers flow. These

same rivers, at their source, can be seen in the lower right of the painting. According to Genesis they are the Pison, Gihon, Tigris, and Euphrates, and they flow from Eden to the four corners of the Earth.

In fifteenth-century cartography, south was up, so that the tip of Africa is shown on the top of the map. It gives a refreshing jolt to the brain, reminding us how convention-bound is our own mental picturing. An "upside-down" globe is just as correct as the one we are used to, and the planets, even if they are not attached to invisible spheres, are, in our minds, often attached to wires representing orbits on a schoolroom model. And though we don't put the Earth at the center of the sun's orbit when we think about it, we do when we don't—when we say "sunrise."

No one can ignore a pointing finger. The extended finger of God's right hand dominates the picture, but in fact its meaning is not certain to scholars today. It may be setting the spheres of the universe in motion, or pointing to a precise moment in history between two of the—now almost obliterated—signs of the zodiac, the moment when Creation took place. It may even be indicating that instant in the future when the Virgin Mary will conceive, thus encompassing the eventual redemption of humanity within the painting's scope. Medieval and Renaissance painters did not shrink from depicting the most complicated conceptions, often treating time and space in ways that would today be called revolutionary.

The Creator is surrounded by cherubim, members of the first hierarchy of angels as described in the Book of Isaiah. They are nothing but faces and wings, suggesting disembodied intelligences. They represent divine wisdom and are usually blue. Seraphim are similar but red. Sometimes the two are called, respectively, the angels of night and of day. God's halo and the golden glory (the sunburst of rays) surrounding it illuminate the blue sky, driving the blue to the edges, as the sun would do. And it warms the naked bodies of the angel and the humans, who are obviously not unrelated species.

THE MYSTIC MILL

Until the modern era, the art of Europe was primarily Christian art, created to serve a religious purpose, and the stories

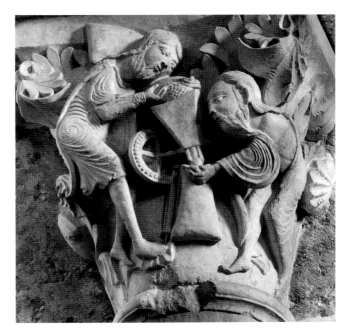

The Mystic Mill.
c. 1140.
Stone capital from the nave of Sainte Madelaine, Vézelay

from the Hebrew scriptures were seen from a Christian point of view—as prefigurations of the life of Christ and the redemption of humanity from sin. Here we see the grain of the Old Testament carefully being poured into the mystic mill to be ground into the precious flour of the New Testament. In later works of art, the mill became a winepress into which the Old Testament grapes were fed by the prophets to become the wine of Christian teaching—alluding to the wine of the Eucharist and the blood of Christ as well. Redemption was the central fact of life, and of the meaning of the Old as well as the New Testament.

For this reason, certain Old Testament stories recur often in reliefs, stained glass, or paintings, while other perfectly wonderful stories are seldom encountered. Jonah's deliverance from the great fish represents the resurrection of Christ, who spent three days in the grave, just as Jonah

Giotto. Jonah and the Great Fish. *1305–6. Fresco. Arena Chapel, Padua*

did in the belly of the fish. It represents also the ultimate deliverance of the faithful. Manna from Heaven prefigured the bread of the Eucharist. But the moving story of the Moabite Ruth and her humble loyalty to her Jewish husband's family, for example, is a less perfect fit with New Testament events and ideas and is rarely seen in paintings and sculpture.

According to the Christian view, the entire history of the universe, and the plan for the redemption of humanity, existed from the beginning, so that the experiences of the ancient Hebrews were enactments of future events. Soon this thinking was extended to the myths of Greece and Rome as well. And, perhaps hardest for us to grasp, events in the present could also have this mystic significance. Bestiaries were filled with amazing stories of the behavior of animals. The pelican pecked at its own breast in order to feed the blood to its young, just as Jesus gave his blood for us. Lion cubs were born dead and came to life three days later.

This is a conception of "reality," of history, and of time that confounds our rational, linear habits. Present events have "happened" (in earlier versions) in the past; past events are "happening" (or fulfilling their significance) now. Holy days are not just commemorative: each Easter Sunday, Jesus rises from the grave. This way of thinking did not end with the end of the Middle Ages. In the seventeenth century, when John Donne wrote of riding westward on Good Friday, he was intensely conscious of the Crucifix-

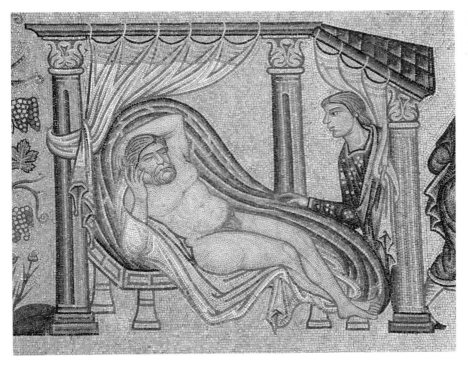

Ham Seeing Noah Naked. *1200. Atrium mosaic. San Marco, Venice*

ion that was *happening* in the East, the direction he should be facing.

While the expressive, concentrating faces on this medieval capital look completely fresh and plausible, the method of depicting drapery is still bound by artistic convention. The spirals that swirl over body bulges were copied from century to century, though clothing never does this.

NOAH'S DRUNKENNESS

It may come as a surprise that the head of the only family on Earth considered righteous enough by God to survive the Flood should manage to get drunk.

Some religious commentators have tried to explain it by saying that no one had ever tried wine before Noah.

The Bible relates that after the Flood, when Noah had to take up farming, he planted grapevines and then drank too much wine. (Either the vines grew very quickly, or the story skipped some years; Noah did live a long time.) He fell asleep naked and was discovered in this state by his son Ham. It was considered very wrong to look upon the naked body of your father, so when Ham told his more virtuous brothers what he had seen, they put a cloak over their shoulders and backed up toward Noah, managing to cover him without looking.

The Bible does not say that Ham mocked his father, but we assume so, because this story was seen as a prefiguring of the mocking of Christ, which is one of the reasons it turns up often in medieval art. It is a bit of a stretch. One cannot help thinking that artists wanted an excuse to depict the naked human form, so beautifully rounded out here in swirls of tesserae (from the Latin for "dice"), the pieces of stone or glass that make up a mosaic.

According to the Bible, Noah fell asleep in a tent. This elegant structure in the vineyard, with its Corinthian columns and slightly disorienting inverted perspective, shows the curtains that appear so often in Byzantine and Italian art, knotted together or looped around a column. They make palpable the heat of

the day, and also the delicious breezes that would cause them to flap if they were not tied.

ABRAHAM ENTERTAINS THE ANGELS

One day three angels appeared outside of Abraham's tent. Receiving them with the hospitality expected among desert peoples, he washed their feet and provided them with an excellent meal. The three anonymous angels—in the Bible they are called men—who visited Abraham were seen as symbolic of the Trinity. This is not quite as farfetched as it sounds, because there is much interesting ambiguity in the Bible account. The pronouns *he* and *they* alternate in confusing ways, and the whole incident is introduced as an appearance unto Abraham of the Lord.

It is a familiar story—of a mysterious stranger, whom the host treats well and who turns out to be divine. In this case, the appearance is also the occasion of a momentous announcement. God tells Abraham and Sarah that, in spite of their very advanced age and Sarah's lifelong barrenness, a son will be born to them, who will be named Isaac. This is a prefiguring of two such annunciations, one to the parents of John the Baptist, and one to the parents of the Virgin Mary, as we shall see. Abraham and Sarah both laugh in disbelief, and Sarah even lies about it, telling God she had not really laughed. "Nay, but thou didst laugh," is God's patient reply.

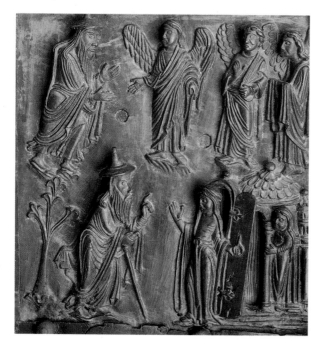

Second Master of San Zeno.
Abraham and the Three Angels; Abraham and Sarah. *Late 12th century. Bronze relief, doors of San Zeno, approx. 21 ⅝ x 19 ⅝". San Zeno, Verona*

In Romanesque and Gothic art, tents, houses, and churches are often barely large enough to hold one person. This way they become elements in the narrative without taking up too much space. For modern eyes these little structures have a magical quality, perhaps reminding us of the packing-crate houses we built for ourselves as children.

Abraham's funnel-shaped hat identifies him as a Jew, as pointed hats usually do. This and the presence of the three angels instantly signal the subject of the relief to the viewer. Art served as a kind of bible for the illiterate, so that such clear signs were very useful. Abraham's open-handed, welcoming gesture provides the dramatic tone, helping an imaginative onlooker to begin to tell his story, maybe even to quote his lines.

This eloquent bronze relief is one of many on the doors of the Church of San Zeno in Verona. Like other Romanesque and Gothic church doors and facades, it served for centuries as a veritable storybook, open even when the church was closed. One imagines a parent "reading" these stories to a child in the late afternoon sunlight, a scene that must have occurred thousands of times.

The full afternoon sun, by the way, lights the front of most churches, because they were built with the same orientation. Inside, the congregation facing the main altar faces the east, the direction of the rising sun and the rising Christ. Every evening across Europe, the last light illumines the rose windows above the front doors of countless churches.

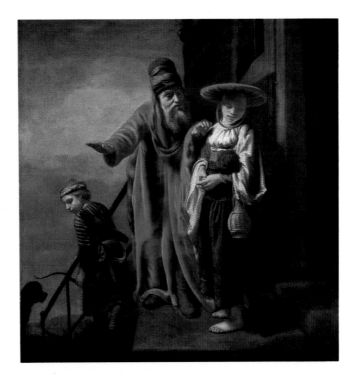

While Abraham's gesture clearly says, "Welcome," in the upper scene, in the lower register it just as clearly says, "Go away." He is sending his second wife, Hagar, her hand lingering on the door pull, and their son, Ishmael, off into the desert. The small, eavesdropping figure is hard to identify with certainty. It is either Sarah or Ishmael.

Nicholas Maes. Abraham Dismissing Hagar and Ishmael. *1653.*
Oil on canvas, 34 ½ x 27 ½". The Metropolitan Museum of Art, New York. Gift of Mrs. Edward Brayton, 1971

HAGAR AND ISHMAEL
ℰℛ

Before the birth of Isaac, Sarah had told Abraham to take her Egyptian handmaiden, Hagar, as a second wife, so that her barrenness would not deprive him of offspring. Later, when Isaac was born and

Ishmael mocked his younger half-brother, Sarah demanded that both child and mother be sent away. Abraham, assured by God that Ishmael would one day found a great nation, gave them bread and water and sent them into the desert.

It is the plight of Hagar and Ishmael as castoffs and exiles that seems to move the painters who, many centuries after the bronze reliefs were made, turned often to this subject. The banishment in Nicholas Maes's painting is almost painful in its psychological penetration. The downcast eyes of mother and son tell us that, contrary to all reason, they are ashamed; they think they deserve their plight.

In the desert their water will run out. Hagar will place her unconscious son under a bush, and walk some distance away,

Second Master of San Zeno. The Sacrifice of Isaac. *Late 12th century. Bronze relief, doors of San Zeno, approx. 21 ⅝ x 19 ⅝". San Zeno, Verona*

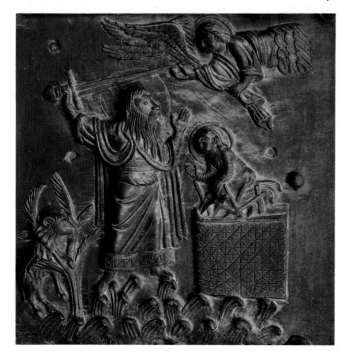

so that she will not have to watch him die. But an angel will swoop down, just in time, and disclose a nearby well, saving both mother and son. The descent of the angel appears often in paintings of the story of Hagar and Ishmael. It provides an opportunity to paint vast desert terrain, and a happy ending.

Abraham is a fascinating character. For example, when God announced his intention to destroy the sinful city of Sodom, Abraham asked, in effect, "But what if there are fifty righteous people in Sodom, will you destroy the whole city, with them in it?" God said no, if there were fifty, he would spare the city. So Abraham asked, "How about forty-five; what if there are forty-five?" This went on until Abraham, a little nervous but absolutely dogged, managed to get the number down to ten. This willingness to challenge God makes it all the more shocking that, when God told Abraham to sacrifice his son, Isaac, Abraham didn't make a peep.

THE SACRIFICE OF ISAAC

ⲥⲟ

The story is a terrible one. As if the sheer horror of such an act were not enough, the telling of it proceeds detail by pathetic detail. God has directed Abraham to make a sacrificial offering of his son. Abraham leads his son up a mountain. The boy, carrying sticks for the fire, asks where the lamb is for the burnt offering. Abraham says God will supply the

lamb. Finally, at the very last minute, an angel stops Abraham's hand. The voice of God commends Abraham for his unquestioning obedience, and a nearby ram that has caught its head in a thicket is substituted for Isaac.

This story passes through the mystic mill rather well: God will do himself what he will not ask of man. He will sacrifice his son. The wood carried by Isaac prefigures Christ carrying his own cross. The ram in the thicket symbolizes the Crucifixion and the Crown of Thorns. Though admittedly things do not work out in perfect one-to-one correspondences, to the faithful it was more than close enough.

The narrative economy of this bronze relief is extraordinary. The angel who emerges from a cloud clasps the raised sword with a delicacy that conveys how eager Abraham is not to use it. The angel's wings are fit into the composition to tell their story. It is unimportant that they grow from the angel's arm instead of his shoulder blades.

HORNS, HATS, AND ANTI-SEMITISM

The horns of Moses appear, though not consistently, in European art right up through the Renaissance. (Even Michelangelo gave Moses a pair, and they are quite convincing, knoblike protuberances. They can be seen in the church of Saint Peter in Chains, in Rome.) It is often said that this convention can be traced to a mistranslation. When Moses

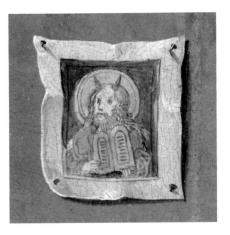

Joos van Cleve. The Annunciation *(detail showing hand-colored woodcut of Moses, probably by Jacob Cornelisz van Oostsanen, tacked to the Virgin Mary's wall).* 1510–40. *Tempera and oil on wood, 34 x 31½". The Metropolitan Museum of Art, New York. Bequest of Michael Friedman, 1931*

came down from the mountain with the tablets of the law, beams of light emanated from his head. The Hebrew word for beams or rays was translated as "horns."

But Saint Jerome, the man who made this mistake, if it was one, was a very competent scholar who may have known exactly what he was doing. Horns had been an attribute for gods and heroes, in Egypt and Mesopotamia, for example, for centuries. They were associated with honor, power and the magical ability to avert evil. Alexander the Great was often depicted with horns. We need only think of the Vikings, or Richard Wagner's Valkyries, for familiar examples of horned headdresses meant to imply superhuman strength in their wearers.

In any case, Moses often has horns, and by extension so, sometimes, do other Jews in European art. Anti-Semitism was not so prevalent in early Christian or early medieval times as it would become later, but no doubt there were some, especially in later centuries, who associated these horns with those of Satan. And, no

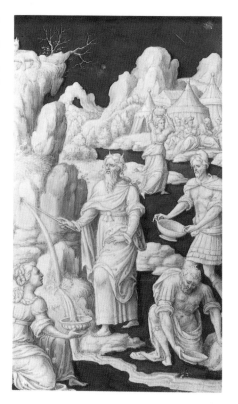

and, when something like this begins to happen, anti-Semitism is obviously at work. So, one would have to know the background of a work of art quite well before inferring any particular attitude toward Jews based on the hats they wear.

To Christians, Jews were, of course, infidels, like Moors, Saracens, pagans, or nonbelievers of any type. The time of cultural relativity had not come. But Christian attempts to convert Jews, when they were noncoercive, reflected an acknowledgment of their value as persons, not the opposite.

MOSES STRIKING THE ROCK

cx/o

Europe has no deserts, yet the "memory" of desert experience is fundamental to Western symbolic language and picturing. "Getting water from a stone," a common phrase for futility, probably alludes to one of the miracles Moses performed during the wandering in the desert described in Exodus. The Israelites were thirsty. As they became more and more angry and impatient with Moses, he called upon God, saying, "They be almost ready to stone me!" The Lord directed Moses to strike a rock with his rod. He did, and water gushed forth.

Moses shows an almost casual confidence in this miniature painting, and the Israelites appear calmer than they sound in Exodus. The rock was thought to be Christ, and the water the blood and water that gushed from the wound in his side;

doubt, there must have been some people who heard tell that all Jews had horns and were ignorant enough to believe it.

The hats worn by Jews should also be viewed as having different meanings at different times and to different people. Jews in early European art often wear pointy hats or, sometimes, funnel-shaped ones. They do not, by any means, have a universally negative meaning. Jews cover their heads out of piety. Many Christian artists knew this and used hats as attributes to make Old Testament figures easily identifiable. It is also true, however, that later in the history of Europe Jews were often required to wear the *Judenhut,*

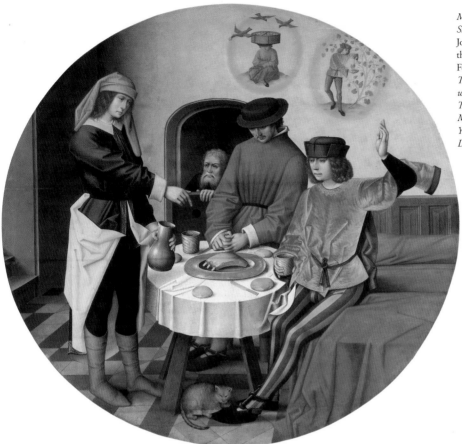

*Master of the
Story of Joseph.*
Joseph Interprets
the Dreams of His
Fellow Prisoners. *c. 1500.
Tempera and oil on
wood, diameter 61 ½".
The Metropolitan
Museum of Art, New
York. Harris Brisbane
Dick Fund, 1953*

or, the rock was the Church, and the water the spiritual comfort and nourishment it provides.

JOSEPH IN EGYPT

Joseph, the youngest son of Jacob, and his favorite, was despised by his brothers. When his unconsciously superior ways became too much for them (he was, in fact, superior), they threw him into a pit and sold him to merchants on their way to Egypt. The lowering of Joseph into the pit and subsequent lifting out was thought to prefigure the Entombment and Resurrection of Jesus.

In Egypt Joseph began to work as a steward in the house of Potiphar. But Potiphar's wife lusted after him and was so insulted by his refusal of her that she accused him of trying to molest *her* and had him jailed by her husband. In prison Joseph was treated well by the

keeper, who was quite taken with him. He put Joseph in charge of the other prisoners. Among them were the butler and baker of the Pharaoh, both of whom woke one morning very disturbed by their dreams.

Joseph was an excellent interpreter of dreams, so he set to work on theirs. The butler had dreamed of a grapevine from which he picked the fruit, filling Pharaoh's cup with it. The baker dreamed that birds stole the baked meats from the basket on his head. Joseph predicted that the baker would die at Pharaoh's hands and that the butler would be restored to his former position. Both predictions came true. Joseph had asked the butler to remember him to Pharaoh when this happened, but the butler forgot all about him until two years later, when Pharaoh had need of an interpreter for his dreams.

Based on Pharaoh's dreams, Joseph predicted a great famine in Egypt. He recommended that the fat harvests of the next seven years be stored to avert disaster. This was done, and Egypt was saved, prefiguring—by something of a stretch —the Miracle of the Loaves and the Fishes. Then, finally, Joseph was raised to great heights in Egypt. He eventually met up with his brothers, forgave them, and was reunited with his father.

Here we see Joseph in prison, living under rather good conditions, as the Bible indicates. They are certainly not ancient Egyptian conditions, however. In sixteenth-century Flanders, historically accurate painting had not yet caught on. But even when, by the nineteenth century,

artists took great pains to keep abreast with archaeology and get all the helmets and sandals right, the results were not necessarily more wonderful than this.

The dream bubbles are a clearly understood popular convention by now, although they could not have been common four hundred years ago. What with the bubbles, hats, cups, loaves of bread, pitcher, table, and cat, the painting is a study in roundness, contained in its own round shape. The artist is unknown, but curves were obviously to his liking. The bearded man in the doorway is a mystery. He holds some kind of panel and regards Joseph intently, much as an artist would while making a likeness. But he could be the keeper, or even Potiphar, the man who had jailed Joseph in the first place. I like to think he is the anonymous artist, giving himself a cameo appearance in his own painting.

As artists turned from painting on wood panel to canvas, the tyranny of the rectangle increased. It is easier to cut wood in interesting shapes than to construct such frames and stretch canvas over them. Paintings with rounded tops and altarpieces with entire mountain ranges of pointed peaks went out of use.

JUDITH AND HOLOFERNES
જી

The word *apocrypha* comes from the Greek for "hidden." A number of stories are contained in books of the Scriptures that ultimately did not receive the official

approval of the church. There are Old Testament as well as New Testament Apocrypha. Some apocryphal accounts have all the power and quality of anything in the Bible while others read like botched fairy tales. Many figure importantly in the art of the Middle Ages and the Renaissance. The apocryphal story of Judith maintained its appeal for many centuries, not surprisingly, given its combination of heroic action, deceit, sex, suspense, and gruesomeness.

The Babylonian army, under their captain Holofernes, cut off the water supply to the Israelite city of Bethulia. Just as the desperate Israelites were about to surrender, Judith, a wealthy, pious, and beautiful widow, convinced the elders to let her try to save the city. She entered the Babylonian camp dressed seductively and suggested to Holofernes a scheme for defeating the Jews. Her beauty and intelligence so impressed the captain that he could not suspect her, and she spent three days in the camp, asking permission only to go out at night to pray.

On the fourth night Holofernes gave a banquet and invited Judith, planning to seduce her. But by the time they were alone, he had become drunk and fallen into a stupor. Judith seized his sword, prayed to God for strength, and beheaded him. Because the Babylonians were accustomed to seeing her leave the camp each night, she was able to depart, taking the captain's head back to her city. In the morning the headless body was discovered, the Babylonians fell into con-

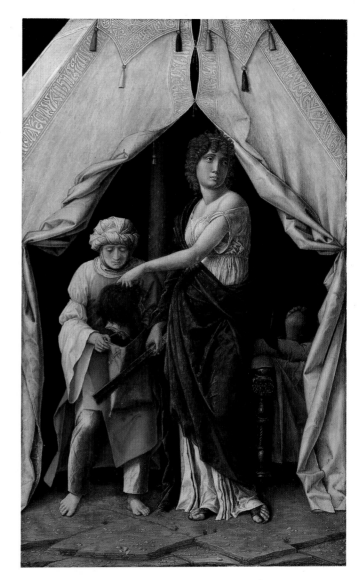

fusion, and the Israelites attacked and defeated them.

The suppressed terror and the barely concealed disgust on the faces of Judith and her servant convince us that the deed was not performed without appalling

Andrea Mantegna.
Judith and Holofernes.
c. 1495. Tempera on panel, 11 ⅞ x 7 ⅛". Board of Trustees, National Gallery of Art, Washington, D.C. Widener Collection

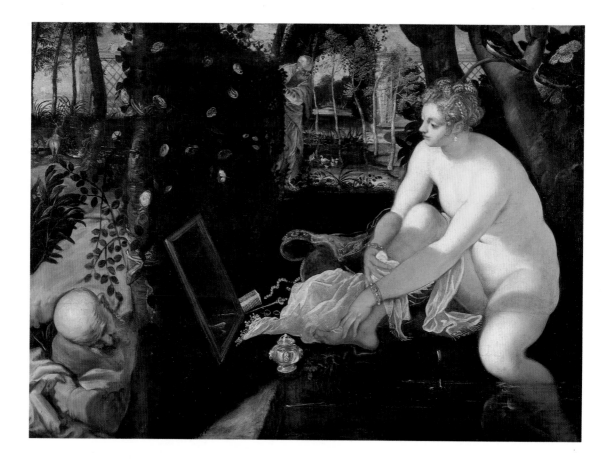

mental and emotional effort. Nor was it physically easy, as Judith's glistening face and the traces of blood on her clothing show. The black sky, the tent's black interior, and the macabre foot of the victim intensify the gloom. Judith looks away, perhaps toward her city. She seems to be trying to remember her purpose and cling to her resolve until she can get there.

By Mantegna's time, it was not unusual for artists to pair this subject with that of Samson and Delilah or another scene that would render it a warning to men to beware the duplicity of women. This painting seems to have no such overtones. It comes closer to the medieval treatment of the subject as an example of virtue overcoming vice. Mantegna is far more subtle, however, suggesting as he does the psychological risks exacted by piety and patriotism in war.

SUSANNAH AND
THE ELDERS

Susannah, another heroine of the apocrypha, was a surpassingly beautiful woman. She lived during the Exile in Babylon as the virtuous wife of a wealthy Jew. Two elders of the community were consumed with lust for her. They hid themselves in her garden, where she customarily bathed. After her serving women had left her alone, the elders surprised her and demanded that she give herself to them. If she refused, they would swear that they had witnessed her committing adultery with a young man. Since they commanded the respect of the community, they would not be doubted, and she would surely have to pay the penalty for adultery, which was death. Susannah struggled anyway, cried for help, and got away from them.

A trial followed, with the results predicted by the elders. Susannah would die for her sin. But just as she was about to be led to her execution, the fearless young hero Daniel cried out that she had not been given a fair trial. He took charge of the proceedings, separated the elders, cross-examined them, and, in a gripping courtroom drama, exposed the contradictions in their testimony and proved that they were lying.

This was a popular subject among the very early Christians. It appears in the catacombs at Rome, where the emphasis is on Susannah's vindication by Daniel. No doubt it was a comforting story for a people that found themselves persecuted by those in power. Later, the story appealed to artists who needed all the legitimate reasons they could find for painting a beautiful nude woman.

In Tintoretto's sumptuous painting the suspense is intense, not just because of the repulsive sneakiness of the elders (one of them seems to be sliding on his belly like a serpent) but also because Susannah, comfortable in her bower, gazing into the mirror thoughtfully with one foot still in the water, really seems to believe that she is alone.

Very few female nudes in European painting are completely naked. Most wear jewels, and some wear hats. Susannah has removed much of her jewelry, while leaving enough on to remain the glamorous woman that her hairstyle suggests she is.

TOBIAS, THE ANGEL,
THE DOG, AND
THE FISH

The story of Tobias comes from the book of Tobit, a late Jewish work, probably written between 200 and 50 BC, that became part of the Christian Apocrypha. Like the stories of Judith and Susannah, it was just too good to be entirely forgotten, even after it was rejected as Scripture.

Tobit was a virtuous man of the city of Nineveh who devoted his life to helping the needy and burying the bodies of the outcast. One night he buried the corpse of a murdered Jew that had been thrown

into the street. He slept outdoors afterward because it was too late to be purified, as required by Jewish law. During the night, somehow, the warm droppings of birds fell into his eyes and he became blind. (This is one of those details that can probably be left unscrutinized.) Unable to work, fallen into poverty, Tobit finally prayed to God to allow him to die.

It so happened that, at that moment on the same day, another such prayer reached the ears of God. It was from a young woman named Sarah, a cousin of Tobit who lived in Media. A demon was in love with Sarah. She had married seven husbands, and each had been struck dead upon entering the bridal chamber. She was beautiful and wise, a very desirable wife, as attested by the bravery of each successive husband. Unable to bear her plight any longer, Sarah prayed for death.

Just as Tobit had finished *his* despairing prayer, he happened to remember a debt owed him by a man in Rages, a city beyond Media. He decided to send his son Tobias to collect it. A traveling companion was found for Tobias, a young man named Azarias, who, it was agreed, would receive half of the debt payment if it could be collected. This Azarias was an angel in disguise. He was, in fact, the archangel Raphael. The two set off with the family dog trotting along beside them. (This is the only sympathetic dog in all biblical literature. It was perhaps part of the family because it functioned as Tobit's Seeing Eye dog.)

At the end of the first day's journey they came to the river Tigris. Tobias went down to wash himself. A fish leaped up at him and he caught it. Raphael directed him to clean the fish, saving the heart, liver, and gall. He did so, and they ate the fish for dinner.

Raphael then told Tobias that they would stay with Sarah's family that night, and that Tobias and Sarah would marry. Tobias had no idea that his companion was really the archangel Raphael, and he was understandably terrified. He had heard about the seven husbands. But Tobias trusted Raphael anyway.

Domenico Ghirlandaio.
Tobias and the Angel.
*1479–86. Tempera on
wood, 6¼ x 16¼".
The Metropolitan
Museum of Art,
New York. Francis L.
Leland Fund, 1913*

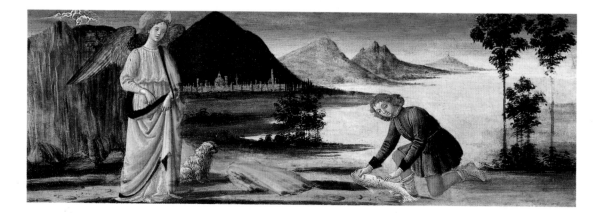

(Though we can see that Tobias's companion is an angel, it is understood that Tobias cannot. Sometimes what is clear to us is not so clear to the actors in a painted narrative.)

Tobias did as he was told and married the beautiful Sarah. Upon entering her chamber, he burned the heart and liver of the fish, as the angel had instructed him to do. The demon fled forever and the two climbed happily into bed.

In the stained-glass piece, we see Tobias, Sarah, and the faithful dog safe and sound in bed. The red blob is a bed curtain that has been tied in a knot with the tail tucked up inside. This was a very common practice in Europe in the warmer months, judging from countless medieval and Renaissance scenes. People did not usually lie flat in bed as we do, but propped themselves up in a semi-seated position.

But that is not the end of the story. While the young couple enjoyed their wedding night, Raphael fetched the debt money from Rages. The next day the three set off for Nineveh. As they approached the house of Tobit, Raphael instructed Tobias to have the fish gall ready for the moment when his father would realize that his son was returning. Tobit would be so excited that he would instinctively open his eyes, which were otherwise always closed. In that instant, Tobias was to apply the fish gall. He did, and Tobit's blindness was cured.

Tremendous rejoicing followed, and when everyone had calmed down, Tobit offered the angel half the debt money, which he of course refused, revealing at

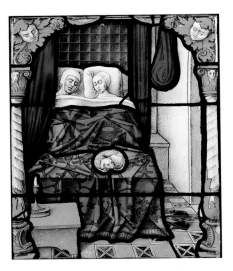

last that he was the archangel Raphael. He then vanished.

The Book of Tobit gave Raphael his reputation as the archangel most interested in human affairs. It is also said to have inspired the Roman Catholic cult of the Guardian Angel. In well-off Renaissance families, when a son was to depart on a long journey, it was not uncommon to commission a painting in which the angel Raphael walks with a Tobias painted in the son's likeness.

The fish is a symbol of conversion, based on Christ's words, "I will make you fishers of men." Adding the simple association of fish and water, it can also represent baptism. And, because the letters in the Greek word for fish are the initial letters of "Jesus Christ, Son of God," the fish is a symbol for Christ himself. However, even though it could be interpreted symbolically, the story of Tobias was loved mostly for its own charm.

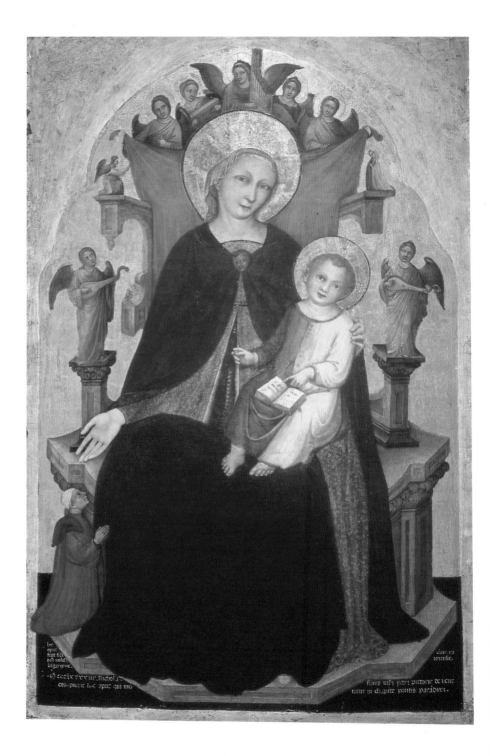

THE VIRGIN MARY

WHERE DID THE VIRGIN COME FROM?

❧

Mary, the mother of Jesus, does appear in the Gospels, but not often, and she seldom speaks. The miraculous cause of her pregnancy notwithstanding, she is simply Christ's mother, and she behaves very much as any mother would. Jesus himself, far from showing unusual reverence, seems rather dismissive of her. How then did Mary come to be worshiped as the Queen of Heaven, the Mother of God, the advocate for sinful, suffering humanity? Where did this Mary come from?

She came from people. It seems that for vast numbers of Christians, an utterly patriarchal view of God was simply inadequate. They saw Mary in visions, they asked her for help, they were saved by her miracles. The church simply could not resist a mother who persisted so vigorously to make herself indispensable. Visions and miracles have always been admissible as evidence in the Roman church—though not all visions and miracles. Certain signs of authenticity are necessary, including the credibility of the witnesses. In any case, if one maintains, as Carl Jung did, that the human psyche is as real as anything else, then the ascendancy of Mary poses no problems, even to belief.

MARY'S CONCEPTION

❧

In theological terms, the story of Mary begins with her Immaculate Conception. This doctrine did not become the official dogma of the Roman Catholic church until 1854, but it had been passionately held by many Christians for centuries.

The Immaculate Conception has nothing to do with the conception of Jesus. It means that Mary herself was conceived without sin. The fall from grace in the Garden of Eden did not apply to her. She is, in fact, the second Eve, who will undo the trouble caused by the first one. She is part of God's plan for the redemption of humanity, and she was there from the beginning.

All this means, among other things, that Mary was not only a human being chosen by God, but that she is herself a goddess. Some of her devotees might take exception to this word goddess, because of its pagan associations and polytheistic implications, but others welcome it as an emphatic corrective to an otherwise exclusively male vision of divinity. With the idea of the Immaculate Conception came a marked increase in painted and sculpted images of Mary standing alone, without the child Jesus in her arms.

Niccolò di Pietro.
Madonna and Child.
c. 1394.
Panel, 42 ⅛ x 25 ⅝ ".
Galleria dell'Accademia,
Venice (see page 50)

JOACHIM AND ANNA,
MARY'S PARENTS
cʌ

Mary's importance was such that her life could not be left in the dark. Legends grew up to fill in the many gaps in her biblical biography, some with a homey, delightful richness of detail, some full of magic and peculiar behavior out of keeping with her character as it came to be seen. While some of these stories died out, many remained familiar well into the Renaissance, and held important places in the repertories of artists. One of them is the story of Mary's parents, and how she came to be born.

A wealthy but virtuous and devout man named Joachim had been married to a loving and like-minded wife named Anna for fifty years. They lived in Jerusalem. On a certain feast day, Joachim carried a lamb as an offering to the Temple, but the high priest (or a scribe—accounts differ) turned him away, saying that he was unworthy to sacrifice in the Temple since God had not blessed him with offspring. As Giotto shows us, Joachim was dashed with grief and shame. He holds the little lamb as tenderly as if it were the child he has never had, almost as if to protect and reassure it of its own worthiness.

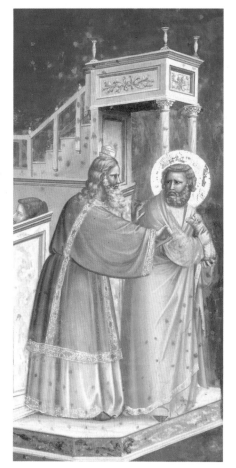

Giotto. Expulsion of Joachim *(detail). 1305–6. Fresco. Arena Chapel, Padua*

Far right: Bernhard Strigel. The Annunciation to Saint Anna and Saint Joachim *(detail). c. 1505–10. Oil on panel, 23 x 11 ¾". Fundación Colección Thyssen-Bornemisza, Madrid*

So downcast was Joachim that he went into the mountains and stayed there with some shepherds. Anna had no idea where he was or whether he was alive or dead. One day, while she was praying, she noticed a sparrow's nest in a laurel tree. She burst into tears and cried to God that even the birds were fruitful, but she was not.

Just then an angel appeared. No doubt it was Gabriel, the messenger of God, who told her that she would conceive and bear a child that would "be held in wonder to the end of time." The angel then told Anna to go and wait for her husband at Jerusalem's Golden Gate.

In Strigel's painting, the angel's speech is visible in the form of a curly banner. Out the window, on a hillside, we can see Joachim, also hearing the news from the angel. Giotto shows us the moment when Joachim finally returns to the city with the shepherds, and Anna rushes into his arms and they kiss.

Now, some say that Joachim and Anna conceived their sinless daughter in the customary way of human beings. Others, since sexuality was firmly tied to sin in most Christian thought, believed it could not be so. Some, in a kind of compromise, said it was the kiss at the Golden Gate that marked the moment of conception. Some very thoroughgoing thinkers on the subject not only denied any "concupiscence" in Mary's conception but even went so far as to speculate upon Anna's. How could the mother of the sinless Mary be impure herself? Anna's mother was thus said to have be-

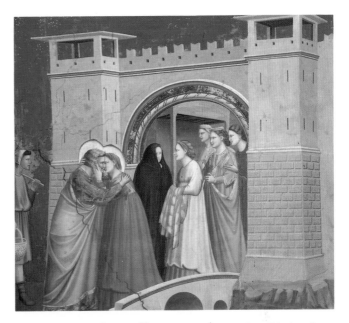

Giotto. Meeting of Joachim and Anna at the Golden Gate. *1305–6. Fresco. Arena Chapel, Padua*

come pregnant by smelling a rose, but that story did not catch on widely.

In any case, the original point of the story of Anna and Joachim seems to have been the miraculous birth of a child to a very old couple, echoing the birth of Isaac to Abraham and Sarah. If there had been no sex, the age of the parents would be irrelevant. This is the miracle embodied in Petrus Christus's mysterious painting of Mary and the infant Jesus in a barren tree hung with her mother's initials (frontispiece, page 2).

When the birth took place, strangely enough, it was an ordinary domestic event. (When John the Baptist was born, he could stand up.) The Birth of the Virgin often provided a chance for painters to create a tender scene and an interesting household interior. Vittore Carpaccio has done his homework and included

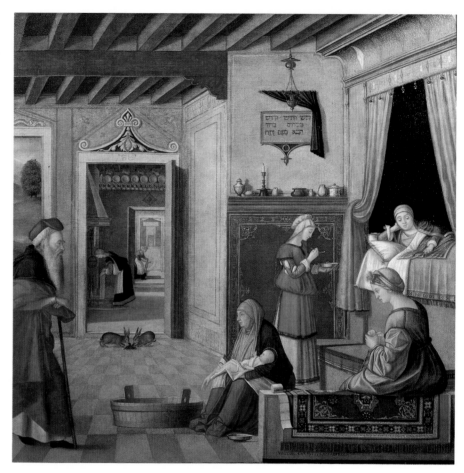

an inscription in Hebrew on the wall of the respectable Jewish household. It is a passage from the Psalms that will eventually be echoed in the cries of the spectators during Jesus's entry into Jerusalem: "Blessed is he that cometh in the name of the Lord; Hosannah in the highest." A servant dries wet laundry in front of the fire, and rabbits probably destined for a stew nibble lettuce on the floor. The artist was not entirely familiar with Jewish life, because rabbits are among the "unclean beasts" and would not have been served in a Jewish household.

A curiously touching theme, in Germany called the *Selbdrift*, gives honor to Anna as the mother of Mary and the grandmother of Christ. Mary sits on her mother's lap, with the baby Jesus on her own. Some thought the subject a bit ridiculous and discouraged its use, but Patinir has captured the charm

of this homage to motherhood with straightforward simplicity. Even an artist as sophisticated as Leonardo was fascinated by the theme and managed somehow to make it work without any loss of dignity to either Anna or Mary. Many who are familiar with his famous *Virgin and Child with Saint Anne* in the Louvre (and the related drawing at The National Gallery in London) fail even to notice that the full-grown Mary is actually sitting on her mother's lap.

MARY'S CHILDHOOD
~

The Virgin Mary showed extraordinary piety even as a toddler. From her mother she learned to read the Scriptures—and quickly understood their hidden meanings. She wanted nothing more than to be in the Temple, and as soon as her parents allowed it she moved right in. There she studied, prayed, and embroidered altar cloths. Mary loved the Sabbath and looked forward to it all week. Not one for idle chatter on any day, on Saturday she spoke only to angels. Even today the rosary is said on Saturday, Mary's day.

The Presentation of the Virgin, a popular subject, shows the moment when she leaves her family and enters the Temple. (This apocryphal story of Mary's residence in the Temple reflects more knowledge of pagan than of Jewish practice. The custom of female virgins performing priestly functions was unheard of in Judaism.)

The many distracting details in Titian's Presentation, especially the wi-

Joachim Patinir. Saint Anne with the Virgin and Child, *exterior wing of the triptych* The Penitence of Saint Jerome. *c. 1515–24. Tempera and oil on wood, 47 ½ x 14". The Metropolitan Museum of Art, New York. Fletcher Fund, 1936*

zened old egg peddler below the steps, have occasioned much interpretation and some criticism. But the powerful use of scale emphasizes Mary's tininess, and the old woman provides a foil for her fresh innocence—and eggs do symbolize both the virgin birth and the Resurrection. The little girl's solitary walk up the huge staircase is especially affecting to

modern viewers who are sensitive to the
scarcity of heroic imagery where girls are
concerned. Her call to a "higher" purpose
could hardly be made more plain.

It was believed that the Temple in
Jerusalem had fifteen steps, but Titian left

a few out. Many painters put them all in,
causing havoc to their compositions. The
rectangular holes at the bottom of the
painting accommodate two doors in
the Scuola della Carita in Venice, for
which the artist painted the picture. It is

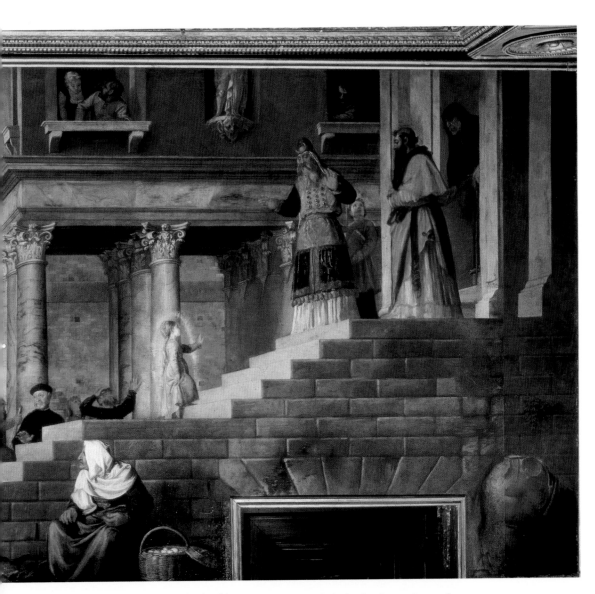

still on the same wall, though the building has become the Galleria dell' Accademia. Titian designed the masonry of the Temple stairs to fit the right-hand door, and no doubt he would have done something equally clever for the door on the left, had it been there when he painted the picture. That rectangle was cut out later. One of the pleasures of looking at European art in Europe is that of seeing mosaics, frescoes, and paintings in situ. There is a special intimacy that

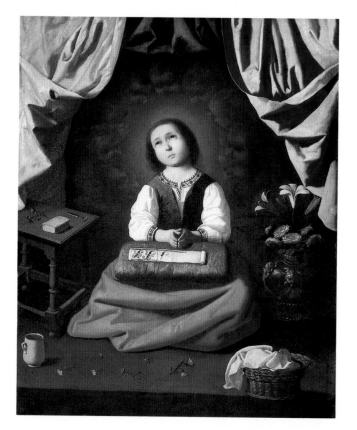

Francisco de Zurbarán.
The Young Virgin.
c. 1632–33.
Oil on canvas, 46 x 37".
The Metropolitan
Museum of Art,
New York. Fletcher
Fund, 1927

blackwork, still popular in Spain—to pray. Her halo is made of the faces of angels portrayed as chubby babies. These "cherubs," as we now call them, are based on classical *putti*, appropriated by Renaissance artists for Christian use. Since they are red, they are seraphim. The white lilies represent Mary's purity, as always. The rose has long been considered Mary's flower as well; she was called the rose without thorns because she was free from sin. The artist seems rather to insist upon some special significance in the seven blossoming sprigs on the floor. They are probably columbines, symbols of either the seven sorrows of Mary—the tragic events in her life—or the seven gifts of the Holy Spirit as described by Isaiah. *Columba* means "dove" in Latin, hence the association of columbines with the Holy Spirit, which is symbolized by a white dove.

It is possible that every single object in the painting had a symbolic reference for the artist, but whether we know all their meanings or not, we can enjoy their convincing, palpable presence. We view the young girl from beyond a ledge, as if she were on a small stage. That and the lifted curtains convince us that this is a privileged glimpse of an utterly private moment.

THE MARRIAGE OF THE VIRGIN

ↄ

When Mary reached puberty, the high priest would no longer allow her to serve in the Temple for fear that she might defile

comes with knowing that the work of art has "lived" on this very wall in this very city since it was created.

The blue mountains in the distance are bluer than might be natural and represent a convention in Italian painting. But it is also true that distant mountains in the atmosphere of the northern Italian skies do have a blue cast—just as clouds in Spain look like the ones El Greco painted. (Travel can explain many things in our artistic heritage.)

The Spanish artist Zurbarán shows Mary interrupting her needlework—

it. (This detail is more in keeping with Jewish belief, which stipulates the ritual uncleanliness of menstruating women.) It was decided that she must marry. She was highly intelligent, virtuous, and incredibly beautiful, and every unmarried man wanted her, except Joseph, a widower who considered himself too old to take a wife. Because the competition was so intense, the priest decided on a kind of contest to prevent strife among the suitors. He asked every unmarried man to bring a rod to the Temple. Joseph did so, but only in a spirit of obedience. The rods were left overnight, and by morning Joseph's had blossomed. (This event was foretold in the Old Testament by the blossoming of Aaron's rod.)

Here Joseph weds Mary in a most decorous ceremony, as conceived by Raphael. Somehow, as we can see, the wedding-ring finger has changed hands in the past few centuries. (For a time in Europe, Protestant wives wore their wedding rings on the left hand, and Catholics on the right.) The disappointed suitors are stylishly dressed Renaissance swains who look rather dashing compared to Joseph in his saintly bare feet and beautiful but soberly designed robe. One breaks his rod over his knee, though without much obvious rage or disappointment, perhaps because more passionate behavior on his part would suggest lustier feelings for Mary than would seem proper. Some earlier versions of the story show less reserve.

But isn't this a painting about a building? Why is that magnificent, domed structure demanding as much attention as Joseph and the Virgin? First, it should be remembered that the story of the Marriage of the Virgin was utterly familiar by the time Raphael painted it. It was only natural to look for a new take on the subject. Then, too, the painting is not so much a narrative one as an object for contemplation. It is more about ideas than actions. The predominance of the Temple may underscore the piety of

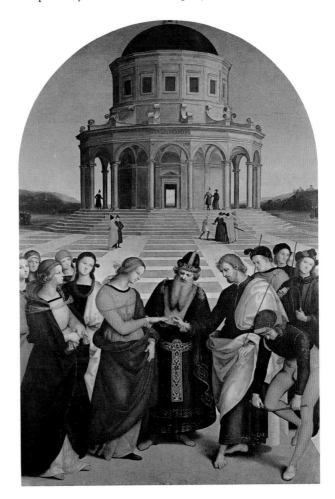

Raphael. Marriage of the Virgin. *1504. Oil on canvas, 67 x 45½". Pinacoteca Brera, Milan*

the husband and wife and the religious significance of their espousal, saying in effect that that is the central reality.

More than anything, however, this painting reflects the taste of an era that was simply wild about architecture. The conception of a great building like this one was interesting in itself. Around this time, a painting of the Last Supper or even the Birth of the Virgin might take place in an architectural setting that would make the Roman Forum look cozy.

The composition of Raphael's painting is wonderfully unified by the domed structure, which acts on the elements of the picture as a magnet on iron filings. And the vanishing point has the effect of drawing us through a blue door into the sky and perhaps toward the future.

Raphael has signed and dated the building. In a sense, he was the architect,

and he was proud of his creation. He was also, no doubt, proud of the painting. Medieval artists seldom signed their work, and as those of the Renaissance began to affix their names to paintings, they often took pains not to spoil the illusion they had created. Writing on the painting itself admits it's a painting; an incised inscription on a wall, or a note on a *cartellino* (a scrap of paper) lying on the floor does not.

THE ANNUNCIATION

The idea of the Virgin Birth was not a new one in the classical Mediterranean world. The amorous visits of gods to humans are well known in mythology, and Pythagoras, Plato, and Alexander the Great were all said to have been born of mortal women who were visited by

Fra Filippo Lippi. The Annunciation. *c. 1448. Oil on panel, 27 x 60". By courtesy of the Trustees, The National Gallery, London*

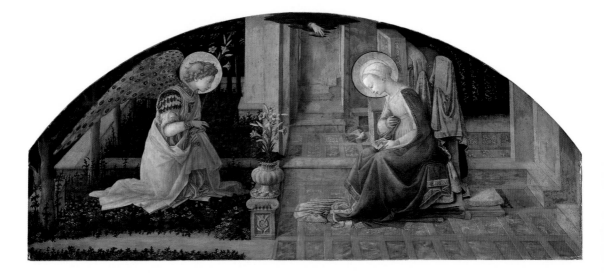

divine spirits. Some even made the claim for themselves. Simon Magus, a pagan prophet or magician who was put to shame in a contest with Saint Peter in Rome, claimed throughout his career that his mother was a virgin. The early Christian theologians defended the doctrine of the Virgin Birth against the smack of pagan influence more strenuously than against its improbability. Their defense involved a view of classical myth and legend much like their view of the Old Testament. As we will see, it was held that God had prepared the world for the coming of Christ by foreshadowing it in earlier events and beliefs—even the beliefs of pagans.

Every Annunciation painting is a meeting of angel and woman. The archangel Gabriel has been sent from Heaven to tell the Virgin that she will bear a son who shall be called Joshua. (Jesus is the Greek form of Joshua, which in Hebrew means "savior.") The angel is sometimes pictured as a mature male, but often he looks young, as if he were Mary's contemporary. He almost always approaches from our left to greet Mary, on the right, who has been reading or praying. His greeting, *Ave Maria, gratia plena* (Hail Mary, full of grace), sometimes issues visibly from his mouth. She holds a book. White lilies, in a vase or carried by Gabriel, symbolize her chastity. The dove of the Holy Spirit, also called the Holy Ghost, descends along a beam of light emanating from God the Father, or from his hand, high in the Heavens. These elements, or most of

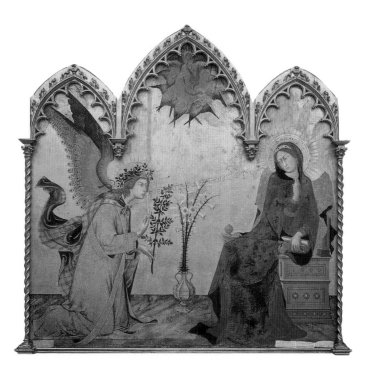

them, have appeared in every Annunciation scene created in the past thousand years or more.

They are the externals. The crucial subject of the Annunciation, the action, is invisible. The angel speaks; Mary apprehends both the honor and terror in the message. But it is not only the moment of her understanding, it is the instant of conception. The Holy Ghost enters her womb and thus effects the incarnation of God as a human being. The day is March 25, nine months before the birth of Christ.

In Christian belief, this pivotal event marks the end of the long estrangement between God and humanity—ever since the Fall—and signals the beginning of reconciliation. This is why the Annunci-

Simone Martini. The Annunciation. *c. 1333. Tempera on wood, 10' x 8'9". Uffizi Gallery, Florence*

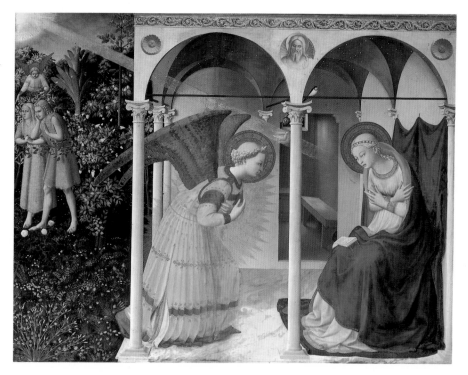

ation is one of the most often painted subjects in Western art. It is the meeting of Heaven and Earth, divine and human, spirit and matter—the yin and yang of the Christian worldview.

No two Annunciation paintings are alike. The artist may prefer a humble, even a shabby setting, or he may lavish his talents on marbles, brocades, and fantastic angel-wing feathers. The psychological confrontation of angelic creature and human woman allows for a tremendous range of emotions. The Virgin may be reluctant, terrified, receptive, or ecstatic. She may even turn away with her torso while reaching toward Gabriel with her hands because she understands in an instant the inescapable fusion of joy and suffering that will be hers.

The conception itself can be conveyed in ways more or less physical, metaphorical, or ethereal. Filippo Lippi paints a slit in Mary's robe at the level of her stomach. Tiny sprays of gold, pollen-like, emanate from it. The dove, encased in a globe of light, hovers over her abdomen like a bee or a hummingbird over a flower. This cannot be seen in a small reproduction. For that, one must stand right in front of the painting itself, rather close.

Simone Martini sends the angel's words in a straight line directly toward the ear of the reluctant Mary. This is in keeping with the opinion held by some

theologians that Mary must have been impregnated through that orifice; the biblical "word made flesh" taken quite literally. She keeps a thumb in the book and pulls back from the angel, covering her neck with the hem of her mantle.

Fra Angelico reminds us of the historical immensity of the event by staging the drama of Adam and Eve and their expulsion from a lush, tropical Paradise right outside the Virgin's little porch. Time is collapsed in symbolic synthesis. Note the future Christ in the carved medallion. In the crowded convergence of imagery just beneath it, the ordinary earthly bird perched on the iron rod seems to be a deliberate counterpart to the heavenly dove close by. It is a swallow, which in legend hibernated during the winter months in the mud of river beds. It is a symbol of spring, Resurrection, and the Incarnation.

Tintoretto's scene is wildly emotional. Mary, surprised in a run-down, almost squalid setting—scraps of lumber and junk filling her courtyard—is bowled over by the rush of Gabriel and his swarm of nose-diving muscular cherubs. She is clearly a strong woman, and she will have to be.

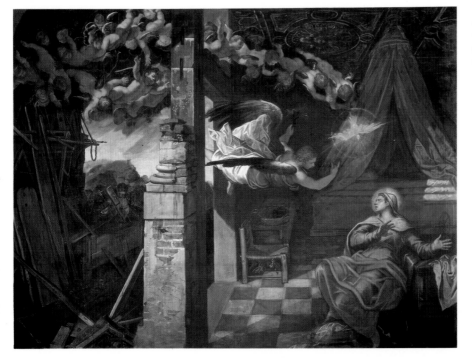

Tintoretto. The Annunciation. *1583–87. Oil on canvas, 37 ¾ x 42 ½". Scuola San Rocco, Venice*

WHY PAINT IN BLACK-AND-WHITE?

There are at least two reasons why artists turned now and then to "grisaille" (from the French for gray), the technique of painting monochromatically in shades of gray. One had to do with the church's highly developed sense of theater, and the other with Europe's increasing appreciation of Greek and Roman art.

Gerard David's version of the Annunciation appears on the outer wings of an altarpiece that enclose a triptych (a three-part work) inside. The Annunciation is appropriate here because it functions almost as the first scene in a movie and is the moment when Christ's life begins. On feast days, the doors would be

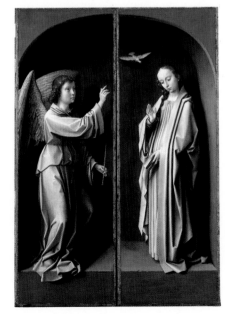

Gerard David. Archangel Gabriel and the Virgin of the Annunciation, *exterior of the wings from an altarpiece. c. 1500. Oil on wood, 34 x 11" each. The Metropolitan Museum of Art, New York. Robert Lehman Collection, 1975*

opened, and the story of his Crucifixion and Resurrection would unfold, painted not in monochrome but in full color. Anyone who remembers the first time he or she saw a movie change suddenly from black-and-white to color probably also remembers gasping.

The surprise was even greater for those who fell for the *trompe l'oeil* (fooling the eye) effect, thinking that the two figures were actually sculptures in recessed niches, thus assuming that there could not possibly be a painting behind them. David promotes the illusionary effect by painting a convincingly worn and chipped ledge for his "statues," but at the same time he undermines it by giving their marmoreal faces a hint of healthy color.

Artists also liked to paint in monochrome because it was so refined, like classical sculpture, or so they thought. Sculptures and many buildings in the ancient world were painted, as many people now know, but some try to forget—those who are offended by the wax-museum or carnival-like images that come to mind when they envision painted marble figures and architecture. (A few decades back, a carefully researched model of the Parthenon, complete with color, was immediately appropriated for a book called *Kitsch.*)

Some who have become used to the idea of painted classical sculpture have trouble remembering that during much of the Middle Ages, sculpture and architectural ornament were also painted in full, living color.

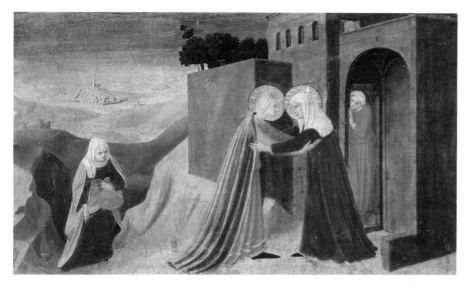

Fra Angelico. The Visitation, *scene from the predella of an altarpiece for San Domenico. c. 1434. Panel, 9 x 15". Museo Diocesano, Cortona*

THE VISITATION

∾

On the occasion of the Annunciation to Mary, the archangel Gabriel also told her that her cousin Elizabeth, who was "well stricken in years" and had always been barren, had conceived a child. These almost exactly recurring forms of miraculous birth were not seen as scriptural cribbing but rather as examples of the marvelous way in which sacred events foretold the future and resonated with the past. This particular miraculous birth, that of John the Baptist to Elizabeth, appears in the Gospel of Luke and predates the apocryphal account of the Birth of the Virgin.

Luke says that Mary hurried into the hills to visit her cousin. Perhaps she wanted to verify the truth of the angel's message. Later, once Mary became the eternal Mother of God, such an interpretation would be blasphemous, but it is suggested by the Gospel.

Elizabeth heard the greeting of the approaching Mary and her baby leaped in her womb. This wonderful detail sounds like the stuff of medieval legend, but it does appear in Luke's account. It was taken to mean that the future prophet, John the Baptist, even in the womb, acknowledged his Savior in the womb of another. John's position as subordinate to Jesus is stressed with care and frequency in the New Testament, suggesting that he was an important prophet with a large following, one whom the Christians were at pains to keep secondary.

Fra Angelico, as was customary, includes a servant woman for each of the principals. The servant trudging with effort up the steep hillside gives us some idea of the speed and emotion with

which Mary has run ahead to embrace her cousin. In some renderings of this scene, Mary and Elizabeth happily and affectionately feel one another's swollen breasts or stomachs.

THE PREGNANT MARY

Given the importance of her pregnancy in Mary's story, it is astounding that we have so few works of art that show her to be visibly with child. It seems likely that

the subject was once less rare than it is today, and that as the Virgin became more and more exalted, this reminder of her corporeality caused some discomfort. Once it was decided that she was free from Original Sin, the problem became compounded, since pregnancy and childbirth were among the "curses" that followed the Fall. This rejection of the physical life seems all the more lamentable when we look upon these pregnant Madonnas—each with her own very different type of grandeur.

The tranquil and absolutely amiable woman who looks at us from the Venetian painting suggests the Mary who was familiar to believers during much of the Middle Ages. In many medieval mystery plays (religious dramas), she defended her devotees with warm affection and sometimes with passion, even swearing at demons on occasion. She was the kind of mother one needed when one's Father was stern and implacable. She must have been easy to pray to.

Yet she is surrounded by the iconography that glorifies her in her role as Queen of Heaven—the crown, the throne, the "cloth of honor" held up behind her by angels. This cloth is not just a convention of painters, but was used even in modest European celebrations—at a peasant wedding, for example, to honor the bride and groom. The lily, of course, represents Mary's purity and the book her wisdom.

But what of the minuscule people on either side of her throne, so small they could be trampled should she stand up

and walk? They are donors; the ones who commissioned the painting, paid for it, and gave it to the church. What fascinating information! Imagine a twentieth-century artist including within a work of art the wealthy couple who will pay for it. This practice did not just promote the fame of the donors, however; their appearance in the same picture with saints or the Virgin made visible a bond between them (something like the effect today of being photographed with the president). It also meant that when they left church and were no longer at prayer, an image of them was still there, praying away. Likewise, after they died, there was a sense in which their prayers continued indefinitely. A comforting thought.

The symmetrical formality of Piero della Francesca's *Madonna del Parto* (Madonna of Childbirth) reminds one of the symmetry of the human body, just as the opening in the Virgin's gown and the canopy parted by angels remind one of the mystery of birth. The fact that the angels could be made by "flopping" and using the same cartoon (the drawing on paper used to outline the figures in the fresco) does not make their exact symmetry any less significant. For all the lack of queenly attributes, this is a sublimely regal vision of Mary.

At the same time, one cannot help noticing that maternity clothing during the Renaissance must have been simply a matter of letting out and, finally, opening up seams. This is the kind of information that paintings often provide as a kind of bonus to the curious.

The black halos were not painted that way originally. They have darkened. But there is such a thing; it is a kind of anti-halo that sometimes appears over the head of Judas Iscariot.

Piero della Francesca.
Madonna del Parto.
c. 1460.
Detached fresco, 81 ⅛ x 80 ". Santa Maria a Nomentana, Monterchi

THE DEATH OF MARY

❧

The events in Mary's life that center around the infant and adult Jesus will occupy us in the next chapter. When Mary had grown old, an angel again appeared to her to announce her imminent death. This scene resembles the Annunciation of the birth of Christ, but Mary's advanced age makes it easy to identify the subject. So now we turn to her death and its rather quirky complications.

Mary seems to have gone to Heaven twice. Early versions of her death refer to it as her "Dormition," that is, her falling asleep, because it was so peaceful. In Hans Multscher's scene, the apostles gather around her bed while her soul, in the form of an innocent child, is taken into the arms of her son and then to Heaven. The brushlike object held in the hand next to Jesus is an aspergillum, a sprinkler for holy water. The European love for luxurious cloth is palpable—as in so many paintings—here in the delicious rendering of the red brocade bedspread and the green hanging curtain.

Later in the story, and in the history of Mariology, she rose from her tomb and was assumed, or taken up, into Heaven. It doesn't take much hair-splitting to realize that, if we still believe in the Dormition, the Assumption involves the raising up of Mary's soulless body only. This is why in some versions of the Assumption, Christ first returns Mary's soul to her body in the tomb. The Assumption of the Virgin did not become an official article of faith in the Roman church until 1950. It was, obviously, believed by many long before that.

Here we see how enormously one vision of the same story can differ from another. In Bernardo Daddi's fourteenth-century painting (the lower part is missing), mirror-image angels bear the Virgin upward while she, with what strikes us almost as a sense of humor, drops her girdle (a sash or belt) to Earth. She wants the apostle Thomas, known to us as doubting Thomas, to have some-

thing from the event to hold onto to help him believe what has happened, even though he has seen it with his own eyes. His hand is just visible at the lower left. The Virgin is enclosed in a *mandorla* (from the Latin for "almond"), a kind of body halo. A golden glory surrounds her body as well, and a halo frames her head.

Titian's Assumption is a huge painting, said to be the largest oil painting in the world, that holds up remarkably well on the page of a small book. Here the forces of nature seem to lift the Virgin, by way of billowing clouds filled with busy angels. It is hard to imagine a woman standing more convincingly on a cloud. The celestial and the human world fly apart in spite of the reaching arms of the men below. With supreme confidence, the artist courts comedy by almost letting a low-flying cherub step on a man's head. High above, in the golden blaze of Heaven, God the Father waits, while an angel holds Mary's crown.

THE MADONNA

✧

Madonna is "my lady" in Italian. Originally a respectful way of addressing Mary, it now seems almost to be one of her names. In five paintings of the Madonna, including the one that opens this chapter, we begin to see just how differently she could be seen at different times and by different artists. It would, in fact, be possible to find many more representations of Mary that would be just as unlike one another as these are.

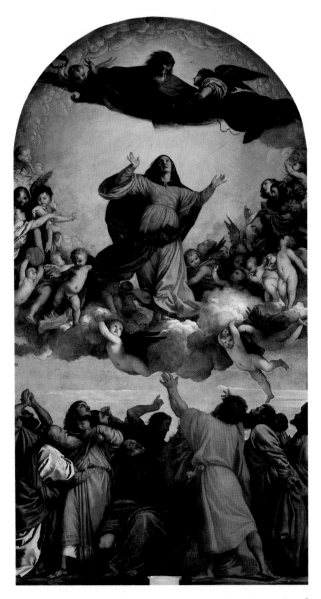

Titian. Assumption of the Virgin. *1516–18. Panel, 22'6" x 11'10". Santa Maria Gloriosa dei Frari, Venice*

The Mary on page 30 is a particularly appealing, almost informal, version of the Madonna Enthroned. She gestures amiably toward her tiny donor at lower left and regards us with friendly openness, as does her little son in his festive two-toned baby gown. As usual, Mary wears blue, with red underneath. Blue is her color and symbolizes Heaven, Truth, Love, and Constancy. Red, a regal color, also symbolizes the Passion and the Holy Ghost. Jewelry is almost never worn by the Virgin, except for the practical brooch that holds her mantle together. This brooch seems to be in the form of a seraph's head. Even the wedding ring we know she received is almost never painted on her hand. Here Mary is Queen of Heaven, so she sits on a throne and wears a crown given to her by Christ at her Coronation (a scene painted of-

ten). It is not considered jewelry. The crown is hard to see, because in this case it is incised in the gilded wood of her halo. The throne is specially designed with angel perches, and from its back a small orchestra provides heavenly music.

Stefano da Verona's flowery scene, where the almost camouflaged angels and birds are sometimes confusable, is an example of the Madonna of Humility, so called because in it the Virgin sits down right on the ground. After centuries of seeing Mary enthroned, her devotees must have found this a radically new vision. In medieval times, the *hortus conclusus,* or enclosed garden, became an important metaphor for Mary's chastity, and, as we have seen, the rose is one of her flowers. Here, within a rose-trellis wall, she shares the abundance of the garden with Saint Catherine of Alexandria, identified by the spear and wheel at her feet. (We will learn about Catherine and her story in chapter five.)

Jean Fouquet's startling Madonna seems to have very little to do with humility. Her regality is almost military, and the gold, marble, pearls, and jewels of her royal trappings are more aggressively expensive than beautiful. Many a guide to painting will quote a tradition that says that the model for the Virgin was Agnès Sorel, the mistress of Charles VII of France, and that the king's treasurer, Etienne Chevalier, commissioned the painting because he was utterly smitten with Agnès—as if this accounts entirely for its unsettling power and seemingly secular qualities.

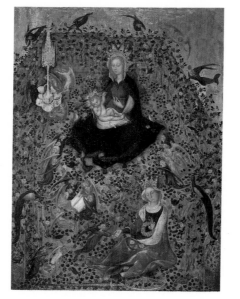

Stefano da Verona. The Madonna of the Rose Garden. *c. 1395–1400. Tempera on panel, 50 ¾ x 37 ½ ". Museo Castelvecchio, Verona*

Perhaps the really secular thing about the image is the mannequin-like stylishness of Mary, whose plucked forehead was the height of fashion, though her equally mannequin-like, almost geometric, globelike breasts are certainly striking. One must be careful before assuming that the circumstances surrounding the painting of the picture, if true, imply any disrespect to Mary on the part of artist, patron, or model.

The cherubim and seraphim surprise us too by being so naturalistic except, of course, for their wings and the look of having been dipped into dye vats. In treatments of Mary with a group of saints, donors, and angels, one of the figures often draws us into the company by looking directly at us. Here a crimson seraph takes this role, but whether he makes anyone feel at home is another question.

Yet the subject itself is anything but revolutionary. The Virgin nursing the infant, or with a breast exposed (Maria Lactans), is the oldest type of Virgin and Child and is found in the catacombs at Rome. It is thought to have been influenced by images of the Egyptian goddess Isis suckling her son Horus.

Images involving the milk of Mary include those in which the souls in Purgatory are nourished by her milk, and one based on a vision of Saint Bernard not pictured here. He kneels before the Virgin, lifting his mouth to a thin stream of milk from her breast. The picture makes Bernard look a bit too much like the familiar kitten in a barn at milking

time to have been painted often. Again, when the physical aspects of Mary's maternity became a sensitive issue, such ideas were discouraged. But a vestige of the subject is still with us in the sweet German wine called Liebfraumilch (Our Lady's milk).

One of the most moving depictions of the Virgin is that known as the Madonna della Misericordia, the Madonna of Mercy. She gathers the human race under her mantle like a solicitous but dignified mother hen, keeping her charges from the cold. If the image was made for a religious order, all of the little people so sheltered would

Jean Fouquet. Madonna and Child with Angels, *right wing of the* Melun Diptych *(now divided).* *c.1450.* *Oil on panel, 36 ⅝ x 33 ½". Musée Royal des Beaux-Arts, Antwerp*

mans look like different species. This is because they were obviously the work of different hands. The Virgin was probably painted on top of an earlier one whose face resembled those in the little crowd of people more closely.

By far the most abstract portrayal of the Virgin is that known as the Immaculate Conception. As we have seen, the very doctrine is rather abstract and would naturally prove difficult to put into visual terms. The form usually followed takes some of its elements from the Apocalypse (or Revelation of Saint John the Divine), the last and most visionary book of the New Testament. In John's vision, a woman appears who was later equated with Mary. She stands on a crescent moon, an ancient symbol of virginity associated with the goddess Diana; she is "clothed in the sun," and on her head is a crown of twelve stars. Other elements, like the "flawless mirror" from the Old Testament Book of Wisdom, may be present, along with the serpent of the Fall, which she tramples underfoot. The presence of just one or two of these ingredients in an image of Mary probably means that it alludes to the doctrine of the Immaculate Conception. Since great controversy surrounded this issue for so long, there are even paintings entitled the Immaculate Conception that embody the idea by showing nothing but a group of theologians arguing about it.

wear identical habits. Most often, she protects everyone: clergy, knights, monarchs, and peasants. In the version of the Madonna Misericordia attributed to Jean Miralheti, she and her brood of hu-

Giovanni Battista Tiepolo. The Immaculate Conception. *1769. Oil on canvas, 9'1 ⅞" x 4'11 ⅞". The Prado, Madrid*

THE LIFE OF JESUS

THE BIRTH OF JESUS

In very early depictions of the Nativity of Christ, Mary reclined while the infant lay on an altar-like structure, suggesting his future sacrifice for humanity. It was a symbolic, not a narrative, rendering. As time passed, artists began to portray a more natural, affectionate connection between mother and newborn. In Giotto's fresco, a midwife appears, helping Mary lift the child. According to one apocryphal account, Joseph went out to fetch help when Mary's time came and returned with two midwives. One, named Salome, had the audacity to doubt the mother's virginity and, as she examined Mary, her hand immediately withered. (It was restored again when she touched the child.) But Giotto's midwife plays a very minor role. Mary, reclining and supporting herself on one elbow, gazes with tender solemnity at the tightly swaddled baby, who looks rather top-heavy in his cruciform halo.

The whole experience has been a bit too much for Joseph, who is nodding off in the foreground. Though he became a venerated and dignified figure many centuries later, during the Middle Ages and early Renaissance Joseph was never much more than an escort, a supernumerary in the drama of the Nativity. A certain amount of affectionate

fun was poked at him—even to his being called the "holy cuckold" in the mystery plays popular in medieval times. He seemed to be in over his head. But one legend of Joseph, while it fits his passive role perfectly, speaks also for his emotional involvement and his own sense of wonder at the events that have overtaken him.

It is said that, during the birth of Jesus, Joseph went outside to find some water. Suddenly, as he was walking to a spring, an absolute silence surrounded

him and everything stopped. Birds froze in the air, perfectly still; water running down the hillside ceased to move; not a leaf stirred. A moment passed, and then, just as suddenly, the birds flew and sang again, the stream rushed down the hill, a sheep bleated in the distance, and Joseph wondered if it had all been a dream. It had been, of course, a miracle, but what a suggestive one for us, who see all of these events through works of art. One can't help thinking that Joseph was, for a moment, living in a painting.

The setting for Christ's birth might be a stable, a cave, an ancient ruin symbolizing the passing of the old order, or

some broken-down combination of all three. But, aside from the mother and child themselves, the most consistently present members of the group are the ox and the ass. They appear in apocryphal writings as symbols of the Gentiles and the Jews, based on a reference to Isaiah, who says of the ox that it knows its master while the ass knows its stall. This would imply an obvious criticism of the Jews who did not follow Christ, but invariably the ox and ass that attend the birth are equally worshipful of the infant. So, we can assume that in Nativities the ass represents the Jews who *did* consider Jesus the savior. All this aside, the two animals are far more eloquent as dumb creatures who know holiness when they see it. Animals in European art sometimes have this particular sensitivity; dogs will detect the presence of angels before people do.

In our rather secular era, we feel a certain fascination with spiritual traditions based on dreams and visions—those of Native American tribes, for example. Yet Christianity abounds with such examples. Artists have long favored a Nativity theme known as the Adoration of the Infant by the Virgin. It is based entirely on a vision. Saint Bridget of Sweden described in her writings how she saw the birth take place. Mary loosened her long hair, knelt down, and gave birth on her knees. The child, lying upon the ground, glowed with an ethereal light. In the mysterious painting by Master Francke, angels are still cloaking Mary's legs with a robe,

suggesting that they have been assisting at the birth. If the rhythmically looping scroll of her speech is any indication, she praises the infant in a sweet and melodious voice.

In Daret's Nativity, Joseph and the turbaned midwives have just arrived—but too late to be of much use. The child, tiny and helpless on the cold ground, looks naked as a tadpole or a fish out of water, which is, after all, just about what a newborn is. In this painting something of the mystery of the doctrine of the Incarnation can be felt by anyone, believer or not. The plan for the salvation of humanity looks almost precarious, and even shocking—to think that God

Jacques Daret. Nativity. 1434–35. Oil on panel, 23 ⅝ x 20 ⅞". Fundación Colección Thyssen-Bornemisza, Madrid

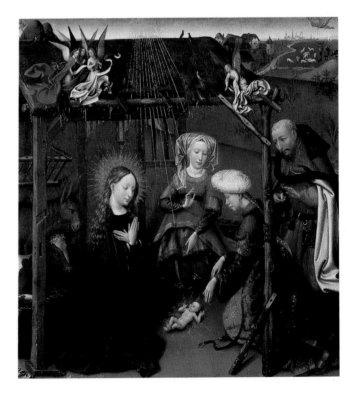

would agree to assume a state of such helplessness.

In all three paintings, the annunciation to the shepherds has been economically included in the scene. Later, the Adoration of the Child by the shepherds would become a popular subject, giving artists a chance to paint poor country folk, their clothing and gear, their animals, their gestures, and their practical gifts: a game bird, firewood, or a basket of eggs. Such "democratic" subject matter would not be painted for its own sake for centuries.

THE THREE KINGS
❧

Long before artists took an interest in the adoration of the shepherds, they painted the homage of the Magi—even on the walls of the catacombs in Rome. The Magi were Persian astrologers, priests of the Mithraic religious cult prevalent in early Christian times. Wearing soft Phrygian caps with forward-pointing crowns (a style later adapted by doges of Venice and the personification of Liberty in France), they kneel before the child, offering gifts. Their presence is clearly meant to serve as an "endorsement" by the wise men, or magicians, from another religious tradition. Later they became kings, and, based on the three gifts mentioned in the Gospels, three in number.

Unknown German artist. The Three Kings, *from an* Adoration Group. *Before 1489. Poplar and maple, polychromy, and gilding, height 64 ½". The Metropolitan Museum of Art, New York. The Cloisters Collection, 1952*

From this point, there was no stopping the medieval imagination. The kings acquired names: Melchior, Balthazar, and Caspar (or Jaspar, or Gaspard). They came to represent the three continents known at the time: Asia, Africa, and Europe, and the three ages of man: young, middle-aged, and old. Their wanderings—before and after Bethlehem—were thoroughly chronicled, as was their death. The miraculous discovery of their bodies in the Holy Land led to the relocation of the bodies to Milan and, finally, to Cologne, where they were received with great rejoicing. (The possession of such important relics was enough to put any town on the map.) The three kings were wonderfully colorful, exotic characters, and great fun to paint. Then too, when church-state tensions were high, they served a propagandistic function as examples of temporal powers appropriately humbling themselves before religious authority.

Here we see three splendid sculptures of these attractive monarchs, and we see how real such creatures of the popular mind became. We can guess just how they move and behave and even when they last shaved.

The woodcut depicts one of the three kings' close calls. After having visited the infant, they spent the night in an inn. They had planned to return to King Herod, as he had requested, with news of the child, but an angel awakened them to explain that Herod was not their friend, and that they had better go home by a different route. In medieval art, the kings always sleep in the same bed, in their

Johannes de Hildesheim. The Three Kings in Bed Warned by an Angel, woodcut from Historia Trium Regum, *c. 1483. Folio [bvii] verso. The Pierpont Morgan Library, New York*

crowns. Private beds were not the rule in medieval Europe, and, as we know, inns in Bethlehem were crowded at the time. Further, the three kings are good friends. But they sleep together mostly because they make a much better picture that way, and they wear their crowns to help us identify them.

THE MASSACRE OF THE INNOCENTS
*

The historical Herod was a ruthless man who married many times and was responsible for the deaths of three of his grown sons. Late in life, he seems to have had bouts of insanity. Perhaps because of these facts, he became the raging archvillain, especially in medieval mystery dramas where his role was played to the hilt, with hysterical outbursts and bloodthirsty ravings, to the great delight of audiences.

When Herod realized that the three kings were not going to return to help him find the future "king of the Jews" (which was supposed to be Herod's title), he ordered the death of all children

Bonanno Pisano.
The Massacre of the
Innocents. c. 1190–1200.
Bronze relief. Door of
San Ranieri, Pisa
Cathedral

under the age of two. The scene, when it is less stylized than in this bronze relief, is one of the most horrible in Western art. Soldiers snatch infants from the arms of their mothers, and small bodies are everywhere. It was quickly decided that these children, the first martyrs, went straight to Heaven. They became known as the Holy Innocents. Artists later tried to work this happy ending into the scene and thus mollify its horror. Sometimes the little ones fly straight up into the sky and the arms of waiting angels.

In the stark simplicity of this relief, the idea of the event is conveyed by the four principals: Herod with signs of his power—throne, crown, palace, and pointing finger—the soldier with his weapon, the mutilated, doll-like children, and the mother trying to shield her child. Her attractive long braids seem to be the only purely descriptive element in the entire composition. Has she stood the child on a rock to make him taller? Is she arguing that he is older than two? She has obviously decided that fleeing is useless, so perhaps this is her plan.

Why wasn't John the Baptist killed in this butchering? If you have asked that question, you are developing a good medieval mind. Elizabeth hid him in her cloak and fled into the hills. Sometimes you can find her in the scene. Perhaps the soldiers thought Elizabeth looked too old to have such a young child. (This possibility is not, as far as I know, in the literature or legend of the Massacre. I add it to show how such stories begin to tell themselves, and how they did just that throughout the Middle Ages.)

THE FLIGHT INTO EGYPT

Like the three kings, Mary and Joseph were warned by an angel of Herod's vicious decree. They fled with the Christ Child into Egypt. Here they have stopped to rest. Joseph gathers chestnuts, the donkey patiently nibbles yellow grass, and Mary feeds the child. Her traveling basket is at hand. Based on the evidence of other paintings, it is probably filled with rolled strips of cloth known

as swaddling clothes, and is the equivalent of a diaper bag.

The fact that this hillside could not possibly be found between Jerusalem and Egypt should bother no one. The clothing is wrong too. The habit of painting stories from Scripture with local settings and contemporary buildings did not arise always from ignorance. As we have seen, the story of Christ did not take place merely in historical time but also in eternity. What had happened once was still happening. Historical accuracy would have been beside the point.

The little refugee family, forced to fend for itself, still maintains its dignity and beauty. To paint the Virgin and Child in dusty old clothes would have been taking realism too far. To clothe Mary entirely in contemporary fashion might also be risking disrespect. Her clothing has a somewhat archaic, classical look. Joseph wears ordinary European shoes and hat.

Gerard David.
The Rest on the Flight
into Egypt. *c. 1510.*
Oil on panel,
17 ½ x 17 ⅜ ".
Board of Trustees,
National Gallery of
Art, Washington, D.C.
Andrew W. Mellon
Collection

Spanish. The Flight into Egypt. *c. 1490–1510. Walnut wood with polychrome, 50 x 34". The Metropolitan Museum of Art, New York. Rogers Fund, 1938*

With his delicate, sensitive face, Jesus is convincing both as a child and a divine being. His wispy halo is painted with reticence, and the symbolism of the grapes, which no doubt prefigure the wine of the Eucharist, is not overstressed. It is always interesting to take note of the object that the baby Jesus clutches in any painting of the Madonna and Child. Though it is invariably symbolic, sometimes the artist has taken pains to make it natural as well.

An orb representing Christ's kingship might also be some ordinary plaything like a ball, or even a bit of cloth, stuffed and tied into a teething cushion.

The carved Spanish group also depicts a scene from the Flight—the moment when a miracle occurs. Mary has asked for some dates from a palm tree. They are too high for Joseph to reach. The child asks the tree to lean down, and it does. It is bent by angels who are probably understood to be invisible, though they are not to us. Joseph tugs on the pliant leaves with one hand to bring the golden dates within reach. The donkey stares almost mournfully at the ground a few feet ahead of him, reminding us what a long way it is to Egypt

Over the centuries, the story of the Flight gathered many details. When the palm tree gave forth its fruit, little Jesus said, "O palm tree, may one of your branches be planted in Paradise." This is said to be why the palm is a symbol of the victory of martyrs. (It was actually a borrowing of the Roman palm of victory.) When the Holy Family passed by, pagan idols spontaneously fell to pieces. When they were robbed by two thieves, one treated them well and the other badly. These, it turns out, were the good thief and the bad thief who would later be crucified with Jesus. So many details accrue that the Flight becomes a little saga in itself. Even the donkey has a name. It is called Thistle.

The Flight into Egypt was a favorite theme for painters; to a greater and greater extent it became an excuse for

painting landscape in a time when art for its own sake was not yet an acceptable idea. As the trees, hills, and sky took over, the figures shrank into small parts of the whole. But even when we have trouble finding the travelers and their donkey climbing a narrow mountain path or descending into some gorge, the scene seems quite appropriate. The powerless little family fleeing from a corrupt and violent ruler looks all the more alone and the world all the more enormous and indifferent, however scenic it may be.

The Tree of Jesse. *Handcolored woodcut from* Speculum Humanae Salvationis, *Augsburg (Günter Zainer). 1473. The Metropolitan Museum of Art, New York. Dick Fund, 1923*

THE TREE OF JESSE

cx/

The Tree of Jesse is a family tree. Isaiah had prophesied that the Messiah would be born of the line of Jesse, the father of King David. This tree appears often in tall stained-glass windows, sprouting from the loins—or the stomach, really—of Jesse and branching into portraits of Old Testament figures, with the Virgin Mary and Jesus at the top. Since windows are expected to be "read" from bottom to top, it was an especially fitting subject. Sometimes pains were taken to prove that both Mary and Joseph were of this lineage, the so-called house of David, though in Joseph's case the "blood" relationship would be irrelevant. A kind of pun gave the prophecy a boost in the Middle Ages. The passage from Isaiah read in part, "A shoot shall grow from the stock of Jesse." The word "shoot" was *virga,* much too close, it was thought, to *virgo* (virgin) to be an accident.

HOLY KINSHIP

cx/

As the thinking about Mary's virginity developed, it was decided by many church fathers that she must have remained a virgin all of her life. Saint Jerome believed that the same was true of Joseph as well. Virginity, we must remember, was a sign of goodness. This caused some serious problems because of the rather clear references in the Gospels to the brothers of Jesus. "Brethren" to the Jews could mean relatives or even friends, it was argued, but this was not specific enough to satisfy everyone. Besides, it was unavoidable that in the Gospels one of these "brethren" was clearly called a son of Mary.

There is also the question of the many Marys. The plethora of Marys in the New Testament can be accounted for partly by the fact that Miriam is a common Jewish name, but also by certain textual confusions a bit too involved to get into here. A rather convoluted solution to both problems was reached when it was decided

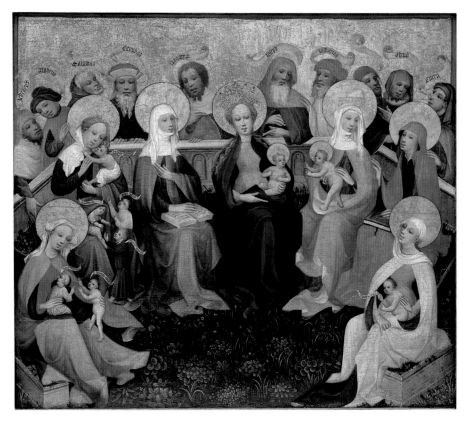

that Anna, Mary's mother, had been widowed and married three times, and each time had had a daughter, each of whom she named Mary. Sons of these Marys were the "brethren" of Jesus. If we add to this extended family Mary's cousin Elizabeth and her child John the Baptist, we can imagine Jesus growing up with an incredibly noisy crowd of cousins.

Members of the family have gathered here for a group portrait of a kind that became popular in the late Middle Ages, especially in German-speaking countries. It is known as the Holy Kinship.

The husbands are in the background. It is mothers and babies who are of interest here. The banners in this painting do not represent speech. They are name tags.

THE PRESENTATION IN THE TEMPLE
&

The scenes from the life of Christ that we encounter most often in art are not always the ones we would expect. For many modern Christians, the Sermon on the Mount is one of the more familiar

and significant moments in the New Testament, yet very few artists have ever painted it. True, it is not action-packed and does not really lend itself to narrative painting, but many other events just as static were painted all the time.

We find the key to this puzzle in the church calendar. The incidents in Jesus's life that were celebrated as festivals found their way into frescoes and altarpieces; others usually did not. This is because on a feast day a work of art depicting the event would be given prominence in the Liturgy. Perhaps a mass would be said before it, or it might be carried in procession.

But what determined the choice of certain events as church feasts and not others? Again, redemption is at the center of everything. The important moments in the Gospels were those that pointed toward Christ's divinity and the plan of salvation. Thus there is no feast of the Sermon on the Mount. But there is a feast for the Presentation of Christ, because on that day the infant Jesus was recognized as the Messiah by a perfect stranger.

Mosaic law required that the firstborn be presented in the Temple. Also, after giving birth, a woman was expected to sacrifice two doves or pigeons in a rite of purification. According to Luke, Mary and Joseph brought the child to the Temple and performed both rites simultaneously. In the Christian church the Presentation became one festival and the Purification (known as Candlemas in English) another.

The old man who holds the infant and gazes so fixedly on him is Simeon (page 66). The Holy Ghost had revealed to Simeon that he would not die until he had seen the Messiah. He was very, very old and ready for death when one day the spirit led him into the Temple. When he saw the child he took him into his arms and said, "Lord, now lettest thou thy servant depart in peace, according to thy word: for mine eyes have seen thy salvation, which thou hast prepared before the face of all people; a light to lighten the Gentiles, and the glory of thy people Israel." The prayer of Simeon, recited for centuries at evening, is one of the most familiar in the Christian liturgy.

For Ambrogio Lorenzetti, the solemnity of the occasion did not preclude a sumptuously decorative treatment, nor did it ban his sense of humor. The baby sucks his fingers and cranes his neck, looking for his mother as it dawns on him that he is in the arms of a stranger. He is oblivious to the old man's words, and so is the high priest, for that matter. Note that Simeon has covered his hands with his robe. You will see this gesture often, in Early Christian art especially (much earlier than this painting), as a sign of respect and deference. On the right is an aged prophetess named Anna who often appears with Simeon in Italian paintings. She holds her prophecy, neatly written out, in her hands. Mary is accompanied by handmaidens and Joseph, as usual, stays in the background. Lorenzetti obviously loves extravagance. The Temple is comprised of a glorious

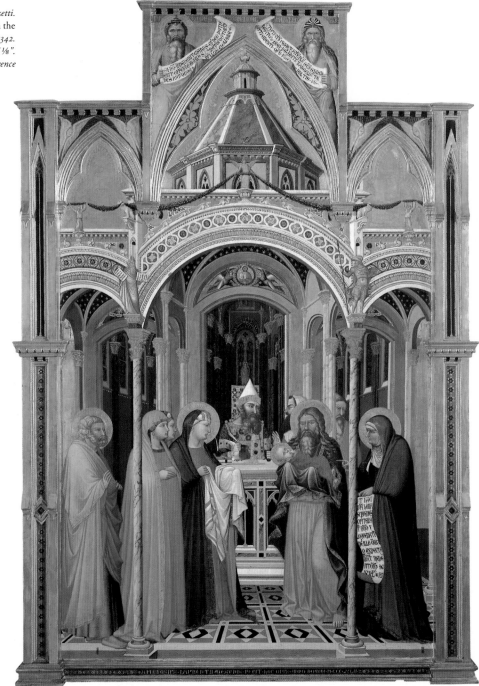

*Ambrogio Lorenzetti.
Presentation in the
Temple. 1342.
Panel, 8′5 ⅛″ x 5′6 ⅛″.
Uffizi Gallery, Florence*

array of decorative details: miniature sculptures of angels and lions holding long garlands, to name only a few. In this painting we see one of the rare appearances of the Virgin wearing earrings.

THE BAPTISM
OF CHRIST
✑

John the Baptist was a forerunner of Christ who prepared the way for him by exhorting sinners to repent and be baptized. As we have learned, he was the son of Mary's cousin Elizabeth and had already recognized his Savior while they were both still in their mothers' wombs. When Jesus comes, along with many others, to be baptized, John protests, saying that he should instead be baptized by Jesus. But, perhaps as a token of his humility, Christ insists.

He stands here, deep in a River Jordan made of very palpable water, even though it is bronze. An angel holds his clothing, and the dove of the Holy Spirit descends upon him. At this moment God proclaims his son in a voice from the Heavens. The relief is alive with a feeling of movement and flow conveyed by texture: the water, the furry tunic John wears under his robe, the energetic drapery.

This scene is one of the most common in Christian art, partly because all churches have either a separate building that serves as a baptistery or at least a place inside the church reserved for baptisms, and it is an obvious choice of subjects for such settings. Christians named John, and it is a common name, have often commissioned paintings dedicated to their namesake and patron, which also accounts for the frequent appearance of the subject.

Jesus is almost never shown nude, except as an infant. Andrea Pisano has used the River Jordan to solve the problem here, but many artists give him a loincloth to wear for his baptism. During the Renaissance, however, Christ's genitals were often given some prominence, both in pictures of his infancy and in treatments of his body after the Crucifixion. The idea that he was a fully human being

Andrea Pisano. Baptism of Christ. 1330–33. Bronze, parcel-gilt relief, 19 ½ x 17". South doors, Baptistery, Florence

required that his sexuality be accounted for, and even stressed; he was sinless, guiltless, and virginal, but his sexuality was an essential part of his being.

In cookbooks, the word *Florentine* means "spinach," but in art it often involves the four-lobed Gothic shape we see here, sometimes known as the quatrefoil or the quadrillobate medallion. It is a stylized blossom representing the flowers from which the city of Florence gets its name. Surrounding the relief is a denticular border (made of dentils, from the Latin for "tooth"), an inheritance from classical architecture.

THE TEMPTATION IN THE WILDERNESS

As we know from the story of Faust and its many variations, the Devil always tries to make a deal. He has the world in his pocket, so he can usually come up with a very tempting offer. In exchange, he gets your immortal soul.

Immediately after he was baptized, Jesus went into the wilderness and fasted for forty days. At the end of that time Satan appeared, tempting Jesus to use his powers to change a stone into a loaf of bread. Jesus replied by saying that man does not live by bread alone, but by the word of God. Then Satan magically transported Jesus to the top of the Temple in Jerusalem, suggesting that he jump, quoting a passage from Scripture that says angels will save him. (From this incident comes the saying that the Devil can quote chapter and verse.) Jesus quoted Scripture right back, reminding the Devil that it is also written, "Thou shalt not tempt the Lord thy God." For his finale, Satan took Jesus to a mountaintop and offered him power over all the cities in the world. "Get thee behind me, Satan," Jesus answered and, the trial being over, angels came to wait upon him with water and food.

Duccio's Satan is clearly an angel in negative. His pterodactyl wings and hairy body combine in an unsavory hybrid. Recoiling in defeat, he has got himself behind Christ; in fact, he has got to the other side of the river that courses through the fantastic landscape dotted with the world's wonderful cities. And they are attractive cities—seven of them—colorful, well built, and fortified, with graceful towers, domes, turrets, and neatly tiled rooftops.

The giant figures, silhouetted against a gold sky, gesture emphatically in dancelike rhythm. Theirs has been a Scripture-quoting contest, a debate, and beyond that a moral trial of motives and the proper use of spiritual power. Yet the artist has given the scene the tension of a fencing match. It is important to the meaning of the Incarnation that Jesus never use his divine powers on his own behalf. Duccio has convinced us that this required a struggle.

The golden sky is a convention that reaches back to the earliest icons, whose gold backgrounds enhanced their preciousness and their dramatic glow in church interiors. As a way to render

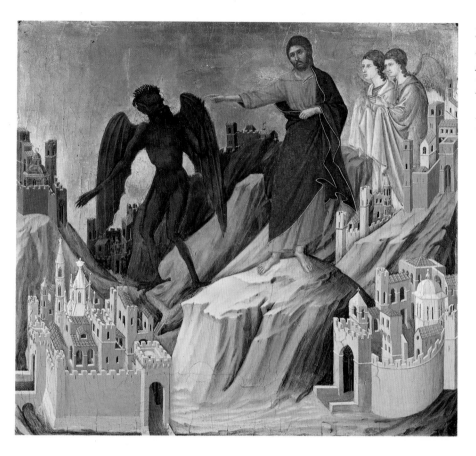

Duccio. The Temptation of Christ on the Mountain, *predella panel from the back of the* Maestà Altarpiece. *1308–11. Tempera on panel, 18 x 18 ¼". The Frick Collection, New York*

sky, gold has a rightness beyond literal description. It flashes and changes as the viewer moves, and seems to suggest light itself.

Juan de Flandes's sneaky Devil has dressed up in a monk's robe, but his horns and the telltale webbed foot give him away (page 70). Satan's disguises are usually better than this. He is a true shape-shifter and sometimes tempts saints in the form of a beautiful young woman. Christ looks at the loaf-shaped stone as if he is truly hungry. On the right, off in the distance, we can just make out the tiny figures of Jesus and Satan atop the temple, and they appear again on the mountaintop, completing all three episodes in the story.

Though there is a world of difference between the vivid, athletic quality of Duccio's treatment of this subject and the contemplative deliberateness in that of Juan de Flandes, the Temptation of Christ remains a story that can appeal only to a very verbal, bookish society, one deeply interested in the inner life.

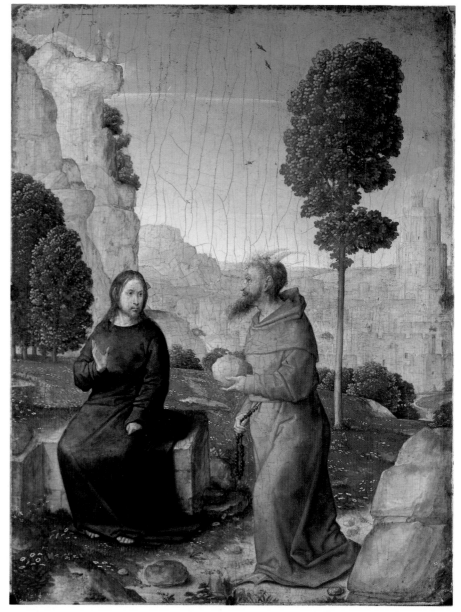

THE MARRIAGE FEAST AT CANA

cx/o

For his first miracle, Jesus saved the host at a wedding from the embarrassment of running out of wine. It does seem rather a trivial way to start, but, naturally, the miracle was given a deeper meaning by later commentators.

In Juan de Flandes's version, Jesus and his mother are seated at the banquet table. The bride and groom sit before a cloth of honor, engrossed in conversation. The groom looks very much like Saint John the Evangelist. (One comes to recognize these people. John is young and beardless, has beautiful, curly brown hair, and usually wears red.) As always, the medieval mind filled in the gaps and decided that the groom at this wedding, unnamed in the Gospel, was John. Since the miracle is described in John's Gospel only, it may have been thought that he had had a special, firsthand experience of it. According to some accounts, the bride, believe it or not, was Mary Magdalen, who became a "scarlet woman" to get even when her husband left her to become one of Christ's disciples.

Jesus has just been told by his mother that the wine is gone. (Her concern in this scene shows her interest in the details of human life and in our less momentous problems.) Discreetly and from a distance, he transforms the purification water to wine with a gesture of blessing, thus prefiguring the mystery of the Eucharist. Along with the Baptism of Christ and the Adoration of the Magi,

the miracle of the Marriage at Cana is celebrated as one of the three festivals of the Epiphany (showing forth) of Christ. On these three occasions, his divine nature and miraculous powers were first made known to the world.

Juan de Flandes. The Wedding Feast at Cana. 1496–1519. Oil on wood, 8 ¼ x 6 ¼". The Metropolitan Museum of Art, New York. The Jack and Bella Linsky Collection, 1982

THE TRANSFIGURATION

cx/o

Of all the events in the life of Jesus, the Transfiguration is the least narrative and most symbolic. Its description almost

amounts to a ready-made icon. One night, Jesus took three of the disciples, Peter, James, and John, to a mountain to pray. As he stood in their presence, he became transformed: his face shone like the sun and his clothing became dazzling white. Moses, representing the law, appeared on one side of him, and Elijah, representing the prophets, on the other. The disciples fell down before the vision, a bright cloud descended, and the voice of God said, "This is my son. Hear him."

In Fra Angelico's *Transfiguration*, two additional figures, the Virgin and Saint Dominic, kneel in the air, flanking the majestic yet sympathetic image of Christ. The picture takes up an entire wall of a monk's small cell in a Dominican monastery, where it was painted as an aid to meditative prayer. The *mandorla* echoes the niche shape and suggests an egg, symbol of the Incarnation and the Resurrection. The only hint of an actual, physical setting is the mountaintop, with the eroded grooves so common in Italian painting. The lack of detail somehow conveys the stillness of the night. That and the glow—almost like that of moonlight—of the miraculous vision create a meditative atmosphere that hovers just on the edge between peacefulness and ecstasy.

Fra Angelico. The Transfiguration. *1438–45. Fresco. Museo di San Marco, Florence*

THE ENTRY INTO JERUSALEM

To ride in a triumphal procession on the back of a donkey is to undercut any impression of worldly power one could possibly create. Jesus's return to Jerusalem signaled his cooperation with the fate that awaited him there. It is the first scene in any cycle of the Passion—the events leading up to and including the Crucifixion. Oblivious to these somber implications, Giotto's enthusiastic spectators climb trees to see Jesus and pick branches to strew in his path. In the right foreground, a woman is hastily removing her mantle in order to throw it under the donkey's feet, and a man in a pink robe, also moved to a spontaneous gesture of adoration, begins to pull his arm out of his sleeve.

Palm Sunday, one week before Easter, marks Christ's entry into Jerusalem and the beginning of Holy Week. On this day, as on many feast days, processions made their way through many European streets. In this case, though, the procession was a reenactment of the biblical one and often involved the pulling of a *palmesel* like the one we see here. Many painted wooden images made for churches were carried or pulled in religious processions. Sometimes they cured afflictions or caused other miracles. It seems that their powers were activated or enhanced by their being put into motion.

THE LAST SUPPER

There are two ways artists have approached the depiction of the Last Supper. One is sacramental and emphasizes the institution of the Eucharist, when Jesus enjoins the disciples to think of the wine as his blood and the bread as his body, which he is about to sacrifice. The other treatment of the scene is dramatic. It captures the moment in which Jesus says that one of the disciples will betray him that very night. They pull back in horror, wondering who the traitor might be.

The easiest figure to identify after Jesus himself is always Judas Iscariot. He is haloless, or his halo is black. Sometimes he is separate from the others, and sometimes he clutches a money bag. He was the one who kept the common purse for the group, but on this occasion the

Giotto. Christ's Entry in Jerusalem. *1305–6. Fresco. Arena Chapel, Padua*

Unknown Swiss artist. Palmesel. c. 1200. Fir and polychromy, height 46⅛". Schweizerisches Landesmuseum, Zurich

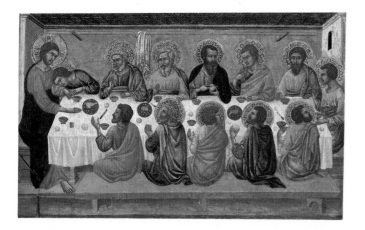

Jesus, in accordance with his relative importance, is much bigger than the other men, and his cruciform halo is slightly larger, also. Of the other eleven, each has his own halo design, reminding us that even in holiness no two persons are exactly alike. The artist has decided that, whatever the viewer's angle of vision, halos have an uncanny way of staying on the opposite side of a saint's head. The towel hanging on the pole behind Peter is probably a reminder of the fact that just before dinner Jesus had demonstrated his humility and the sacrificial nature of his life by washing and drying the feet of each of the disciples.

bag contains the thirty pieces of silver he has taken in payment for his betrayal.

John the Evangelist, the disciple especially loved by Jesus, is usually shown with his head on Christ's breast. This is an awkward position when one sits at a table. Since the disciples probably would have reclined while eating, especially on the first night of Passover—the occasion of the Last Supper—the biblical description of John's head on the bosom of Christ makes more sense than it seems to under modern dining conditions.

When Ugolino painted his Last Supper, most Florentines would have been able to name each disciple in it. John, as we have already seen, is young and clean shaven, and his hair is brown and curly. Though his cloak is falling from his shoulders, it is, as usual, red. Peter is sitting next to John. His white hair and beard, short, full, and very curly, identify him. The other two clean-shaven men are probably Philip and Thomas.

THE KISS OF JUDAS

ↄ⌀

After the Passover supper, a night of betrayals ensued. Jesus went to the Garden of Gethsemane to pray, taking James, Peter, and John to watch with him. Though it was clear that Jesus' final hour was at hand, the three disciples repeatedly fell asleep. In some paintings they obviously snore; with their heads falling back and mouths open, they are terribly human. Later that night, when Peter was recognized as one of Christ's followers, he denied it, not once but three times, just as Jesus had said he would.

Here we see the most famous betrayal of all. With a kiss, Judas identifies Jesus to the soldiers and priests who have come to arrest him. Peter, seized by rage, cuts the ear from Malchus, one of the priests' servants. Jesus will restore the

ear, saying that he who lives by the sword shall die by the sword. But those who live by the sword have clearly taken charge in this midnight scene full of violence and almost audible clamor. While the sky bristles with torches, axes, and spears, Giotto orchestrates the action with glances, gazes, and stares. Almost all eyes are on Jesus, whose eyes look deeply into those of the traitor who had been his friend.

From here Christ will be taken before Pilate, tried, mocked and beaten, crowned with thorns, and made to carry the instrument of his death, the cross, to the place of execution.

THE CRUCIFIXION

The Romans routinely used crucifixion as a form of torture and execution for common criminals of the lowest order. The early Christians were ridiculed for worshiping a god who had been crucified, so they avoided the visual portrayal

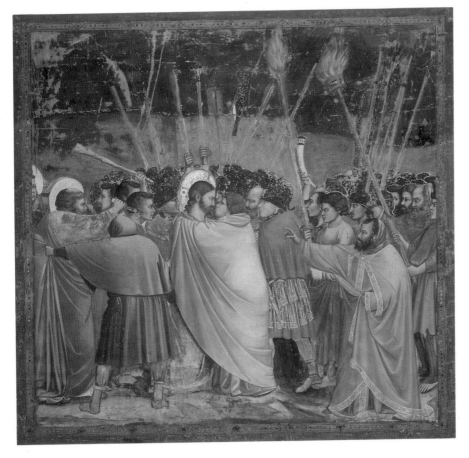

Giotto. The Kiss of Judas. *1305–6. Fresco. Arena Chapel, Padua*

of the subject. By the fourth century, however, a cross, without the body of Christ, had become a central symbol, and in the fifth century Christ began to appear, affixed to the cross but without any signs of physical suffering. A triumphant figure, gazing forward into space, his dignity often enhanced by a regal robe, he symbolized victory over death.

This richly colored yet restrained Catalan crucifix is of that type, almost. It seems to signal a transition. Jesus does not stare into space but looks downward pensively, and his face does seem to acknowledge suffering—if not physical, perhaps spiritual; if not his own, then the world's.

A crucifix is a portable object, often carried in procession. In its four corners, narrative or symbolic elements might ap-

pear, but these are usually quite simplified. Crucifixion scenes, on the other hand, can range from the stark to the massively complex. Beneath the cross we might find only Mary and Saint John, and above it, the sun and moon, referring to the darkness that fell at noon, the hour of Christ's death. On the ground at the foot of the cross we will probably find a skull. The event took place at a killing ground known as Golgotha—the place of skulls—but the skull pictured is a specific one. It belongs to Adam, whose sin is now absolved. The place is the site of the Fall, and the cross is the tree from which the fateful fruit was taken. It is the tree of death and the tree of life—and the center of the world.

The two thieves who were crucified along with Jesus often appear, sometimes tied rather than nailed to their crosses. The "good thief," who repented and believed in Christ's divinity, is on his right ("good") side, and the bad thief on his left ("bad") side. There may be soldiers, some casting lots for Christ's cloak; there may be many other characters, with names and stories of their own, including the many Marys. Angels sometimes fly above, weeping and writhing in their flight, or catching the Redeemer's blood in chalices, in reference, of course, to the Eucharist.

At the top of the cross itself there is usually a placard bearing the initials INRI. This stands for the Latin phrase *Iesus Nazarenus Rex Iudaeorum,* which means "Jesus of Nazareth King of the Jews." Pontius Pilate wrote this inscription in Greek, Hebrew, and Latin, and in some paintings it appears in all three languages.

Batlló Crucifix. Mid-12th century. Polychrome on wood, height 36". Museu Nacional d'Art de Catalunya, Barcelona

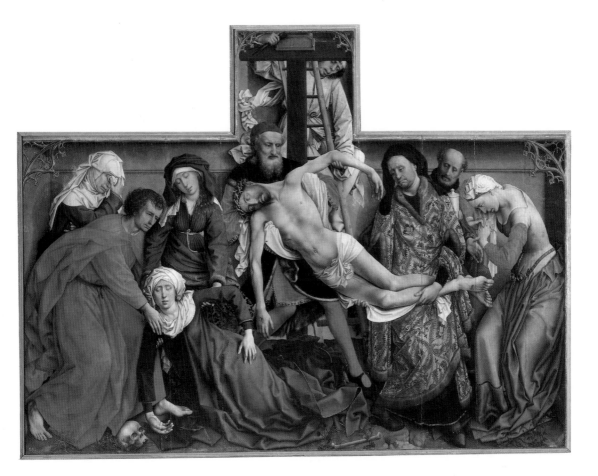

THE DESCENT
FROM THE CROSS

∾

Here we encounter a treatment of the
death of Christ that came into being as
his humanity—and his human suffer-
ing—increased in importance. More and
more it was held that, though Christ ulti-
mately triumphed, the very meaning of the
Incarnation required that he know the
worst of human life, and experience it.

Joseph of Arimathaea was a wealthy

and respected member of the Sanhedrin,
the Jews' highest legislative body. He was
also a secret follower of Jesus. When
Christ's agony was over, Joseph obtained
permission from Pontius Pilate to re-
move the body from the cross. He went
to Golgotha, bringing with him a white
linen sheet. Another follower, Nico-
demus, provided myrrh and aloes with
which to anoint the body.

Van der Weyden shows the two richly
dressed men lowering the corpse to the

Rogier van der Weyden.
The Descent from the
Cross. *c. 1435.*
Tempera on panel,
7′2⅝″ x 8′7⅛″.
The Prado, Madrid

ground. Mary swoons to unconsciousness; Mary Magdalen doubles over in pain. All motion in this extraordinary painting is downward, the heaviness of grief becoming almost literal. No vista stretches out behind the place of execution, only a wall, ricocheting our attention back to the stricken company.

The crowdedness of the composition is essential to its emotional impact, but in no way do the persons become a mere crowd. Saint John the Evangelist may be true to his usual physical description, but his face is that of a distinct individual. Even the action maintains absolute coherence. Notice that among these ten figures, every pair of hands is accounted for and articulated, along with the action in which each hand is engaged.

The Descent from the Cross, sometimes known as the Deposition, is followed by the Lamentation, or *Pietà,* and the Entombment. But before Christ rises from the grave and appears again on Earth, he must descend into the underworld—Satan's realm of death.

THE HARROWING OF HELL

ప

Just scratch the surface of this world, and you will find another one underneath. Between the time of Jesus's death and his Resurrection, he went into Hell, or into Purgatory (Limbo), to be more precise, to recover the souls of the righteous who had died before his Crucifixion. In this artist's version, Christ has already flat-

tened a bristling demon under the unhinged trapdoor, and now he reaches into the well of darkness for the waiting souls. John the Baptist in the shaggy camel-skin shirt, only recently dead, and King David with his crown and Book of Psalms are easiest to recognize. Adam and Eve, the oldest in the crowd, stand on the upper left.

The cutaway of the hillside crust seems perfectly acceptable to modern viewers. Indeed, we hardly notice it, partly because we are used to the convention, and partly because the artist has given the baked earth a familiar, naturalistic crumbly edge. Christ's blazing yellow aura illuminates the faces, hair, and garments of the crowd, giving Limbo a problematic glamour; it looks more exciting than the blank terrain of the world above. But perhaps this is fitting. The opulent colors speak above all else of the preciousness of people.

THE SUPPER AT EMMAUS

ప

On the Sunday after the Crucifixion, two of Christ's followers were walking toward a village called Emmaus when a stranger joined them. They spoke of their grief, at the same time wondering at the news that Jesus's tomb had been found empty that morning. "We trusted that it had been he which should have redeemed Israel," they said. "O fools," the stranger answered, "and slow of heart to believe all that the prophets have spoken." Then, beginning with Moses, he

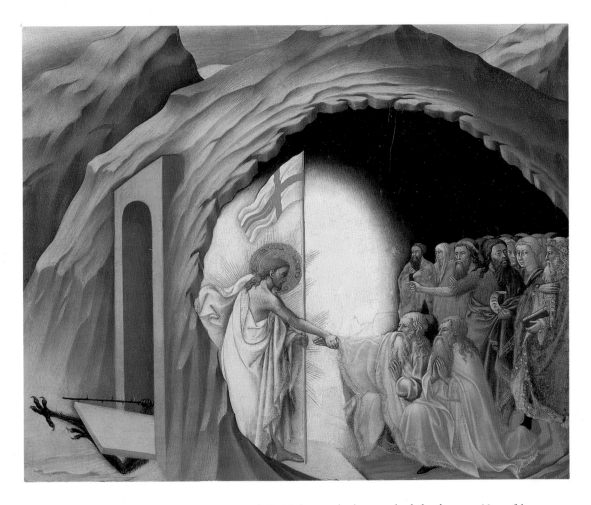

explained all the Scriptures concerning himself, because he was, of course, the risen Christ.

When the three reached their destination, Jesus prepared to continue on his way, but the two persuaded him to stay for supper: "Abide with us, for it is toward evening, and the day is far spent." Jesus sat down with them, broke the bread and blessed it, and at once they recognized him. He then vanished from their sight, and they rushed back to Jerusalem to tell the others.

Again, we have a variant of the tale of the mysterious stranger, one who is given proper hospitality and reveals himself to be divine. But in this case the story carries the additional power of the stranger having returned from the dead. Who has not glimpsed in the street, for just a moment, a loved one or friend who has recently died? The significance of the Resurrec-

Master of the Osservanza. Christ in Limbo. *c. 1440–44. Tempera and gold on panel, 15 x 18½". The Fogg Art Museum, Harvard University Art Museums. Gift of Paul J. Sachs as "a testimonial to my friend Edward W. Forbes"*

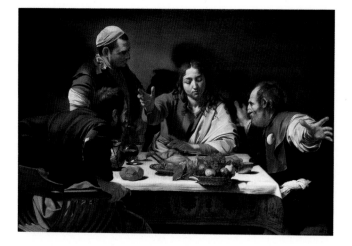

pel account, are clearly his contemporaries, and the food they are about to enjoy has the same quality of the actual. Just as we can sometimes see the beginnings of landscape painting in the background of a Flight into Egypt, in the supper Caravaggio describes so lovingly, especially the basket of fruit inching toward us on the table's edge, we see the beginnings of still life as an important, independent genre.

DOUBTING THOMAS
☙

In their weaknesses, certain of the disciples served nicely to console the ordinary believer who could not rise to the heroic stature that seemed right for a follower of Jesus. Peter was rash, passionately loyal, but sometimes cowardly in a pinch. He, James, and John were deeply devoted but not so much that they could stay awake when needed. Thomas's flaw was that he did not believe what he could not verify with his own two hands. His eyes were not enough. Mary had to drop her girdle down to him even as he watched her Assumption into Heaven, though in some versions of the story, to be fair to Thomas, he had missed seeing the Assumption, so Mary dropped her girdle down from Heaven later.

Like Mary, Jesus indulges Thomas in this need of his. He offers his wounds to be touched and examined, because Thomas has bluntly said that, until he has done so, he will not believe that Christ

tion is that the wish this represents has come true. For many today Christianity is seen as a system of morality or a message of universal love. But, for the early Christians it meant above all that the end of time was soon to come, and when it did, all the faithful would rise from the grave and be received in Paradise. The finality of death was simply untrue.

Traditionally the three figures who journey to Emmaus are dressed as pilgrims, and one vestige of this tradition remains in Caravaggio's painting. It is the shell on the chest of the man on the right. Pilgrims were tourists of a sort, and they usually wore wide hats and carried a staff, a wallet, and a canteen-like "pilgrim bottle" or a gourd for the same purpose. They also collected souvenirs, like the scallop shell that told the world that one had been to Santiago di Compostella, one of the great pilgrim centers of Europe.

Caravaggio's figures, including the servant, who does not appear in the Gos-

has truly risen from the grave. Here we have a painting involving one simple action and twelve people; a group portrait, more than anything. How extraordinary that it can hold our interest at all. No doubt this is partly because it implies a great deal about the variety in human beings and the tensions between them with just its use of color. The colors, bouncing off one another like balls on a billiard table, interact as strenuously as any group of twelve men would do.

Note that there are eleven disciples. Judas has not yet been replaced. By the time this happens, Jesus will have ascended into Heaven. Two of the men look right at us, as if we might be considered for the replacement. *Cartellini* on the floor bear the name of the artist, the date of the painting, and some information on its commissioning.

VERONICA'S NAPKIN
⁂

At the beginning of this chapter, Veronica held up her veil, or napkin, bearing the perfect image of the face of Jesus (page 54). In one of the legends of Christ's Passion, Veronica watched as he struggled through the streets of Jerusalem carrying his cross. When he fell, she rushed forward to wipe his sweating, bleeding face. Miraculously Christ's image was left upon the cloth—the equivalent of a magical photograph that would preserve his appearance forever. It seems that an image of Jesus believed to be a true likeness, and therefore called the

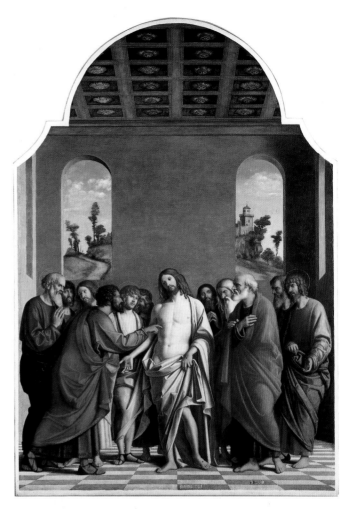

vera eikon, was the germ of the story of Veronica.

In Memling's painting, Veronica simply presents the image, which has been made to exude as much—or more—life than the "living" face of Veronica herself. The arresting effect was probably meant to stimulate meditation on Christ's suffering, death, and ultimate triumph. It surely was meant to convey the sense of his continuing presence on Earth.

Cima da Conegliano.
The Incredulity of Saint Thomas. *1504.*
Transferred from wood to synthetic panel, painted surface 9'7¾" x 6'6".
By courtesy of the Trustees, The National Gallery, London

EARTH AND HEAVEN

THE HAND OF GOD

☙

The link between Heaven and Earth is usually made by the Holy Ghost. But sometimes God the Father, represented by his hand, reaches down from the sky to affect our lives.

The hand of God appears early in the history of Christian art, where it reflects a reticence to picture God the Father, though since we were made in his image and he is our Father, we already have a being in mind that is very much like a man.

This golden hand, dispersing demons over the still recognizable city of Paris, creates concentric rings of ripples, implying that the sky is a kind of upside-down lake suspended high above us, or even suggesting that we live in a fish-bowl world beneath the precincts of Heaven.

PENTECOST

☙

The apostles were convinced that Jesus was the Messiah, but after he had ascended into Heaven they found themselves in a world much the same as it had been before. They prayed continually for guidance. Ten days after the Ascension they gathered in an upstairs room for the feast of Shavout, or Pentecost (Greek for fiftieth, because it came fifty days after Passover). As described in the Acts of the Apostles, "Suddenly there came from the sky a noise like that of a strong, driving wind, which filled the whole house." Tongues of flame descended, one resting on each person present. Then each was filled with the Holy Spirit and began to talk, miraculously, in a foreign language he had not known before. Outside, passersby in the street below heard the commotion and thought that the disciples were drunk, but soon twelve foreigners from twelve countries gathered to listen, each astounded to hear his own language. (Besides, Saint Peter pointed out, they would hardly be drunk, it being only the third hour of the day.)

The gift of tongues is another of those fantasies that many more have had than would want to admit. How often one feels on the very verge of penetrating a completely foreign language, if only for the simple lifting of a veil. It is this magical quality of Pentecost that appealed to many medieval artists. Foreigners in their foreign outfits stand beneath the windows of the upper room, listening and looking up in wonder.

But El Greco chose to paint the moment of the Holy Spirit's descent (page 84). No one speaks as yet; all are caught up in the throes of the mystical experience, an experience not of tranquillity or contemplation but of a low-level frenzy,

Jean Fouquet. Descent of the Holy Ghost upon the Faithful. *c. 1452. Manuscript illumination, 7 ¾ x 5 ¾". The Metropolitan Museum of Art, New York. Robert Lehman Collection, 1975*

something like physical love. The spirit reaches down, bridging the gap between Earth and Heaven. Indeed, for El Greco, no such gap seems to exist. The human beings themselves flicker and undulate like flames. The distinction between spirit and matter dissolves.

The disciples are again twelve in number, Judas having been replaced by Matthias. The Virgin is at the center of the group and close by are two other women, probably Mary Magdalene and another Mary.

THE TRINITY
⌘

Father, Son, and Holy Ghost are one being. As far as the visual arts are concerned, this is not a conception made in Heaven. Many artists have grappled with depicting the Trinity, some with the rather outlandish result of a three-headed man, and some with a set of identical triplets. In early Christian times, when the church was still averse to naturalistic images of God, the Trinity was often depicted symbolically, for example by three interlocking circles. Agnolo Gaddi's painting represents a conventional device that many artists finally settled on: God the Father holds the cross on which his Son is crucified, while the dove of the Holy Ghost hovers just above it.

The dove, rather than the flames of Pentecost, became the primary symbol for the Holy Spirit. The symbol derives from the words of Saint John the Baptist, "I saw the spirit coming down from

Heaven like a dove and resting upon him." In the Greek and Roman tradition a bird represented the soul, and the dove brought with it the associations of peace and good tidings from the story of Noah, so that it already had very positive connotations. Flames can get out of control, even as symbols.

One will sometimes encounter a saint (especially Gregory the Great or Saint Thomas Aquinas) with a bird perched on his shoulder or hovering near his ear. This is the dove of the Holy Ghost whispering to him. It indicates divine inspiration and probably has nothing to do with the expression, "A little bird told me."

We have noted the tendency among early Christians to avoid making images of God the Father, as if nowadays we have no trouble with such picturing. But even our most tasteless Hollywood biblical epics seem uncomfortable with anything more specific than a booming voice for God. Many of us, if we look too long at this bearded man with his piercing gaze, find that he begins to look too much like someone we know. Further, our fairly recent uneasiness with assigning gender to such a conception as God has given new life to the qualms of the early Christians.

HEAVEN AND HELL
cx/

Sometimes the heavenly Paradise is a garden where the blessed read, make music, and pick fruit. One of the loveliest

views of Paradise is one probably painted by Zanobi Strozzi but copied from a lost painting by Fra Angelico (page 86). The washed freshness of the colors, the suggestion of joyous music, and the orderly yet exuberant dancing of the blessed actually convey something like ecstatic spiritual pleasure.

The uniformity among the population can partly be explained by the fact that in Heaven everyone will be thirty years old, the ideal age. If Fra Angelico has anything to say about it, most of us will also be blonds. His preference for golden hair is obvious. Even

a dark-skinned, African-looking angel in his Coronation of the Virgin has blonde curls (on page 87, she is in the top, two heads to the right of the throne). It is not easy to paint a picture of bliss, which from the outside might appear quite boring. Fra Angelico conveys rapture through color. About a century earlier, his fellow Florentine, Dante, described the ineffable light of Paradise. Somehow Angelico's bouquet of colors—seen seldom in nature except in tropical fish and the plumage of jungle birds—manages to capture the blinding yet sweet light of Dante's Paradise.

Heaven, as we can see, is a monarchy. On this occasion, saints holding their attributes and angels making music gather for the Virgin's coronation. Shortly, she will join her son on the throne's second

cushion. Music is important to almost every conception of Heaven, but it is essential to Fra Angelico's. His angels are seldom without trumpets or stringed instruments.

In Van Eyck's painting of the Last Judgment, Heaven is a kind of floorless courtroom (page 88). Christ presides, flanked by Mary and John, much as he often is in scenes of the Crucifixion. The saved souls stand or sit in orderly rows, and the whole scene looks alarmingly like church.

But more interesting is the shoreline view of Earth, showing the land and the sea giving up their dead, and, below that, the archangel Michael straddling the back of a leering bat-winged Death who not only forms the demarcation between worlds but seems to be giving birth to (or much worse, defecating) the condemned. Among the naked souls are speckled monsters, giant prawns, and creatures with both beak and horns, as well as bishops and monarchs. There are always bishops and monarchs in Hell. Painters seem anxious to remind us that high position in the church or the world will never be enough to save an unrepentant sinner. There are bishops and monarchs in Heaven too. In this painting one is being greeted by an angel while the other has an angel escort who lifts his finger like a headwaiter, recommending his case to the divine judge.

In Hell an artist's imagination can go hog-wild, and often it does. Serpents coil around arms and legs and even emerge from eye sockets; monsters devour body

parts with mouths that are placed where even a monster's mouth shouldn't be; toads hang from the sexual organs of the lustful; gluttons are forced to eat the inedible. Hells that are based on Dante have a more orderly quality: pun-ishments are meted out on spiraling, de-scending levels and can be understood to fit their crimes. But most often Hell is a swirling sinkhole of horrors that would challenge the modern filmmakers' special-effects industry.

Fra Angelico. The Coronation of the Virgin. *c. 1430. Tempera on panel, 83 ⅞ x 83 ⅛ ". Musée du Louvre, Paris*

LAST THINGS

The Apocalypse ("unveiling," in Greek), also known as the Revelation of Saint John the Divine, is the last book in the Bible. *Divine* comes from the Latin *divinus*, meaning soothsayer. In Saint John's case it seems to mean prophet or seer, though *divine* eventually came to signify clergyman or theologian.

The Revelation was thought to have been written by the same John who wrote the fourth Gospel, though this is probably untrue. It is a visionary work in the tradition of the Old Testament Book of Daniel, from which it derives many of its images. Just as Old Testament prophets described the ultimate delivery of Israel from its oppressors, John's visions predict the imminent rescue of the Christians from the Beast, or Antichrist, who symbolized the persecuting Roman emperor or Rome itself. Later, when Rome became Christian, other enemies were found to fit the description of the Beast. After the Reformation, the Protestants reverted to Rome as the Beast's true identity, but the Rome of the popes.

The Apocalypse is sometimes confused with the Last Judgment, but it is actually both more earthbound and, in a sense, political, and more fantastic. It describes the cataclysmic events in this world that will precede and lead up to the final judgment. It then closes with a vision of the Heavenly City that will follow.

Memling's John is older now, and has grown a beard. He has been exiled by the Emperor Domition to the island of

Patmos, where he is writing down his vision. A glance at this painting will explain why the Book of Revelation is twenty-two chapters long. The vision is a complex one, filled with difficult and obscure symbols, some of them describable with words but impossible to picture. Creatures with many eyes, dragons with many heads, balls of fire or beautiful cities descending from the sky, the throne of God surrounded by crowned men in white, and, most famously, the four horsemen representing divine wrath—sights like these in paintings or on church ceilings or walls are almost always references to the Apocalypse, the last days of Earth before the demise of the enemies of the righteous.

THE FOUR BEASTS OF THE EVANGELISTS

∾

A vision described by Ezekiel of four beasts (or a creature made of four beasts) seems to have been the inspiration for a vision in John's Apocalypse in which four similar beasts surround the throne of God. Somehow it was decided that these creatures must represent the four men who wrote the Gospels: Matthew, Mark, Luke, and John, known collectively as the Evangelists. Who first made this connection, no one knows. At any rate, the beasts of the Evangelists are much simplified from the biblical creatures who have, among other things, countless eyes and wings all over the place and would be impossible to sculpt or paint.

Hans Memling. John on Patmos, *right wing of the* Altarpiece of the Virgin with Saints and Angels. *1479. Panel, 67 ¾ x 31 ⅛ " (each wing). Hospital of Saint John, Bruges*

Matthew is symbolized by a winged man. (Revelation tells us he is not an angel but a winged man.) Mark's animal is the winged lion, Luke's the winged ox, and John's the eagle (obviously winged already). Reasons for these assignments were soon found. John is the eagle because his Gospel is the most mystical; it soars highest and closest to God, as does the eagle. The reasons for the other

assignments are even less convincing. But what is convincing is the way in which these animals become familiar, almost inevitable companions to the four Evangelists. We expect to see Luke's ox when we see Luke, not just as his identifying symbol, but almost as his pet. It is another example of what image-making can do. Show us something long enough, paint or sculpt it well enough, and it begins to seem inevitable and no more arbitrary than a traffic light.

The winged man in this carved ivory book cover is the only one aware of the custom of covering the hands to show respect. But if ever a hoofed, pawed, or clawed animal held a book properly,

these do. And if ever an animal looked as if it could read, these certainly do. The ninth-century artist has given each a facial expression that implies deep thought and subtle emotion.

The animal in the central medallion is the Lamb of God. It looks like a dog, but for some reason early Lambs of God often do. The Lamb of God is, of course, Christ, because the lamb was a sacrificial animal in Hebrew and other ancient Near Eastern religious rituals. When halos first came into use in Christian art, the Lamb of God was the only animal to have one, but later the Evangelists' beasts acquired them too, as did the dove of the Holy Spirit.

CHRIST PANTOCRATOR
❧

Pantocrator comes from the Greek for "all" and "ruler." The Pantocrator is the image of Christ as ruler of the universe. The first and last letters of the alphabet—alpha and omega—signify that he is both the beginning and the end—of time and history and the meaning of life.

Above an array of saints, Christ sits on a rainbow, as John saw him in his vision —though it is a stylized rainbow, decorated with stripes, dots, and acanthus leaves. His mandorla is also striped. As a matter of fact, early Spanish art shows a great love of stripes, especially wide bands of color that enliven backgrounds in frescoes and manuscript paintings. The drapery patterns are orderly but elab-

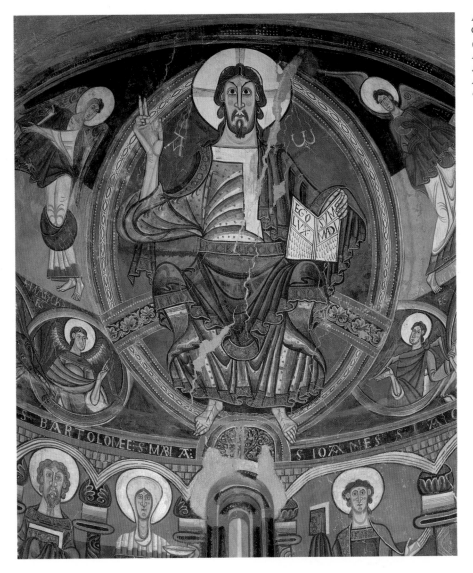

orate, and they bear very little relation to the way clothing and gravity really interact. More than anything, this image demonstrates the power of three devices to instill religious awe: high placement, strict symmetry, and very large eyes.

MODEL BUILDINGS

৵

In this ivory relief of Christ in Majesty, Jesus sits again on a rainbow, but he is encircled by a laurel wreath signifying victory (page 92). The image is similar to that

of the Pantocrator, but in this case Christ looks far more approachable. He is, in fact, being approached. The Empero Otto is trying to look humble. Hands covered to show respect, he offers Christ the church he has caused to be built, the Magdeburg Cathedral. The building of this church should weigh on his side when the final judgment comes, and the representation in ivory of him offering it will serve as a reminder, and perhaps keep anyone else from taking the credit. This kind of bald attempt to purchase redemption did not seem at all crass to many monarchs and wealthy personages. One often encounters a supplicant holding what looks like a birdhouse but is really a church.

Sometimes a whole town is carried on a platter like an elaborate pastry, but then the bearer is usually recommending his city for patronage or some kind of favor. A woman holding a tower, however, is Saint Barbara. It represents the scene of her captivity, as we shall see.

South German or North Italian. Christ in Majesty with Emperor Otto I. *962–73. Ivory relief, 5 x 4 ½ ". The Metropolitan Museum of Art, New York. Bequest of George Blumenthal, 1941*

THE HALO

Now and then a person simply glows. We have all seen it, or perhaps more accurately, felt it. In the Mediterranean world this experience found pictorial expression. It began, as we might expect, with the sun. The fan of beams splaying from the edge of a cloud became the rays that emanated from the garland on the head of the Greek sun god Helios. Eventually many gods wore this crown of light, known now as a glory. Pharaohs and emperors followed suit, being divine themselves, or at least candidates for divinity. It could be said that the sawtooth paper crown cut out by a child is a vestige of this badge of Mediterranean ambition.

The Christians adopted the round halo. It was first given to Christ and the Lamb of God, later to the angels, and eventually to the saints. The golden disk-shaped blur seen in Byzantine art is known as the revolving halo. In one of the rare cases of an influence traveling from West to East, the halo traveled though Gandhara, finally reaching the Buddha. The body halo, or aureole, was reserved for Christ and the Virgin, and still is. Only in its stylized form is it called the mandorla, for its almond shape.

Once you begin collecting rare halos, it is hard to stop. The triangle is quite rare. It symbolizes the Trinity and, when it appears, will almost always be worn by God the Father. Once in a while, however, the infant Christ has a triangular halo, no doubt to emphasize his place in the Trinity. As triangles these halos

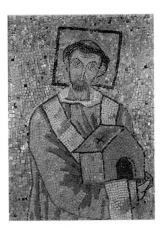

may be rather imperfect, more like diamonds, probably because the points on either side of the head can look awkward when they are too acute.

Allegorical figures such as the virtues wear hexagonal halos if they wear any at all. Here is Hope, one of the three theological virtues—Faith, Hope, and Charity—as described by Paul in his famous letter to the Corinthians. The four cardinal virtues—Justice, Prudence, Fortitude, and Temperance—are taken from Plato's *Republic* and were added to the other three by the church fathers to make a total of seven. In the decoration of Gothic cathedrals, one will often encounter the virtues treading their corresponding vices, in human or animal form, underfoot.

A circle is perfect; so is Heaven. Earth is imperfect; so is the square. A square halo tells us that its wearer was still living on Earth when the work of art was created and that he or she was probably a saint (by popular canonization, since the official kind cannot be accomplished until after death). Now and then the square halo was not much more than an attribute denoting a very fine and respectable person, but usually sainthood was implied. The mosaic is of Pope John VII, holding a model of the oratory, or chapel, he caused to be built inside Old Saint Peter's in Rome. The actual chapel must have been more majestic than it appears here.

When medieval artists painted on wood and gilded both their skies and

*Antoniazzo Romano.
Detail of* God the
Father, *from the*
Altarpiece of the
Confraternity of
the Annunciation.
*c. 1489–90.
Santa Maria sopra
Minerva, Rome*

Alesso di Andrea.
Hope. *1347.
Fresco. Pistoia
Cathedral, Pistoia*

Pope John VII. *705–6.
Mosaic fragment,
33 ⅞ x 25 ⅜".
Vatican Museums,
Rome. The Fabbrica
of Saint Peter, Rome*

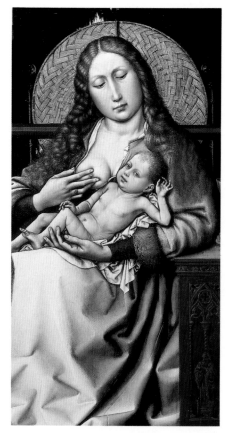

halos, they often gave the halos intricate and subtle detail by tooling—enhancing them with stipples, dots, lacy rosettes, and sometimes the saints' names as an aid to identification. The cruciform design within a halo was used exclusively for Jesus and, occasionally, God the Father.

As the Renaissance progressed, the halo changed to a tilting disk, painted in perspective, then to a thin ring of light, something a circling firefly would leave on film at a long exposure. The result was very refined and especially useful where many saints were shown in groups (as in the painting on page 81). Medieval-style halos in a crowd scene can take over the whole picture and make a bubble bath of it. This delicate ring also suggests a new, sophisticated embarrassment about the whole idea of a halo.

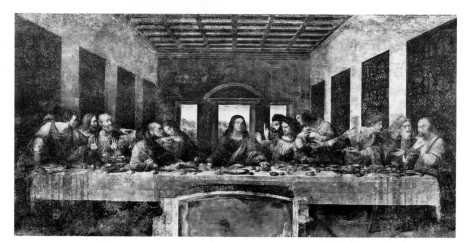

SUBLIMINAL HALOS

∾

Many artists dropped the halo and never missed it. Some of the most fascinating effects, however, were created by painters who tried to have it both ways. If the cloth of honor hanging behind the Virgin is a tapestry or an Oriental rug, and one of its circular patterns just happens to fall behind her head, the result is both naturalistic and religiously suggestive. If, as in Campin's painting, Mary sits before a wicker firescreen, the concentric circles of the weave make the halo, and the flame visible over the top recalls the Holy Spirit of the Pentecost.

Leonardo achieves this effect geometrically. As the ceiling's and the walls' receding parallels converge on the vanishing point, they can also be said to emanate outward from that point—the head of Christ—forming a kind of hidden glory. And the arc of the doorway above his head, if completed into a circle, finds its center at the same point, turning it into a halo.

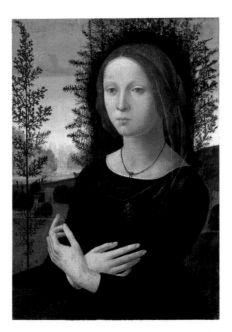

thought that in both cases the tree is a juniper, and the sitter is named Ginevra (Juniper), meaning that we also have a pun on our hands. Artists have always liked to play games, especially Renaissance artists.

VARIATIONS ON THE HALO

∾

There is no question that what stops us when we walk past Lorenzo di Credi's portrait of a young woman is her bristling black halo. Here we have nothing more than an artist playing with the tradition, and our expectations, and thereby throwing us completely off guard. Leonardo painted a similar picture, and it is

RELICS

∾

A surprising aspect of medieval culture, and one that has not vanished from popular belief today, is the great importance of dead bodies. Given the superiority of the spirit and the tainted nature of all things physical, one might reasonably expect that bodies after death would count for nothing at all. This was hardly the case. The resurrection was to be of the body. All would rise from the grave

Swiss. Reliquary Arm
of Saint Valentine.
14th century.
Silver, parcel gilt, 21 ½ x
7 ⅝ ". The Metropolitan
Museum of Art, New
York. Gift of J. Pierpont
Morgan, 1917

with their bodies intact. The beheaded
would be reheaded, and so on. And after
judgment, life would continue—in both
Heaven and Hell—in a world of matter.

Saints' remains were a special case.
Some saints were so sinless that their
flesh proved to be incorruptible; their
bodies never decayed and their corpses
smelled sweet indefinitely. Now and then
one runs across such a body in a Euro-
pean church, lying under glass. The sight
is not entirely convincing.

Coming close to the remains of a
saint, even just a body part or a scrap,
was thought to have miraculous effects.
Their holiness remained, even in the
dust to which they had returned. In our
time, the popular conception of the
magical powers of DNA and the bur-
geoning folklore it has engendered come
to mind. Relic collecting became wide-
spread and intense. Many were false, of
course, but no doubt some were real.

Artists and craftsmen provided the
containers for these relics, and their reli-
quaries comprise some of the most el-
egant artifacts of the age. Some are in
the shape of the relic they contain; there
are feet, heads, and torsos of wood, silver,
and gold. Some are boxes shaped like
gorgeous treasure chests or small chur-
ches. This silver arm of Saint Valentine,
beautifully clothed in a sleeve with gold
buttons and trim, even has a finger ring
set with a stone.

The gesture is one we have seen. Jesus
confers blessings with it and so do priests
of all rank even to the present day. It is
called the *benedictio Latina* and it goes

back a long way. The gesture was used by
members of the late antique mystery
cults, that of the Phrygian nature god
Sbazios in particular. It is quite a sur-
prise, as one wanders through a collec-
tion of ancient art, to encounter a bronze
hand making the very sign made by
priests today, covered with frogs, snakes,
turtles, lizards, grasshoppers, rabbits,
pine cones, grapes, and other symbols of
the Earth's fecundity.

Reliquaries did not always contain
the remains of saints. An enormous, pink
wing feather, once left behind by the
archangel Gabriel, was cherished for
many years in the Escorial, near Madrid.
Other holy objects, also potent as miracle
workers, were housed in specially made
containers. One might hold Mary's wed-
ding ring, or wine from the Last Supper,
or a fragment of the true cross.

THE INVENTION OF
THE CROSS
☙

A word should be said about some
strange verbal usages that have made
their way into the literature of art and
onto the wall labels of museums. In some
instances, Latinate terms are clung to
that are simply quaint, as when a saint is
said to have been lapidated, or to have
met his death through decollation. But in
other cases the result is confusing, to say
the least. The *translation,* for example, of
Saint Mark's body simply refers to its
being moved from Alexandria to Venice
(stolen, to be really precise). In a Sacred

Conversation, no one speaks. The Latin *conversatio* means "company," as in the company one keeps, so *Sacred Conversation* signifies holy company, usually a group of saints surrounding the Madonna. (A *conversation piece*, by the way, was originally a picture of a group of people, not a peculiar knickknack that insures against having nothing to say.)

Likewise, the *invention* of the cross refers simply to its finding (one of the original meanings of the word when it first came into English). It is difficult to understand why these terms have not gone out of use. Surely most scholars don't wish to exclude the uninitiated by speaking in a private language, but there may be a few who do.

The Legend of the True Cross is one of the most lengthy and involved of the Christian tales. Helena, the mother of the fourth-century Roman emperor Constantine, became a devout Christian after her son's conversion. The actual cross on which Christ died, held aloft by angels, appeared to her in a vision. She traveled to the Holy Land and there retrieved it, along with the nails used to crucify Christ, the bodies of the three kings, the tunic of the Virgin Mary (which was lying in the stable in Bethlehem, miraculously untouched for three hundred years), and some of the straw on which the infant had been laid.

This cross, it turns out, had been made with wood from the fateful Tree of Knowledge, a branch of which Adam took with him when he left Eden. Moses used it as the pole on which he raised the

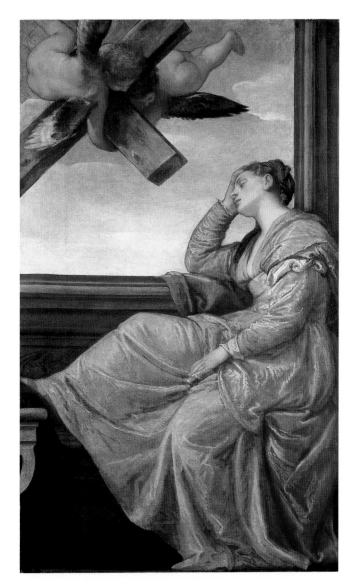

brazen serpent. It was impossible to build anything with this wood because it changed size, and, if you measured and sawed it, you always cut off too much. In the time of Solomon it was thrown over a stream as a bridge. The Queen of Sheba

Paolo Veronese.
Saint Helen:
Vision of the Cross.
Mid-16th century.
Oil on canvas,
6′5½″ x 3′9¼″.
By courtesy of the
Trustees, The National
Gallery, London

sensed its future use and walked barefoot in the water rather than tread on it. It was later found floating in the pool of Bethesda (helping to cause the water's curative powers) and was fashioned into the cross. Briefly, that is the story of the True Cross.

In Veronese's painting, Saint Helena receives the vision that announces her calling. Often a saint's first vision foretells future martyrdom. To Helena it said, Go on a trip.

DEMONS AND MONSTERS

co

There are many lesser devils who work under Satan's direction. Some are pagan gods, who still exist, but as demons. Demons are everywhere, like germs. One

man was possessed of a demon that had disguised itself as a fly and managed to get swallowed with a glass of wine. However they take possession of a person, they usually leave through the mouth. Some people like to consort with demons; they are witches. But the San Zeno Master's shapely woman with her caressable round stomach (polished by admirers) is obviously an innocent victim. We are glad she is rid of the thing. The confident bishop who presides over the exorcism is San Zeno of Verona. Zeno usually retains the Italian "San" in English because he is a local saint closely associated with his church, always referred to as San Zeno. The young woman is, of course, a princess. The bishop was highly regarded during his lifetime (in the eighth century). King Pepin thought so much of Zeno that he wanted to be buried in the same grave with him.

For centuries, devils, demons, and witches continued to hold an important place in the imagination and the art of Europe, especially in the North. Eventually, in the countries of the Reformation, the Virgin disappeared, the saints disappeared, but the demons and witches stayed on. (It seems a bit like throwing out the baby and keeping the bath water.)

On the subject of monsters, it is easy for us to be smug. Almost all forms of life are familiar to us through scientific publication, photography, and mass media. But if we lived in another time and place and had never seen an elephant, and rumors persisted of an animal with a seven-foot nose, how would we know what to

Third Master of San Zeno. San Zeno Frees the Princess of a Demon. Late 12th century. Bronze relief, doors of San Zeno, c. 21 ⅝ x 19 ⅝ ". San Zeno, Verona

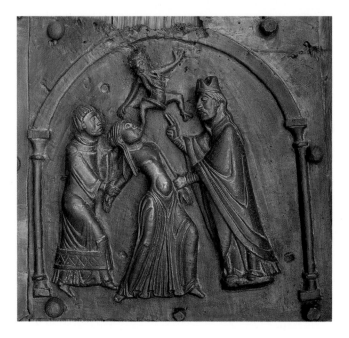

think? Is such an animal more likely than a dragon? A dragon looks like a large lizard. An elephant doesn't look like a large anything else.

Monsters such as centaurs, Satyrs, and griffins had the authority of ancient representations to attest to their reality. It is true they had not been seen in the flesh, but that was because they stayed as far away from civilization as they could. If Cyclopes, headless men with eyes in their chests, and whole tribes of dog-faced people were reported to exist in the remote reaches of the world, who could be sure they did not?

Dog-faced people are mentioned especially often in medieval accounts of the beings who live in the most foreign of lands. I personally became less likely to laugh at the medievals for their credulousness when a young man, quite well educated, told me in all seriousness that in a remote region of China there exists a breed of dog with the face of a man.

WILD PERSONS

The wild man was the Big Foot of medieval Europe. Hair grew all over his body except on his hands, feet, elbows, and knees. Wild women (like the female Big Foot) must have been shy because they were less often spotted. Their appearance was similar except for their hairless breasts. Reports of such people, without the quantities of hair, can be traced as far back as Herodotus in the fifth century BC. They have all the quali-

Hartmann Schedel. Prodigies, three woodcuts from the Nuremberg Chronicle. 1493. The Metropolitan Museum of Art, New York. Rogers Fund, 1921

ties of mythological beings, but surely there were marginal people living in the forests of the ancient world and of Europe, and some feral ones as well. Whatever the facts behind their legend, wild men and women were known to exist, and the woods were full of them. They gathered nuts and berries and hunted for

meat, which they caught with their hands and ate raw. They could not speak, and, worst of all, they knew nothing of God.

These creatures represented everything that was not civilized. Thus, depending on the current feeling about civilization, attitudes toward wild persons varied. In the early Middle Ages, when civilized society represented goodness, piety, and the only defense against chaos, the wild ones were nothing but unredeemed, sinful, repugnant menaces. In the late Middle Ages, when many felt dissatisfied with the social order, the wild inhabitants of the forests were thought to be simple, uncorrupted, and enviable. Further, many saints' legends told of penitents who retired to the wilderness to

Fundort Wholen.
Wild Man. *15th century.*
Glazed ceramic oven
tile, 9 ¼ x 8 ½ ".
Schweizerisches
Landesmuseum, Zurich

Far right:
The Housebook Master.
Wild Woman and
Children on Stag.
c. 1465. Engraving.
Rijksprentenkabinet,
Rijksmuseum,
Amsterdam

expiate their sins by living a primitive life. Sometimes, to shield them from the elements, their bodies miraculously grew hair. Clearly, where attitudes toward the wild man and his consort were concerned, ambivalence ran high.

SNAKE OIL
cᴏ

The Italians were not much given to social criticism in paint. Their moralizing art taught by good example through allegory, not by bad example through satire. For object lessons and social satire we must go to the Northern artists. Some of their visual sermons are wonderfully simple: the slob family, for example (dogs on the table, babies smoking pipes), or the progress of easy virtue (all downhill). In this scene, we have what is thought to

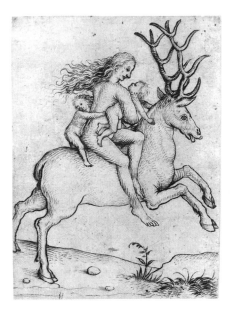

be a satire on quack doctors and the gullibility of what we now call the consumer. The seated man has agreed to have a stone removed from his head, for a steep price, no doubt. The "surgeon" has probably palmed a small stone, which he will produce, a bit bloody, from the incision in his patient's scalp. His cohorts are a colorful pair, stranger than Pinocchio's fox and cat. The entire scene, and some of the more puzzling details in it, may be based on old Dutch proverbs. On the other hand, Hieronymus Bosch is such an original artist, and a mysterious one, that there is no end to the speculation about this and most of his other paintings.

LOVE OF ALLEGORY
AND ALLEGORY
OF LOVE

∾

Every civilization on Earth tells stories that have allegorical resonances, but long ago Europeans fell in love with visual allegory to an extent not known in other cultures. The Wheel of Fortune (which is not a roulette wheel) turns, lifting the lucky ones who ascend on one side while the recently lucky fall off the other. A young man chooses between two beckoning women, Virtue and Vice, dressing their parts. Landscapes divide in half; a barren stretch on the left signifying the Law (of the Old Testament), while flourishing valleys and hills on the right signify the Mercy and Grace of the Gospel.

The most common type of allegory is the representation of abstract ideas as human beings. We have already met Hope, one of the theological virtues. Charity, which means love, both of one's neighbor and of God, also took the form of a woman. Her attribute was often a flame, emanating from a vase or candle, or a bowl of fruit or cornucopia. By the sixteenth century, however, Charity almost invariably suckled two or three babies (or even more). Since the depiction of the nursing Virgin had fallen out of favor with the church, Charity can be said to have taken her job. One can see why a human function as vital and basic as lactation needed its place in art, and found it.

Hieronymus Bosch. The Cure for Folly. *c. 1490. Oil on board, 18 ⅞ x 13 ¾". The Prado, Madrid*

*Guido Reni.
Charity. c. 1630.
Oil on canvas, 54 x
41¾". The Metropolitan
Museum of Art, New
York. Gift of Mr.
and Mrs. Charles
Wrightman, 1974*

The stocky babies this Charity feeds are clearly well nourished and happy. It seems they are pink, pinker, and pinkest, depending on which was last fed. Charity's pallor in contrast to their rosiness is not meant to suggest that she is being drained of life. She is simply very fashionably lily-white. Her supply of milk must be inexhaustible, as would be fitting for a figure who represents love.

Clothing and fashion are fascinating subjects, no less in paintings than in life. In the centuries since European painting began, certain puzzling customs of self-adornment have come and gone, the most exotic being two-foot-long shoes, healthful jewelry, plucked foreheads, elaborately folded head coverings, slashed sleeves, and codpieces.

The well-known elongation of figures in Gothic art extended to life as well. People liked to be thin, as much as they do today. The church's encouragement of food deprivation was sometimes close to sanctioned anorexia, though of course many people ate as well as they could and enjoyed it when they did.

Clothing styles in this period avoided blunt endings. Shoes, hats, and sleeves often tapered off to a point (see the sleeves of the princess on page 119). Very long, pointed shoes, like those worn by the young man on page 105, were elegant but highly inconvenient. One had to take each step with a kick that propelled the end of the shoe in front of the foot. In wet weather or on muddy terrain, these shoes were supported from beneath by long, pointed, wooden platform clogs.

The Romans believed that various precious and semiprecious stones could cure or fend off certain diseases or even help to ensure life after death. The stones themselves were beneficial, and their efficacy was enhanced by the engraving on them of certain words and images, usu-

ally of gods—Egyptian, Greek, Hebrew, Roman, Christian, sometimes in combination. A doctor or magician would "prescribe" the stone and the inscription. Much of this lore survived through the Middle Ages and the Renaissance, and along with it the habit of wearing jeweled rings for health reasons. The recent flurry of interest in crystals is not very different.

The use of coral for amulets is ancient indeed, going back to early Celtic tribes on the Italian peninsula. A horn-shaped piece of coral was thought especially effective in averting evil, partly because of its phallic associations. In many paintings of the Madonna and Child, Mary has, like any conscientious Italian mother of the time, protected her baby with a necklace of coral. Why the Christ Child would need such protection is a good question. The coral-horn talisman has by no means disappeared, though now it might be made of plastic.

In the fifteenth century, fashionable women, and to a lesser extent, men, were especially taken with high foreheads and almost invisible eyebrows (see Fouquet's Madonna, page 51). A great deal of hair was plucked or shaved away to achieve this look, and many women had their necks shaved as well. The main thing was not to be hairy, or a lowbrow.

For a while women folded white linen over their heads and around their faces in patterns of origami-like complexity. Some of these styles survived into the twentieth century in the habits of nuns. Nuns began by dressing in the standard fashion of their time so as not

Piero della Francesca.
The Montefeltro
Altarpiece *(detail).*
c. 1470.
Tempera on panel,
8′ x 5′ 7″. Pinacoteca
Brera, Milan

to make themselves conspicuous, but, as styles changed around them, their clothing had the opposite effect. Similarly, church furnishings, even in an American suburb, still tend to resemble standard household Gothic. Academic gowns and cowls, seen now only on graduation day, are also wonderful medieval survivals.

Sleeves and dresses were for a long time separate items. This is how it could be that a knight would carry his lady's sleeve into a joust. (The lady Greensleeves probably wore a dress of a different color.) Sleeves were fastened to the armholes of dresses with ribbon or shoelace-like points, sometimes decorative as well as functional. The sleeve itself could be a highly elaborate article of clothing, smocked or puckered, with little medallions, jewels, or pearls sewn on all over it. The technique that took Europe by storm, though, was slashing. Slits in the fabric, vertical or horizontal, long or short, widely or closely spaced, were used to give it fullness. (Think of the paper lanterns children make in school, and

*Albrecht Dürer.
Triumphal Procession
of Maximilian I
(detail). 1514–16.
Woodcut. The Metro-
politan Museum of
Art, New York.
Harris Brisbane Dick
Fund, 1932*

the principle will be clear.) Gauzy under-garments were often pulled through the slits to make attractive little puffs.

Swords and other weapons were worn by men long after the need to go forth armed had vanished. At formal and offi-cial events and in portraits, kings and noblemen sported weapons as a kind of jewelry. Indeed, certain male fashions—the sort we are used to seeing in produc-tions of Shakespeare—are derived from the padded underwear worn with a suit of armor. No doubt much glamour and prestige adhered to this clothing right from the start.

We think of our times as being fairly outrageous, and to prove it we might cite the costumes certain celebrities like to wear in public. But nothing we have compares to the codpiece. It began in the fifteenth century as a practical addi-tion to men's clothing when the two legs of the hose, formerly separate, were joined at the top to become trousers. It then evolved from a plain cloth pouch to a padded one until, finally, the codpiece became a structured and stuffed append-age something like the forearm of a large teddy bear. That it was meant to imply great sexual prowess, or at least continu-

ous arousal, cannot be doubted, nor that it was considered a proper and elegant feature of one's costume. Some of the most prominent and richly decorated codpieces of the time appear in portraits of kings. One might wonder whether a state of perpetual arousal would render a monarch more or less effective as a monarch, but there it is. (A codpiece somewhere between modest and flamboyant is worn by the butler in striped hose on page 23.) Both the slashed outfits and the codpieces sported by the gentlemen in Dürer's woodcut are worn with pride and propriety.

DEATH AND DYING
ဢ

During the Middle Ages, one of the biggest favors you could do for your friends was to remind them that they might not live to see tomorrow. This bracing information caused slackers to straighten out and serious sinners to confess and do penance, readying themselves for the most important event of their lives, dying. That death comes to everyone, often without warning, was the subject of many works of art, especially after the Black Death struck Europe in the fourteenth century.

The Dance of Death, a theme that was treated often during and after the fifteenth century, showed the living and the decomposing dead in a kind of procession or dance. It spoke of the immanence of death and the fact that all, from pope to peasant, were the same in

Death's eyes. Grizzly as it was, the dance could have its comic moments.

The drypoint is by the Housebook Master. Since his identity is unknown, the artist is named after the main work executed in his style, in this case a manuscript of drawings of household gear and such known as the *Housebook*. An identification of this type is a pretty sure sign that somewhere, right now, there is a student or art historian working hard to track the artist down and give him or her a real name. The young man in the drypoint is far too attractive, prosperous, stylish, and complacent to believe Death, who, in this picture at least, shows much solicitousness and sympathy.

The Housebook Master. Death and the Young Man. Probably late 15th century. Drypoint. Rijksmuseum, Amsterdam

symbols is present; bread, wine, or an egg suggesting Resurrection. The reflected window hints at some kind of hope, just barely, unless its cross is more than a naturalistic detail. Much of the iconography in these paintings sprang from the mind of the artist or his patron, not solely from the received set of traditions. We can only guess about the significance of that cross.

THE VANITAS STILL LIFE

cxs

Two centuries after *Death and the Young Man*, its theme is still important but is treated less directly. The *vanitas* is an example of a genre that came into its own with the rise of still-life painting in seventeenth-century Holland and Flanders. The best *vanitas* paintings contradict themselves. They purport to teach us the emptiness and impermanence of worldly possessions and material objects while infusing them with transcendent significance and giving them relative permanence.

The modern implication of conceit now associated with the word *vanity* is not present in the use of *vanitas*, the Latin word for "emptiness." Here, the overturned glass, the toppled ink bottle and inkwell, the lamp run out of oil—all insist upon the theme. Learning, symbolized by the book, perhaps all human endeavor, is for nothing. The only spark of life in the picture is a literal one, fading quickly on the lamp wick. In this example, none of the usual Christian

HOW NOT TO DIE

cxs

Living well is not enough; one must also die well. The bedridden man in the German woodcut has discovered what he can do with a few swift kicks. Overturning tables, pushing people away, he has succumbed to the urgings of the gleeful devil at his bedside, who has led him into impatience, one of the temptations of the dying described in a handbook on how to do it right, the *Ars Moriendi* (The Art of Dying). The goal of an ideal death must have been helpful to many sick and dying persons; certainly it was useful for those who nursed them.

The arrow of death, and even the shadow of the arrow of death, point right at Bosch's miser, sitting in his deathbed. Death seems to have caught his eye, but he is still reaching toward the money bag offered him by a demon. An angel is doing everything he can to help in this contest over the miser's soul. He kneels right on the bed, trying to direct the old man's gaze upward toward the crucifix in the window.

The miser's room is infested with de-mons. Some are even reading his mail. No doubt there are others under and be-hind the bed that we cannot see. The old man in the foreground is probably also the miser, before his fatal illness, squir-reling money away with his right hand while holding a rosary in his left. This is a clear indication of his priorities. The right hand is the "good" one, the left is not so good.

We don't really know whether this foreground scene represents the present and the death scene the future, or whether death is arriving in the present and the foreground represents the miser's past. Further, there are more symbols than we know what to do with, for ex-ample the weapons and bits of armor ly-ing on the ground outside. Possibly this painting was the left wing of a triptych, as the receding left-to-right perspective of

the room suggests. In that case, the armor might relate to something in the adjoining picture. But the truth is, no painting by Hieronymus Bosch can be fully explained, even when we have all the parts.

HOW TO LIVE
♥

During times of plague, it was noticed that hermits and those in isolated monasteries were often spared. This was attributed to their protection from moral corruption more than their inaccesibility to contagion. This picture is a detail of Starnina's large panorama full of vignettes reminding us how death comes, so often unexpectedly, even to the rich and powerful. The part of the painting we can see shows the only sure triumph over death: the life of the religious hermit. Cut back to almost nothing; cultivate your soul; concentrate on the next life. Surprisingly, the hermits' existence looks far more attractive than it sounds. The weather is good, beautiful animals wander about, everyone lives separately yet together, like a crowd of Henry Thoreaus in a bungalow colony at Walden Pond. (The title, *Thebaid*, refers to the desert city of Thebes.)

THE GARDEN OF LOVE
♥

There is another side to the Middle Ages. As the centuries passed and some relief from barbarous invasions and a certain amount of prosperity were attained, the charming and very odd tradition, or state of mind, known as "courtly love" was born. Human beings again were beautiful, and love, finally, was something to

celebrate, even if it was supposed to remain unrequited (and surely not all of it did). The *feeling* at least was a good thing, and a civilizing one.

The tradition gave rise to much beauty, as well as some obsessive excesses. The artistic production of this phenomenon was mostly literary, but two themes growing from the courtly love tradition, the Siege on the Castle of Love and the Garden of Love, are encountered in many works of art. The Siege is an allegorical conception. In it, knights attack a castle representing Chastity, and virtuous ladies defend the castle, usually pelting the knights with roses. At first, the emphasis was on the value of chastity; later things went rather amok and the siege became a celebration of the joys of seduction.

In the Garden of Love, young women and men talk, feast, and make music. Their behavior is decorous and their clothing lovely. A fountain is always present, sometimes surmounted by a statue of Cupid. In Italy the theme developed as an allegory of the five senses, and this German tapestry may have that meaning too. The youth and three maidens at the round table are about to eat roast pork. Somehow they will have to maintain their sweet manners even though the fork is not yet part of the table service. There is a tablecloth, but no napkins in sight.

Nuremberg Manufactory. The Garden of Love. *c. 1460. Tapestry, 25 ⅝ x 55 ½". Germanisches Nationalmuseum, Nuremberg*

SAINTS

As persons, saints have only one thing in common: extraordinary devotion to God. In this a saint resembles someone who has just fallen in love. She is single-minded, she lacks perspective, she can bore you to death talking constantly of her beloved. Or he is giddy, spontaneous, full of energy. Or serious to the point of torpidity. Or brilliant in her ability to put everything into a new light. Or exasperating in his stubborn lack of interest in his own well-being. Saints often have literal minds. If the Bible says pray without ceasing, they try to do it.

Saints can be rich, poor, smart, dumb, capable, helpless, political, oblivious, beautiful, hideous, lovable, or repellent. Many of the saints in this chapter will be lovable, but that only reflects the preferences of many artists and the author. Real saints are not cute; their actual lives are utterly serious and sometimes unimaginably difficult. But miracles and endearing acts of charity make good pictures.

Saints' stories spring from the factual accounts of actual persons and the amazing workings of the human imagination. The Catholic church's tortuous process of beatification and canonization will not concern us here. It is about as interesting as the textbook chapter called "How a Bill Becomes a Law." More interesting is the fact that some of the most important and popular saints of the Middle Ages and Renaissance are the very ones who did not exist. This is not surprising. These are the saints we need the most. So, we will ignore the church's purge in 1966 of "false" or strictly legendary saints. Happily, their images were not thrown out with their seals of approval. (If only the Protestant Reformation had been able to make its point while stopping short of the effacing and burning orgies that left so many northern European churches more blank than school auditoriums.)

Saint stories are not for the faint of heart. Most end in martyrdom, sometimes of a most hideous kind. When saints appear in a crowd—in Heaven, for example—they often look like an armed squadron. This is not because they are violent but because they carry their identifying attributes, and the attributes are often the instruments by which they were tortured or killed.

In the stories of saints, the natural world responds to them in a special way. Animals trust them, listen to what they have to say, and sometimes provide needed help. Even the elements are in sympathy. Often they will not cooperate when saints are being martyred; water will not drown, and fire will not burn them.

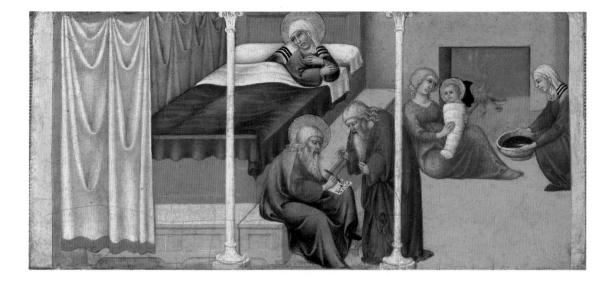

SAINT JOHN
THE BAPTIST

❧

One day Zacharias, a priest of the Temple in Jerusalem, was burning incense when an angel appeared to him. He was understandably frightened, but the angel said, "Fear not." This was a good start. It indicates that the angel was real and not a devil in disguise (they will try anything). An angel will want to dispel fear, while a devil cannot resist taking advantage of it. "Thy prayer is heard," the angel continued, "and thy wife Elizabeth shall bear thee a son, and thou shalt call his name John."

Because Zacharias and his wife were very old and she had always been barren, he could not believe the news. Zacharias made the mistake of asking for a sign from the angel. He was struck dumb. Nine months later, after the birth, friends asked Elizabeth whether the child would be named after his father. She said no, he should be called John. Zacharias was consulted. Di Pietro illustrates the moment when Zacharias took up a tablet, wrote, "His name is John," and regained his speech.

There is a tradition that Mary was present at the birth of her cousin Elizabeth's child, but neither of the two haloless women in Sano di Pietro's painting can be she. Zacharias writes in scribbles meant to look like Hebrew, a nice attempt at authenticity. Tiny John looks strong, upright, and single-minded, as he should. He will become a holy man and a prophet, will drink no strong drink, will head for the desert while still young wearing nothing but a shaggy camel skin, and will live on honey and locusts. Did he really eat bugs? There is disagreement on this issue. Some say

he ate locusts and some say he ate the pods of the locust tree, which in parts of the Mediterranean world are called Saint John's bread.

In some legends of the Flight into Egypt, the Holy Family meets up with young John and his parents on their return. This is why certain paintings of the Madonna show her outdoors with two baby boys, one the child Jesus and the other little John, who is already dressing his part and has a delightfully scruffy appearance. One of John's attributes is the lamb, because later he called Jesus the "lamb of God who takes away the sins of the world." Polidoro Lanzani has sent the boy tottering headlong toward Jesus and Mary, lugging a patient lamb like a captured puppy. As a grown man, John will carry a tall, slender reed stick with a crossbar lashed to it near the top. Its ascetic and rustic elegance suit him perfectly.

John's message to all was, "Repent!" He said it to every sinner he met, including King Herod. Herod had taken his half-brother's wife, and John rebuked him for it. The woman, known as Herodias, was incensed. She demanded that her husband imprison John. When her daughter, Salome, danced for Herod, he was so taken with the girl that he promised her anything she wanted. Coached by her mother, Salome asked for the head of John the Baptist on a charger. Asking for the man's head is bad enough, but the platter adds a cynical attention to detail that is quite revolting.

With perfect economy, Gozzoli shows the dance, the beheading, and the delivery of the severed head at one time and almost in one room (page 114). We don't know exactly what constituted lascivious dancing in the fifteenth century, but this could not be it. Perhaps Gozzoli thought such propriety was called for in

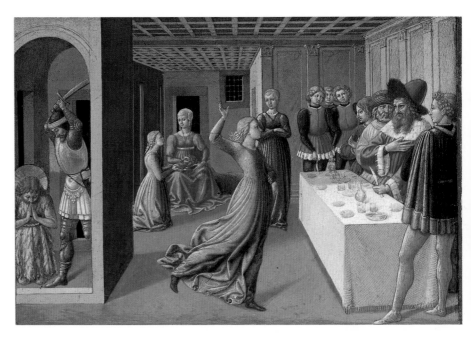

a painting meant to edify. In earlier, medieval art Salome seems often to be performing contortions, backflips, or handstands rather than dancing.

It is interesting to note that John's halo has not accompanied his head. Sometimes halos do that and sometimes they remain attached to the body, giving it the look of a blank, round hand mirror. As we have said, saint stories are not for the faint of heart.

MARY MAGDALEN
ↄ

Mary Magdalen did not exist, so it was absolutely necessary to invent her. A compelling personality who seems perfectly to fill a void in the Christian story, she is a composite of more than one New Testament woman, whose legend was further embellished during the Middle Ages.

As the legend has it, Mary of Magdala was a prostitute, reformed and transformed by her encounter with Jesus. She sat at his feet, rapt in his words, as extravagant in her new spirituality as she had been in her former sensual life. (Her sister, Martha, was busy at this time fixing dinner, a fact Martha resented, but Jesus insisted that Mary's spiritual work was just as important.) Later Mary washed Christ's feet with her tears, dried them with her hair, and anointed them with fabulously expensive ointment—for which Judas wanted Jesus to rebuke her, on the grounds that the money could have been used to help the poor.

In paintings of the Crucifixion, Mary Magdalen weeps passionately, sometimes

Master of the Lehman Crucifixion. Noli Me Tangere *(pinnacle of an altarpiece). First half of the 14th century. Wood, painted area 21 ¾ x 14 ⅞". By courtesy of the Trustees, The National Gallery, London*

Pistoiese Master.
Mary Magdalen.
Late 14th century. Fresco.
San Domenico, Pistoia

Me Not"), is an often-painted moment. Jesus probably could not be touched because he was not an ordinary physical being, though there is not much agreement on this issue among biblical scholars. The golden sky and radiant color and the enormous stature of the figures in the odd landscape create an ethereal atmosphere appropriate to the encounter.

Later, Mary Magdalen left for the wilderness and became a hermit. She went naked, but her long hair covered her. In some accounts, beautiful hair miraculously grew all over her body. She owned nothing and survived solely on the bread that a raven—in some versions an angel—brought her each day.

Mary Magdalen has a strong and coherent personality. Her emotions are passionate, her gestures are large, her clothing is vivid, and her hair is long. A red dress and a pyx, a covered goblet-shaped vessel containing the precious salve, will almost always identify her. Her directness and her potent spontaneity strike a sympathetic chord for many women today.

lifting her hands to the sky, sometimes embracing the cross. Here we see her, on the first to visit Christ's tomb, just as she realizes that the man she thought was the gardener is the risen Christ (page 115). The hoe he carries refers to this, though it is understood that he did not really carry a hoe. She rushes toward him and falls to her knees. His response, remembered as *Noli Me Tangere* ("Touch

SAINT PETER
ↄ

Peter is the only saint who appears regularly in jokes—the ones about "getting into Heaven." This is because, as the acknowledged leader of the apostles, he was given by Christ the power to bind and to loose, to condemn and forgive. His attribute, a pair of keys, refers to this function. In jokes he is the keeper of the

golden gates. Outside of jokes, he is also the first pope, the "rock," from *petrus*, his name, on whom the church was founded. In his tireless preaching of the Gospel, Peter met with hardships and close calls. He was jailed in Jerusalem, but an angel came in the night and led him out, right past one sleeping guard after another.

We have already come to know Peter, with his curly gray hair and beard, and his emotional, impetuous nature. It was sometimes said that, at the Last Supper, Jesus refused to name the traitor, Judas, openly and directly because he knew Peter would have torn him to pieces on the spot. Because Peter wept so bitterly after having denied Christ, he is often painted in tears. But he is a powerful figure, able to cure the sick with only his

shadow and triumphant in a protracted contest with the leading sorcerer of his day—and close friend of the Emperor Nero—Simon Magus.

This Simon once offered Peter money for the secrets of his power (thus the term "simony"). Simon was no petty magician; he could cause statues to laugh and dogs to sing, and he could fly. But Peter's power came from God and Simon's from Satan. In a showdown in Rome, Simon sailed high above the city, but Peter knelt and prayed that the invisible demons holding him aloft would let go. They did, and Simon fell to his death.

Peter is often pictured with Paul, his close friend. Together they came to represent the two branches of Christendom, the Jewish and the Gentile, be-

Masaccio. Crucifixion of Saint Peter, *from the predella of the polyptych for Santa Maria del Carmine, Pisa. 1426. Oil on poplar panel, 8 ¼ x 12". Picture Gallery, Dahlem Museum, Berlin*

cause, though both were born Jewish, Paul preached to the Gentiles after his conversion. It is said that they were martyred on the same day. Paul, as a Roman citizen, was beheaded, but Peter, since he was not, was crucified. He requested that his cross be turned head downward, because he felt unworthy to die in the same way as his master. Thus his halo is one of the few ever to lie flat on the ground.

SAINT LUKE, THE PAINTER

How do we know what Jesus looked like, or Mary? Of course we don't know, and there has never been any agreement even among those who thought they did know. One early apocryphal writer maintained that Jesus was small and misshapen, an idea that was completely ignored. But, as we have seen, the legend of Veronica was meant to answer this question where Jesus was concerned. The appearance of Mary is likewise supposed to have been recorded. The artist was Luke, the Evangelist who was also a physician. Some say that Luke painted the Virgin's likeness during her lifetime, and some that she came to him in a vision and in this way sat—or floated—for her portrait. The legend is Greek in origin but there are some churches in Rome that boast icon-like paintings of Mary said to have been painted by Luke himself.

In this German woodcut, Luke's ox reclines with the self-satisfied uselessness of any household pet while an apprentice grinds colors and Luke concentrates on his painting. The Virgin's apparition seems to be suspended just outside the window, though the space in the composition is somewhat puzzling. We are sure Luke can see her, but not so sure how. Drapery is often used to convey a feeling of energy and busyness, as the rearing hem of Luke's robe does so nicely here.

Unknown German artist. Saint Luke Painting the Virgin, *from* The Golden Legend, *Anton Koberger Publ., 1488. Woodcut, 3 ½ x 7 ⅛". The Metropolitan Museum of Art, New York. Harris Brisbane Dick Fund, 1928*

Altichiero da Zevio.
Saint George Liberates
the Princess. *1370.*
Fresco. San Zeno, Verona

SAINT GEORGE, THE DRAGON, AND THE PRINCESS

ᔆ

According to the usual pattern, a fable is followed by a moral, or a story is told first and later amplified with allegorical significance. Saint George's case developed the other way around. His tale began as a symbol. The historical George converted the heathens in the area of Cappadocia to Christianity. In the early Greek church he was therefore depicted as a hero defeating paganism, which was represented by a dragon, while Cappadocia, personified—as places often were—by a woman, looked on. Time passed and the significance of the symbol was lost. Churchgoers gazed at the image but no longer understood it, so they made something up.

Once there was a hideous dragon that lived at the bottom of a deep lake beside the town of Trebizond. This monster would prowl about the city walls at will, killing anyone who came near with its poisonous breath. To keep it from destroying the whole town, the dragon was

offered two sheep every day. Soon there were so few sheep that it was given one sheep and one human being a day. Each day a youth or a maiden was chosen by lot and made a sacrifice to the dragon. Finally the lot fell to the king's daughter. She accepted her fate and walked resignedly to the edge of town. On that very day, George happened to be riding by. He found her in tears and insisted that she tell him her plight. She did, and then begged him to leave before he too became dragon fodder. George did not hesitate. He armed himself with the sign of the cross, went forward to find the dragon, and stabbed it in the throat, killing it.

In another version of the story, he merely wounded the dragon and cried to the princess to throw her girdle around the creature's neck. As soon as she did, it rose and followed her like a dog on a leash. George later killed the monster, but not until he and the princess had pa-

raded it through the streets and converted the whole city to Christianity.

It is this more magical and less physical feat that we see in the fresco attributed to Altichiero. George directs his lance with little effort and looks to the princess for approval. She admires the blue and beautifully mottled horse. The dragon coils its tail around the horse's hind leg in a slow and decorous dance. Dress and cape linings of fur pelts, dragon scales and wings, even the horse's tail—all have the quiet, absorbing authority of careful design. The dragon leash is a mere filament, but it will prove strong enough.

COSMAS AND DAMIAN, THE DOCTOR TWINS

cx

Cosmas and Damian were highly skilled physicians who never refused treatment to anyone, including animals, and always refused payment. They were, in fact, distinguished by the honorable Greek title—rare even then in their profession—of *anargyres,* moneyless. The emperor imprisoned them for their Christian beliefs and finally had them martyred, but not without some false starts. They were thrown into the ocean, from which an angel fished them out, then into a fire, which would not burn them; they were stoned, but not one stone hit its mark, and many fell back on the tormentors, causing injury, death, and great confusion. The last resort was beheading, which almost always works, as it did this time (though another pair

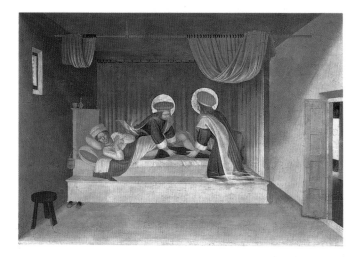

Fra Angelico. Saints Cosmas and Damian Healing the Deacon Justinian, *from the predella of the* San Marco Altarpiece. *c. 1440. Panel, 14 ½ x 17 ¾ ". Museo di San Marco, Florence*

of twin saints, Felix and Regula of Zurich, simply picked up their severed heads, which continued to praise God, and walked away).

In paintings, Cosmas and Damian often wear the red robes and caps of physicians and hold surgical instruments, ointment boxes, or a mortar and pestle. In Florence they became patrons of the Medici family, partly because of the pun on the name Medici, Italian for "doctor," and their image is often encountered in the art of that city.

Here the twin doctors perform their most spectacular operation, especially considering the fact that they are working posthumously. They come in the night to a man with a cancerous leg and replace it with the leg of a Moor who had died earlier that day. Unlike our modern transplants, however, this one goes both ways. They anoint the sick leg and join it to the body of the dead Moor as well, presumably so that he will not be inconvenienced on the day of Resurrection. Note that the saints have no feet, and their lower bodies taper off into wispy clouds. This is because they are appearing miraculously after their deaths and not as ordinary physical beings.

SAINT SEBASTIAN
❧

Sebastian was an officer of the Pretorian Guard at the time of the Emperor

The Master of the Playing Cards. Martyrdom of Saint Sebastian. c. 1440–55. Engraving. The Metropolitan Museum of Art, New York. Harris Brisbane Dick Fund, 1934

Diocletian. When it was discovered that Sebastian was a Christian, executioners of the emperor shot him with arrows until he was presumed dead. But a woman named Irene, realizing that Sebastian was alive, took him home and nursed him back to health. He was finally beaten to death because he refused to remain quiet about his faith. Though his story is starkly simple, Sebastian is one of the saints most often painted, partly because artists welcomed the opportunity to depict a standing male nude.

An ancient belief held that disease was caused by the arrows of Apollo, and this association caused Sebastian to be called upon in the fourth century as a protector against the plague. In this role he is often grouped with Saint Roch, a self-sacrificing itinerant healer who finally died of plague himself, and the physicians Cosmas and Damian.

SAINT ANTHONY
OF THE DESERT

cs

In the painting by the Sienese master Sassetta, two soul mates meet after a lifetime of trying to do the same thing: to live the almost impossible life of a religious hermit, eating little, owning almost nothing, communing only with God. Anthony, in his nineties, learned in a vision that he was not the only hermit. Another, Paul of Thebes, could be found

in a cave with a spring of water outside its door. Knowing nothing more, Anthony set forth to find Paul.

To portray time, all you need is space. The journey has been a long one. It began in the upper left corner of the painting. First, Anthony hiked through the dark wilderness behind the mountain. It was cold as well as dark; he put on his extra cloak and discarded the hobo-style stick he had used to carry it.

Barefoot, he walked the stony road that leaves the picture on the right and then returns—who knows how many miles later. A centaur—the kind of creature one encounters at the ends of the Earth—offers dates from a palm branch and gives directions to the hermit's cave. The centaur has been civilized by Paul's influence. Anthony must be getting close.

Finally, the journey ends. The old saints drop their crutches. Anthony's bald head rests on Paul's shoulder. Feet and halos overlap in the saints' exhausted, relieved embrace.

The work by Velázquez was painted about two hundred years later, but the story picks up right where Sassetta left off. The raven must have seen Anthony approaching. Today it has brought a full loaf of bread for Saint Paul and his guest instead of the usual half. Here the scenes in the background depict both the past and the future. Anthony meets the direction-giving centaur on a distant hillside, but closer, in the valley, Paul is dying while Anthony prays beside him. Lions dig the grave because Anthony is too old and weak to do it himself.

SAINT JEROME AND THE LION

cx/cy

Jerome, the most learned of the saints, translated the Old and New Testaments into Latin. Being highly literate, he wrote letters, and as a result quite a bit is known about him as a historical figure. This did not inhibit the growth of legends, however, and one of the best of them is the story of Jerome and the lion.

One day, a roaring lion entered Jerome's monastery. The monks fled in terror but Jerome insisted they screw up their courage and help him welcome the lion as a guest. Before long Jerome ascertained that the beast was roaring in pain. He discovered a thorn in his paw, removed it, and he and the lion became friends for life.

The now utterly gentle lion was given the job of guarding the donkey that hauled firewood for the monastery. But it happened one afternoon that the lion dozed off and the donkey was stolen. The poor lion searched everywhere for his companion but at nightfall he had to return to the monks, hanging his head in guilt. "No dinner for you," they said. "You've had a whole donkey today." And they made the lion do the job of carrying firewood. In the end, the lion finally encountered the robbers with the donkey, chased them to the monastery, and was vindicated.

Once again, a symbol was probably the seed of this story. In early representations of Saint Jerome a lion often accompanied him, not as a companion but as a

symbol of his fearlessness, strength, and noble character.

Jerome is almost always painted as an old man with a very long beard and the wide red hat of a cardinal, The hat is an anachronism, because the office of cardinal was not instituted until about three hundred years after Jerome's death. The cluttered study where Colantonio has put him contains more anachronisms, but it is a beautiful jumble of still lifes evoking Jerome's scholarly

Diego Velázquez.
Saint Anthony Abbot
and Saint Paul the
Hermit. *c. 1634.*
*Oil on canvas, 8'5 ⅛" x
6'2". The Prado, Madrid*

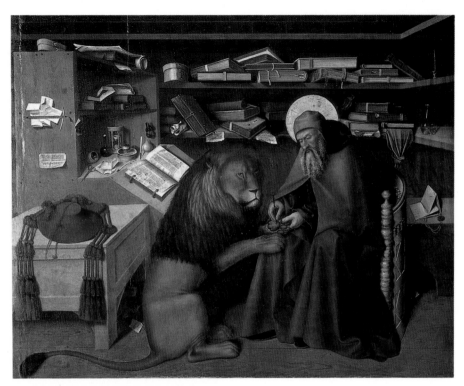

existence: plain board shelves, a desk
knocked together with nails, books full
of improvised bookmarks, writing im-
plements, scraps of paper, and little notes
to himself tacked up here and there.
The lion, for once, is almost in scale.
Most of Jerome's lions are the size of
cocker spaniels.

Like all saints, Jerome was acutely
aware of his own sinfulness. A sin that
grieved him fiercely was his preference
for the literary style of the classics over
that of the holy Scriptures. He dreamed
once that he went before the great Judge
on the final day and was accused of being
a Ciceronian, not a Christian. It was nei-

ther the first nor the last time that taste
and piety have come into conflict.

Self-torture is one of the aspects of
sainthood and the ascetic life that
many of us would rather forget. It's not
healthy! we think, but it wasn't meant
to be healthy. It was meant to punish
the body for its evil inclinations and to
drive those inclinations away. To pur-
sue physical health and long life was be-
side the point and would put your soul
at risk. It would be a great distortion if
we were to imagine only the attractive,
"healthy" aspects of the lives of saints
like Jerome and Francis while ignoring
their self-imposed discomfort, self-in-

flicted pain, and deliberate food and sleep deprivation.

Saint Jerome spent four years in the desert. His home, he said in a letter, was a "recess among rocks and precipices," and his only companions were "scorpions and wild beasts." He was haunted by demons and temptations, but also consoled by heavenly visions. For penance he beat his chest, though not with a rock—artists almost always add the rock, as if Jerome had not gone far enough. Jerome's lion watches all this with an expression that says he really wishes the saint would stop. There is a tradition that tells of the lion weeping to see Jerome use himself so cruelly, but this lion is too stoic for that.

THE TEMPTATION OF SAINTS

How could these monsters be tempting Saint Anthony (page 126)? Surely they are pestering, annoying, frightening the wits out of him, but tempting? Again the problem is merely verbal. The noun *temptation* once had the meaning, now obsolete, of a proving, a test, or a trial. Like many saints who subjected themselves to solitary asceticism and long periods of fasting, Anthony was beset by demons and monsters, what we might call hallucinations.

Both Jerome and Anthony were visited by great temptations, and they were often painted in the presence of their tormentors. Anthony's demons did more

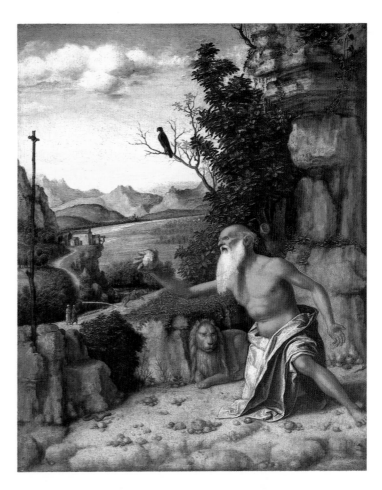

than distract and demoralize him, they attacked and bit him and bore him aloft, all at the same time. Sometimes he was left lying on the ground, half dead from their tortures. Once, some well-meaning passersby found him in such a state and carried him home to nurse him. But as soon as Anthony awoke from his swoon he demanded to be taken back to his cell so that he could resume the struggle.

Cima da Conegliano. Saint Jerome in a Landscape. c. 1500–1510. Paint on wood, 12 ⅝ x 10 ⅛". By courtesy of the Trustees, The National Gallery, London

Saints were tempted in the more familiar sense as well. Sometimes Satan put gold or silver treasure in their paths, or set huge banquet tables in their cells, or sent beautiful women to entice them to sinful thoughts. Both Anthony and Jerome prayed through it all and never failed to overcome their baser instincts. For this reason Anthony is often accompanied by a pig, representing the kind of impulses he had conquered.

Patinir's demons neither scream nor grimace. Their eerie patience and quiet persistence are more terrifying than violent behavior would be. Anthony turns away from them, but we cannot. The special power of these beings is that they are so fascinating to look at.

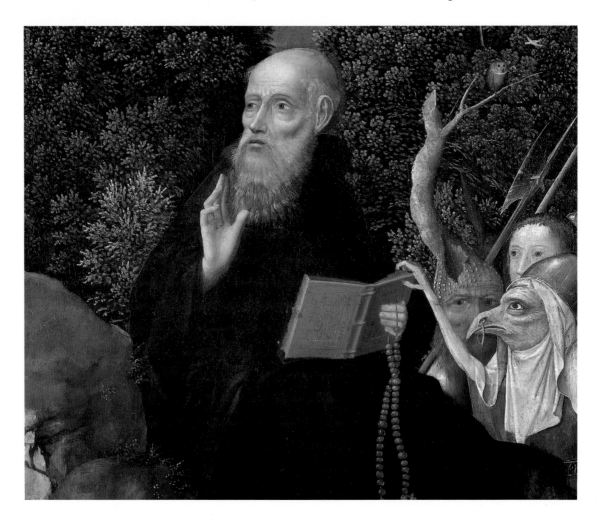

SAINT FRANCIS TAKES
HIS CLOTHES OFF

Like Anthony the hermit and Jerome,
Francis of Assisi also sought physical suf-
fering and practiced harsh penances. It
once happened that while he was at
prayer he heard a voice advising him that
it would be a great sin for one to go too
far with these mortifications of the flesh
and accidentally kill oneself. But Francis
was not fooled. He knew it was the En-
emy speaking, trying to "lead him into
lukewarmness." Late in his life, Francis
asked the pardon of his poor "brother
body" for all the trouble he had caused it,
suggesting that he did not lack all sense
of proportion about these things. Of all
the hardships Francis embraced, his fa-
vorite was "Lady Poverty," whom he said
he had taken as his wife.

Francis did not begin in poverty. He
was the son of a prosperous merchant and
somewhat given to elegance himself. One
day, as he prayed in an old, rundown
church, he heard the voice of Christ
speaking to him from the cross, asking
that he save the building from ruin.
Francis immediately sold some of his
father's merchandise and rushed to the
priest with the money.

His father was furious. As the two
argued in the presence of the bishop,
Francis realized that his inheritance was
not his to use as he believed he should.
He renounced it, right down to the
clothes on his back which, it was now
clear to him, really belonged to his fa-
ther. In Sassetta's scene, he has pulled

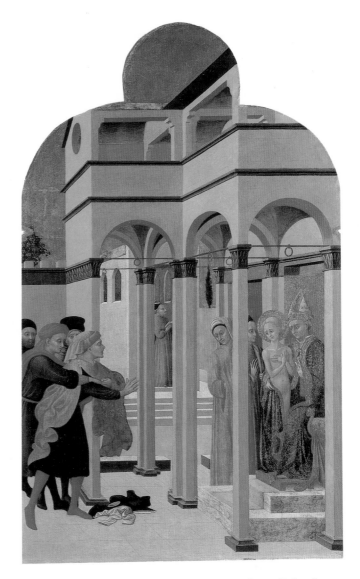

*Sassetta (Stefano di
Giovanni).* Saint Francis
Renounces His Earthly
Father, *from the back of
the* Sansepolcro
Altarpiece. *1437–44.
Panel, 34 ½ x 20 ¾".
By courtesy of the
Trustees, The National
Gallery, London*

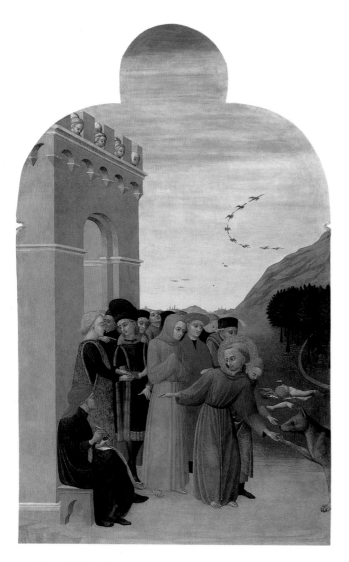

them off and dropped them to the ground. Francis's father is truly livid, having to be restrained by onlookers. Francis takes shelter in the robes of the bishop, and his life of poverty has begun.

The bishop's clothing is richer than the father's, but he is not a monk, as Francis soon will be. Perhaps the most interesting features of the bishop's vestments are his stigmata gloves, embroidered with colorful disks, representing the wounds of Christ, on the palms. It is possible Sassetta meant to remind us that eventually Francis's actual flesh would, through a miracle, be marked with the stigmata, and to emphasize the contrast between the life of a saint and an ordinary human. Once again, this detail cannot be seen in a small reproduction. That will require standing in front of the original in London.

SAINT FRANCIS AND THE WOLF
ঝ

Yes, the wolf and Saint Francis are shaking hands. From now on, the wolf will refrain from eating citizens of Gubbio as long as the city will put out a nice plate of meat for him every day, at its own expense. As his gesture suggests, Saint Francis arbitrated this deal, an enlightened political compromise with nature that conveys more than sentimental wisdom to us in the twentieth century.

The city's men are witness to the truce. The women watch from the safety of the town wall's battlements, though

Sassetta (Stefano di Giovanni). Saint Francis and the Wolf of Gubbio, *from the back of the* Sansepolcro Altarpiece. *1437–44. Panel, 34 ⅝ x 20 ½". By courtesy of the Trustees, The National Gallery, London*

they appear no more delicate than the men do. The notary is still writing out the agreement; it is quite a document, long on "fine print" so to speak.

If it is possible to read the facial expressions of wolves, this one looks repentant but by no means harmless. A trace of blood at his mouth, and a concentrated, almost desperate stare in his downcast eyes suggest that the wolf really cannot help himself, and that the thought of eating even Saint Francis may not be far from his thoughts. Perhaps he is as dubious as the humans about whether this arrangement can last. Bones and body parts still litter the landscape, but the geese loop around in the sky as if to signal a radical change of direction in the world.

SAINT FRANCIS AND THE STIGMATA

While in retreat in the mountains, Saint Francis had a vision of a seraph-like man in the shape of a cross. As he beheld the vision, his feet, hands, and right side were pierced with the wounds of Christ. Although Francis did not say the vision was of Christ himself, most artists have interpreted it that way. He bore the scars for the remaining two years of his life. The other saint who is depicted in the act of receiving the stigmata is Saint Catherine of Siena, though her experience was different in that she felt the wounds but they left no mark. She is said to have asked that they be invisible so as not to cause a sensation.

Giotto. Saint Francis Receiving the Stigmata. *c. 1320. Tempera on panel, 11' 1⅝" x 5'3 ¾". Musée du Louvre, Paris*

Below the main picture in this altarpiece is the predella, made up of a row of scenes from the life of Francis. They read left to right, as do comic strips today, but this was not invariably the case when narrative pictures in boxes first appeared.

On the left, Pope Innocent III is having a dream. Francis has traveled to Rome to ask for official sanction for his religious order, the Franciscans, and to receive permission to preach. The pope is persuaded by the dream in which his church, Saint John in Lateran, begins to list seriously and is about to topple when Francis appears and holds it up. (The pope is also said to have had this dream about Francis's contemporary, Saint Dominic, when *he* went to Rome to ask the same sanction for his order, the Dominicans.)

In the center panel the pope receives Francis and the other Franciscans. On the right, in one of the most famous events in the saint's life, Francis is preaching to the birds. Birds, and other animals, including insects, listened attentively to Francis whenever he addressed them. Some say that, at the end of this sermon, the birds took flight and formed a cross in the sky.

SAINT CHRISTOPHER
AND THE BABY
ఆ

Saint Christopher is a type known to us in popular literature, the giant who is a bit low on brain power. Happily, a high IQ is not required for sainthood. Christopher is almost the L'il Abner of the saints.

Christopher wanted to serve the world's greatest ruler. He thought he had found such a master, but this king showed tremendous fear of the devil. So Christopher went to work for Satan. Then one day he saw his new master cringe at the sign of the cross, and thus Christopher became a Christian. An appropriate job was hard to find in his new life. As a monk he was hopeless, incapable of fasting and unable to recite prayers because he became confused and could not remember the words.

Finally, a bishop suggested that Christopher ferry people across a fast-flowing river where many travelers had drowned. There was no need for a boat, since Christopher could simply pick his customers up and wade to the other side. He pulled a palm tree up by its roots, made it into a staff, and began his new job.

One day a small child asked to be taken across the river. Christopher swung him up onto his shoulder and stepped into the water. The weight of the child became almost unbearable. It was all Christopher could do to stay upright through the current, slog up the opposite bank, and lower the child to the ground. It was, of course, the Christ Child, who carries the weight of the world on *his* shoulders. After the child vanished, Christopher planted his staff in the ground and it burst into bloom.

Christopher became the patron saint of travelers. His image is usually very large, often reaching the height of a church wall. This is partly because he was a giant. It is also because even a glimpse of

Saint Christopher will keep one safe all day, and an enormous image is likely to be glimpsed.

The Christopher who appears at the opening of this chapter is so big and strong he wears a millstone as a bracelet and carries two extra passengers across the fishy stream by tucking them under his belt (page 110). The Christ Child on his shoulders holds a globe in his hand. This is not an early depiction of Earth as a sphere. With ingenious economy it invokes the first three days of Creation: the separation of light from darkness, Heaven from Earth, and the water from the dry land.

Many early altarpieces combine a large image of a saint with episodic narratives, either from the saint's life or, as in this case, from the lives of various saints. In this one appear some heavenly beings with monastic tonsure, a rare instance of bald angels.

SAINT MARGARET AND THE DRAGON
℮

Margaret is one of the legendary virgin martyrs, of whom there are many. Virginity was more than just abstinence from sex; it had a positive value and a certain power in the Christian imagination, in men as well as women. Now and then couples were said to have agreed to chaste marriages, right from the start. An unsettling idea to us, it was considered not only virtuous but reasonable.

Margaret had her heart set on being a Christian virgin, but the prefect of Antioch wanted to marry her. When she refused, he tortured her and threw her in a dungeon. There, Satan appeared in the form of a dragon and swallowed her. She produced her cross and the dragon burst open. She was finally martyred, but just before her beheading, Margaret prayed that she be given power to aid women in childbirth, making their births as easy as her delivery from the dragon had been. Her wish was granted, and she became the patron saint of women in labor.

That is one version of her story. There is another that rivals most opera plots for strangeness. In this story Margaret realizes in the middle of her wedding celebration that she really wants to remain a Christian virgin. She disappears, cuts off her hair, dresses as a man, escapes into the night, and presents herself at a monastery. After spending years as an exemplary monk known as Pelagius, she is appointed head of a convent. When one of her nuns becomes pregnant, Pelagius is accused, and this is how she ends up in jail. She is vindicated, but not until after her death.

Raphael's dragon undulates beneath and around Margaret like a whirlpool, performing the role often played in painting by swirling drapery. Three women in Christian art appear with dragons, but the confusion they cause is easy to clear up. Margaret may have a dragon on a leash, but if Saint George is not in sight, you will know she is not the princess he saved. Martha, the hardworking housekeeper and sister of Mary Magdalen, is said to have traveled to France after Christ's Resurrection, where she sprinkled a troublesome dragon with holy water, causing its death. If Martha appears with a dragon, she will have an aspergillum in her hand.

Raphael. Saint Margaret. *Early-16th century. Oil on canvas, 75 ⅝ x 48". Kunsthistorisches Museum, Vienna*

Vittore Carpaccio.
The Dream of Saint
Ursula. *1495.*
Oil on canvas, 9' x 8'9".
Galleria dell'Accademia,
Venice

URSULA AND THE ELEVEN THOUSAND VIRGINS

cⁿɔ

Ursula, a Christian princess of Brittany who had vowed to remain a virgin, was incredibly beautiful and learned. She had learned all of history "by heart," knew the winds, the stars, and, especially, theology. Naturally, her reputation spread. A pagan prince of England wanted to marry her.

She told his ambassadors that she was willing if he agreed to three requests: he must give her three years for the visiting of holy shrines; he must provide her with ten virgin traveling companions and, for each of them and herself, a thousand more virgins apiece; and he must become a Christian. The English prince had never seen her, but he thought this was not too much to ask. The story is a long one but before it is over this cast of thousands—

apt expression, for once—goes to Rome, the virgins sailing the ships themselves, and then to Cologne where they are, every one of them, martyred by the Huns.

There is some evidence of a group of young women having been martyred at Cologne. The "rational" explanations that have been put forward to explain the multiplication of their numbers are as curious and folkloric as the legend itself. One chronicler thinks that XI. M. V. on a cemetery monument in that city was misunderstood to mean eleven thousand virgins instead of eleven martyred virgins. Another theory has it that one of the virgins was named Undecimilla, "Eleven Thousand," and this gave rise to the confusion.

Ursula was an extremely popular saint, and her story appears often in painting, primarily in the form of arrivals, departures, and crowd scenes, as one might im-

agine. Sometimes she is shown sheltering her companions under her cloak in the same fashion as the Madonna Misericordia. On page 133 is another often-painted moment in her saga, the simplest one of all: Ursula's dream, or vision (there is seldom much distinction made between the two in saints' stories). Her little dog has already sensed the arrival of the angel who will foretell Ursula's fate and offer her the palm of martyrdom. Ursula is still asleep, but the dog sits upright as if to say, What's that?

SAINT LUCY
❦

Lucy, a beautiful maiden of Syracuse, also wished to remain a virgin, but she was already betrothed to a wealthy, greedy young pagan. When Lucy's prayers caused her widowed mother to be healed of an ailment, she took the opportunity to suggest that they sell all of their goods and give the money to the poor. After some persuading, the mother agreed. The fiancé became alarmed by what he saw happening, but a clever servant put him off the track by saying that Lucy had decided to buy a valuable new property and was raising capital for the purchase. Thinking he would be enriched, he watched while all of Lucy's wealth disappeared.

When the young man discovered what Lucy had done, he brought her before the governor, an evil pagan, who began to persecute her for her Christian beliefs. She was quite unmoved by his threats, so he ordered that she be thrown

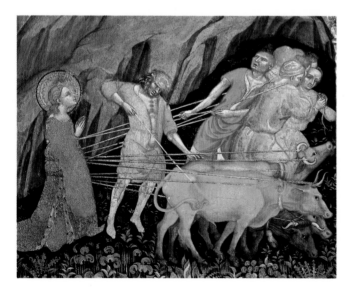

Jacobello del Fiore. Saint Lucy Resisting Efforts to Move Her. Early 15th century. Tempera on wood. Pinacoteca Civica, Fermo

into a brothel. At this Lucy was literally unmoved. She had become miraculously heavy. Strong men tried to carry her off, oxen were tied to her, but she would not budge. Finally she was stabbed in the neck and killed.

Lucy is often shown holding a pair of eyes, her rather disturbing attribute. Her name comes from the Latin word for "light," and the eyes were originally a symbolic way to convey her identity. But not everyone understood this symbolism. The story grew up that she had been so relentlessly pursued by a lover who claimed to be tormented by the beauty of her eyes that she cut them out and sent them to him. He, of course, repented and became a devout Christian. Lucy got her eyes back through another miracle, and they were even more beautiful than before.

SAINT NICHOLAS OF BARI

Throughout Europe and the East, particularly in Greece and Russia, Nicholas has long been one of the most beloved of all the saints. As Santa Claus, the Americanization of the Dutch dialect *Sinte Klaas*, he has also found his way into popular culture, bringing with him certain vestigial traces of his origin. Among these are thought to be his hat, an evolved (or devolved) form of the bishop's miter, and his love of regaling the young with presents, since Nicholas is the patron saint of children.

Carlo Crivelli.
Saint Lucy, *from the* Demidoff Altarpiece. *c. 1476. Tempera on wood, 35 ⅞" x 10 ½". By courtesy of the Trustees, The National Gallery, London*

· 135 ·

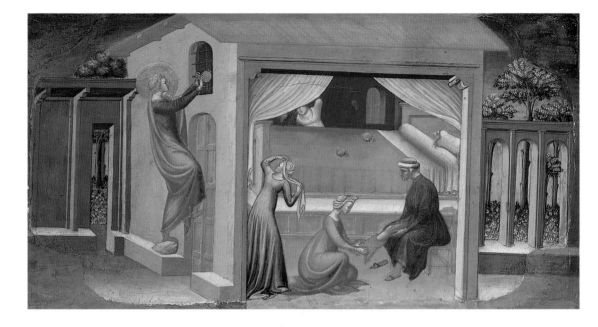

Bicci di Lorenzo. Saint Nicholas Providing Dowries, *from the predella of an altarpiece. 1433–35. Tempera on wood, 12 x 22 ¼". The Metropolitan Museum of Art, New York. Gift of Courdet Brothers, 1888*

Nicholas was the Bishop of Myrna in Asia Minor. Why then is he called Nicholas of Bari? Not because he ever lived there but because he is now dead there. Citizens of Bari in Italy piously and patriotically stole the body and took it to their hometown. (It was further claimed by some Venetians that the body was stolen again and removed to their city. So, for all we know he might be Nicholas of Venice.)

From the day of his birth it was clear that Nicholas was destined for the religious life. He rose in his bath basin and lifted his hands in prayer. On fast days he refused his mother's breast. He was orphaned as a young man, and he set about using his inherited wealth to help others.

A noble citizen of Myrna, a widower with three daughters, had been reduced to extreme poverty. Without money for dowries there was no hope of marriage for the young women, and without marriage they would starve. The only profession open to them was prostitution, which the old man had begun to think must be their fate. But young Nicholas heard of their terrible circumstances and came in the night with a bag (or a ball) of gold for each daughter. He spotted a transom over the doorway, dropped the gold through it, and fled in order to protect his anonymity. Three marriages followed soon thereafter and all lived happily in the manner to which they should have been accustomed. There may be a survival of this nocturnal delivery in the toys that come down our chimneys on Christmas Eve, but this is merely speculation.

The cutaway side of the little house painted by Bicci di Lorenzo is framed like a stage, with the bed curtains completing the effect. The daughters are obviously good girls, dressed modestly but well, living in an orderly house that has room for nothing but a bed. One helps her father with his hose while the other two unwind their turban-like headdresses. The daughter in green has just noticed what is happening. Nicholas may be in his stocking feet, which would certainly help him come and go silently. The palpable moonlight and the impression of quiet are achieved in ways hard to pinpoint. The artist has convinced us that no one but Nicholas is out tonight.

Nicholas performed many miracles, often having to do with the number three. He saved three unjustly accused men, freed three innocent prisoners, and brought back to life three boys who had been killed and pickled by an innkeeper during a famine. Also during a famine, he multiplied a shipment of grain many times. Nicholas helped the helpless, the poor, the hungry, those in slavery, and sailors in stormy seas. He saved countless ships, both during his life and afterward.

NICHOLAS OF TOLENTINO REVIVES THE BIRDS

❧

This Nicholas was an Augustinian monk, a tireless worker and effective preacher. But he is best known for the many miracles that were attributed to him. The most unforgettable occurred when Nicholas was very sick. His brothers thought it best that he try to regain his strength, even if it meant departing for once from his strict vegetarian diet.

Benvenuto Tisi da Garofalo. Saint Nicholas of Tolentino Reviving the Birds. *c. 1530. Oil on canvas transferred from wood, 12 ⅞ x 26". The Metropolitan Museum of Art, New York. Gift of J. Pierpont Morgan, 1917*

They brought him a dish of roasted birds. Dismayed by the birds' demise, Nicholas blessed them and brought them back to life. In altarpieces, Nicholas of Tolentino appears in the black Augustinian habit, usually holding a crucifix entwined with lilies as well as a plate of birds in stages of unroasting, growing feathers, and flying away.

Nicholas's monastic brothers, the Augustinians, were named for Saint Augustine. Many orders were not just named for but founded by the person for whom they were named. Serious art students find it helpful to learn the orders and their outfits.

SAINT EUSTACE AND THE STAG

cx

Eustace was a long-suffering martyr whose faith, like Job's, was tested by many trials. His conversion took place when he was a virtuous, prosperous, and noble Roman named Placidus, an officer in Trajan's army. Placidus was a great lover of the chase. One day, while hunting with his soldiers, he spotted a beautiful stag in the distance. He left the others and chased it into the forest. The stag stopped on a hill above him, turned, and looked down upon Eustace. A radiant cross with the figure of Christ upon it

appeared between the creature's antlers. Then Jesus spoke (some say he spoke through the mouth of the stag), saying, "Why do you pursue me? I am Christ, whom you have served hitherto without knowing me." Placidus was converted, baptized, and renamed Eustace.

Then his troubles began, because the Devil was furious to have lost this noble and prestigious soul. Eustace was stripped of his fortune, his wife was taken by pirates, one son by a wolf and the other by a lion. He wandered the world, at one point reminding God that even Job had his own dunghill to sit on. Finally, fifteen years later, in a operatic quartet of recognition, all four were reunited, reinstated as respected citizens, and martyred as Christians. In saints' lives this constitutes a doubly happy ending. As the voice from the stag had foretold, Eustace was brought down from the "haughty vanity of the world, and lifted up again in the riches of the spirit."

Pisanello's huntsman hardly seems terrified by the vision before him. The horse is more startled than he is. The forest is a place of wonders, a decorative tapestry of beautiful creatures. But it is just this dark, quiet mysteriousness that causes us to start when we see the miraculous vision. The *cartellino* curling on the forest floor was probably meant to hold a motto, which for some reason was never painted in. It is hard to know whether words would have added or subtracted from the effect of this fantastic scene.

DISASTER UNDONE

Miracle paintings are instant happy endings. One no sooner comprehends the disaster than it is over, fixed, it never happened. A dog attacks a child. Another child falls from a balcony. The posthumous Saint Augustine hears the cries of the distraught mothers and

swoops down from Heaven to the rescue. Such stories are delightfully gratifying, and their treatment can provide masterful examples of wordless narrative clarity. In Simone Martini's panel, for example, we know that when Augustine arrived to soften the child's fall, he also made sure that the careening wooden balcony slat kept out of her way.

This Saint Augustine, incidentally, is known in Italian as Agostino Novello, to distinguish him from the more famous, earlier Saint Augustine. A jurist, papal legate, and brother of the Augustinian order, he retired to a monastery near Siena in 1300. After his death many miracles were ascribed to him.

THE "EX-VOTO"
ひ

When prayers are answered, people sometimes show their gratitude by creating a picture or donating an object to a church. These are *ex-votos* ("in accordance with a vow"). A pilgrimage church almost always contains an accumulation of *ex-votos*, reflecting all kinds of happy outcomes at all levels of artistic competence and sophistication. A museum attached to the church of Saint Anthony at Padua is a repository for votive objects and paintings that should not be missed by those who are interested in such things. Among the countless wedding bouquets and baby shoes are some very fine twentieth-century works of folk art. Many have a narrative power and simplicity reminiscent of Simone's.

A SACRED CONVERSATION
ひ

As we have said, a Sacred Conversation has nothing to do with talking. It means "sacred company," a holy group of persons (and, in this case, angels too.) Here the Madonna, with a rather halo-like roundel in the cloth of honor that forms her backdrop, sits in a kind of bower with the infant Jesus, Saint Catherine of Alexandria (receiving a ring from the baby Jesus), Saint Barbara, two angels, and a donor. The donor, in black, has modestly stayed in the background, but he is normal size. The age of tiny donors is past.

While the picture has nothing to do with talking, it does have to do with communing. The silent, spiritual interaction of the figures is almost palpable in their serene expressions, and, again, in the colors of their costumes, which seem to speak for them. This painting is an altarpiece, and is meant to aid contemplation and prayer, not to tell a story. Even so, one event is taking place, a highly important spiritual event in the life of Saint Catherine.

SAINT CATHERINE OF ALEXANDRIA
ひ

Saint Catherine was a princess. She was, of course, beautiful, but among the women saints Catherine is the one most famous for her intellect. When she was a child her father was so impressed with her intelligence that he surrounded her

with learned tutors, all of whom she soon began to teach. He provided her with a magnificent collection of books and mathematical and scientific instruments, all of which she put to good use. She was especially fond of the teachings of Socrates and Plato, which prepared her later to embrace a doctrine of higher purity.

When her father died, Catherine was advised to marry. She described the only husband she would settle for, someone of such great power, beauty, and benign goodness that her counselors despaired. A religious hermit soon appeared and gave Catherine a picture of the Virgin and the infant Jesus. She put the picture in her study and that night dreamed that she came before Mary and the child. But little Jesus turned away from her, saying she was not beautiful enough for him. She woke and wept until morning, and then called for the hermit. He converted her, and that night in her dream Jesus placed a wedding ring on her finger. She woke, and there was the ring.

Then *her* troubles began. Catherine was persecuted by the Emperor Maxentius, who lusted after her. He sent fifty scholars to argue with her and refute her beliefs. She converted them. He threw her in jail, where his wife visited her and was converted. Maxentius then devised an instrument made of spiked wheels with which to torture and kill her, but a thunderbolt cracked the wheels apart before they could do their work. Catherine was finally beheaded, but after her death angels put her back together and transported her body through the air to Mount Sinai, where a monastery was built in her name.

The allegory of the nuptial bond between Christ and Catherine has many precursors and echoes in the Christian tradition. The love poetry of the Song of Songs was given mystical interpretation by Jewish commentators long before Christianity. In mystical literature, the soul (as in many languages) is feminine and is cast as the beloved, while Christ, or God, is the lover or the bridegroom.

As a saint, Catherine was second only to Mary Magdalen in popularity. Her case is a particularly strange one in that the only historical basis for her story seems to be that of a young woman of Alexandria named Hypatia, a philosopher famous for her wisdom and great learning. But Hypatia was not a Christian. In fact, she is believed to have been murdered by a group of fanatical Christian monks in 415.

Catherine is always crowned, and her principal attribute is the broken wheel.

With it, the palm, the spear, and a book representing her intellectual powers, she sometimes has her hands full. In Memling's painting, the wheel and spear lie at her feet.

SAINT BARBARA

Barbara is the Rapunzel of hagiography. Her father, Dioscorus, loved her with such possessiveness that he locked her in a tower to hide her beauty from the eyes of any young man who might wish to marry her. Then he went on a journey. In the tower, Barbara contemplated life, the world, and the stars in the sky; she came to the conclusion, entirely on her own, that the idols she had been taught to worship could not be true gods.

Somehow the fame of a certain sage reached her. This was the Christian thinker Origen. She wrote him a letter and he sent one of his disciples, disguised as a physician, to instruct her. Thus Barbara became a Christian.

Barbara's tower had two windows, but she ordered her father's builders to add a third, which was the first thing Dioscorus noticed when he returned from his trip. His daughter explained that the three windows represented the Father, the Son, and the Holy Ghost, which lighted her soul. All the man's love for his daughter turned to uncontrollable rage, and eventually Dioscorus beheaded her with his own hands. Within an instant of this murder, he was struck by lightning and consumed by fire. This

violent ending to the story caused Barbara to be associated with gunpowder and explosives, which will explain the otherwise puzzling cannon that sometimes appears at her feet. Usually she holds her three-windowed tower. In the painting by Memling, Barbara's tower makes a quiet appearance in the landscape behind her.

These two women, Barbara and Catherine, were seen as representatives of the two types of life, the active and the contemplative. Thus, in Memling's painting, a symbolic wholeness is achieved by the inclusion of both of them. Catherine was the patron of scholars and teachers and protector of universities, schools, and libraries. Barbara watched over knights, soldiers, armorers, and all those in danger of sudden and unexpected death.

THE FURTHER ABUSE OF THE SAINTS

Most of the works of art discussed in this chapter on saints have served a narrative function, but any visitor to a church or a museum will notice how often the Virgin and the saints just sit or stand there, doing nothing. As in a Sacred Conversation, they are devotional images, aids to prayer. Now, it is obvious that many people over the centuries made a habit of praying directly to these images. This is idolatry, plain and simple. The church has always tried to maintain a distinction between that which is represented and the representation, but not with complete success.

Especially once a miracle has occurred, it can be very hard to convince all believers that potency does not in some way reside in the statue or picture itself. Yet even the most blatant idolaters may have more self-awareness than we think. It has been reported that a certain tribal supplication, directed at a clay figure, ends with, "And if you don't, we'll show you the stick we made you with."

Even worse than idolatry was an unfortunate thing that happened to the saints as a result of confusing cure and cause. Toward the end of the Middle Ages, saints who were called upon to prevent or cure illnesses were sometimes blamed for actually causing them as well. If you displeased or neglected Saint Vitus, he might just give you Saint Vitus's dance. What a fate. Saint Vitus probably would have preferred another dousing in a cauldron of boiling oil to this.

KNOWING THE PLAYERS WITHOUT A PROGRAM

Thanks to their attributes, you now know each of the men and women in Lochner's lineups, originally from one altarpiece, now split up (pages 144–45). Barbara has her tower and the palm of martyrdom, Catherine her wheel and spear, the Evangelists have their creatures, and Luke his portrait of the Virgin as well. John is identified not just by his eagle, but also by his youthful,

clean-shaven face and his curly brown hair. The pen case hanging from his belt refers to his writing. He is not wearing red, but for identification purposes four signals ought to do the trick. The remaining puzzle might be that cup and snake and, of course, there is a story behind that.

Once a priest at a temple of Diana challenged John to drink a cup of poison, just to prove his God was powerful enough to save him. John agreed but suggested that two condemned prisoners drink from the cup first. They did and they died. (This seems very heartless of John, but he made everything come out

all right in the end.) John then drained the cup and, as a finale, brought the two prisoners back to life. The snake represents the poison. Eventually the cup came to symbolize the Eucharist as well, and the snake Satan, rendered harmless by the Blood of Christ.

The ground under these saints, hard-packed earth dotted with shadow-casting pebbles, is somewhat incongruous, given the fine robes and golden backdrop. But it keeps the saints literally down to earth, just as the bare feet of Matthew and John quietly assert their holiness.

ROME REVISED

The legacy of Greece and, especially, Rome was embraced with passion in the Renaissance, but as Saint Jerome's guilty love for Cicero demonstrated, the culture of the classical world had not been lost during the Middle Ages. After all, Latin was the international language of Europe, and the incessant copying of manuscripts that went on in monasteries ensured the survival of certain classical authors as well as Christian texts.

Some of these survivals would have been unrecognizable to the ancients. The Sibyls, for example—the priestesses of Apollo who were consulted as oracles—appear in Gothic cathedrals, foretelling, like Old Testament prophets, the coming of Christ. The exploits of historical figures like Alexander the Great blossomed into wild, fairy-tale adventures. And in a very influential book of the Middle Ages, the *Moralized Ovid,* the *Metamorphoses* were "explained" as Christian allegories. On the whole, medieval scholars thought of Greece and Rome as part of their own heritage, though the study of history as we now think of it, and the practice of archaeology, would not have their real beginnings until later.

Many Christian rites and ideas sprang originally from classical thought: the idea of a Heaven beyond the stars was Roman, Hell is an elaboration of the torturous region of Tantalus, and the idea of Purgatory—of the necessary purgation of the soul before it could achieve union with the divine—had origins in Stoic philosophy. The Christian sacred meal developed in part from the banquet that the Bacchantes shared with the gods, including the wine that ensured their immortality.

There were many visual survivals in the Middle Ages, among them Romanesque architecture, an outgrowth, as its name attests, of Roman styles. Both baptisteries and baptismal fonts took their octagonal shape from the octagonal baths of the Romans. The technique of continuous narration, in which the same figure appears more than once in a painting, was learned from Roman examples on sarcophagi and elsewhere. The figure of the winged Victory was adopted by early Christians as an angel and persists as the "standard" angel today: a long-haired female with large wings and classical drapery. Classical dress never died out in art, especially on the bodies of heavenly and allegorical figures. Cherubs, the flying babies that began to turn up in the Renaissance and multiplied prodigiously during the Baroque era, were classical *putti* brought back to life. Even Satan sometimes looks like a Satyr.

Of all the legacies of the classical tradition, none is more basic than the overwhelming importance of the human figure. The misty trees and craggy moun-

Piero della Francesca. Triumph of Duke Federico II. After 1474. Tempera and oil on panel, 18 x 13". Uffizi Gallery, Florence

tains of Chinese art are its nouns and verbs, just as men and women are ours. With the Renaissance this basic language was refreshed by the return of the classical love of health, physical vigor, and beauty. Humans continued to be persons with all-important souls, but their bodies, and now more often their naked bodies, were cause for celebration. The classical centrality of the figure itself, however, had been there all along.

WHAT IS A TRIUMPH?
ও

The idea of the triumph comes from ancient Rome, where victorious generals rode in grand processions through the streets, often passing through newly constructed triumphal arches built in their honor. (Jesus' humble entrance into Jerusalem may have been a conscious undercutting of the Roman triumph.) In Renaissance towns, triumphal processions were revived, sometimes in honor of persons, sometimes of abstract ideas like the liberal arts. The Renaissance poet Petrarch wrote allegorical descriptions of the triumphs of Love, Chastity, Death, Fame, Time, and Eternity, and these themes were painted often.

Most often in European art, a triumph involves something like a parade float. The triumph that heads this chapter is a good example. It is an allegorical glorification of the Duke of Urbino, who is riding along in a car pulled by white horses. He is accompanied by the cardinal virtues while being crowned by Vic-

tory, who stands on a globe, as Fortune often does, suggesting the precariousness of such states.

PHYLLIS AND ARISTOTLE
ও

The moral of this story, to put last things first, is, A Beautiful Woman Can Make Any Man into a Beast, only worse—a beast of burden. The assumption, of course, is that that is just what a beautiful woman likes to do. Aristotle, could he come back to us for a while, would probably be astounded to find that he was the brunt of this popular medieval tale.

Alexander the Great became so obsessed with his bride, Phyllis, that he lost all interest in ruling and conquering. (Sometimes she is his concubine, not his wife, and sometimes her name is Campaspe.) Aristotle, who had been Alexander's teacher, went to his former pupil and pleaded with him to return to his duties. Phyllis was furious. She seduced Aristotle and reduced him to the figure we see here, who has agreed to carry her on his back to prove his love for her. Alexander walked in on the two of them in his garden, and not by accident either. Phyllis had planned the whole thing. When the incredulous Alexander asked his teacher how this could possibly have happened, Aristotle arose and delivered a lame speech about teaching by bad example.

Since Alexander was *the* legendary superhero to the medievals—conqueror not

only of kingdoms but of gigantic ants, six-headed giants, and the famous dog-faced people—and since Aristotle was *the* great philosopher, the cautionary and comic value of the story was considerable. The Roman poet Virgil got similar treatment. A much-loved story told of his attempted nocturnal visit to a woman who had promised to haul him up to her window in a laundry basket. She left him in midair, where the town discovered him the next morning.

We can guess how most men regarded the image of Aristotle and Phyllis when it was popular, but we must wonder whether it made women feel more slandered or triumphant. It depended, no doubt, on the woman.

An aquamanile is a container for water. The spout on this one issues from Aristotle's neck. It is secular, but most aquamaniles that survive from the Middle Ages were used for the mass and take the form of horses, lions, or other noble creatures.

VENUS AND MARS
∾

Scholars in the Renaissance did not so much discover classical civilization as rediscover it with a new curiosity, a new appreciation of its inherent greatness, and a conviction that it was worth studying for its own sake. For a long time, however, they were to see Greece and Rome through late Roman eyes. Most of the art available to them was late Roman, and most of the classical writers

Mosan. Aquamanile in the Shape of Aristotle and Phyllis. *c. 1400. Bronze, height 13 ¼". The Metropolitan Museum of Art, New York. Robert Lehman Collection, 1975*

they rediscovered dated from late Roman times. Many of these later writers took a rather perverse pride in using outlandish metaphors with deliberately hidden meanings. Plotinus (who lived from 104 to 270 AD) was the most important of these thinkers, known as the Neoplatonists. The humanists of fifteenth-century Italy who enthusiastically delved into his thought are also, confusingly, called Neoplatonists.

Iconography became great sport in the Renaissance, a way to display one's learning and mental dexterity and sometimes a way to exclude those not in the know. But there was more behind it than intellectual vanity. On the positive side was the stimulating idea that life and art—especially art—can be "solved," that both present us with elaborate puzzles, the deciphering of which leads

to wisdom; not just cleverness, but wisdom. There was, in fact, a belief held among these enthusiasts that a secret, sacred knowledge was contained in the stories and writings of the past. Secrets known by Moses and Christ (deliberately left obscure in their teachings) were the same as the arcane secrets of the Greeks, Persians, and Egyptians. These universal mysteries could be uncovered by diligent, imaginative study. (Today, scholars employing a Jungian approach have a similar view, though their point of departure and their conclusions differ widely.)

The classical gods, incidentally, were known in Europe until fairly recently by their Roman rather than their Greek names (though there are cases where the Romans themselves retained the original Greek). We will follow the custom here, so as to be in agreement with the artists under discussion.

The Renaissance story of Venus and Mars is not so much a story as an idea. It springs from a view of the loves of the gods—and their resulting offspring—as metaphors for natural forces, for how the universe works.

Venus is love and beauty; she is also graciousness and amiability, unlike one of her offspring, Cupid, who represents the wilder and more thoughtless side of love. Mars, as the god of war, is vengeful and destructive. He represents strife and hate. But beauty/love cannot exist without its opposite, therefore Venus loves Mars. Further, the destructive impulse cannot have full reign without disastrous results. Mars must be tamed by

Venus. Through the union of these contraries a child is born: Harmony. It is not love that makes the world go round, but love in partnership with strife.

Renaissance artists reveled in the idea. Often the tamed Mars is depicted as a man exhausted by love, sleeping beside Venus, who is placid but awake. Veronese's Mars is a wonderful combination of powerful physique and gentle behavior. He draws a garment across Venus to protect her modesty, as he should. His hand may even be caught in its sleeve, as would be appropriate. The toddler Cupid ties the left legs of the lovers together, just as a busily playing human child might do, to keep a parent from leaving. The action works on both levels: the naturalistic and the symbolic.

The bridled horse, no doubt, is passion restrained, and the milk that squirts from Venus's breast suggests that she also represents *caritas*, Charity, and is an emblem for chastity transformed by love into kindness and generosity. More details abound that could support further speculation, and further wisdom.

AUGUSTUS AND THE SIBYL

There are anywhere from ten to twelve Sibyls, each named for her place of origin: the Libyan Sibyl is from Libya, the Persian Sibyl from Persia, and so on. Often they wear turbans, to indicate that they are pagans, but they also carry, in addition to books, very Christian attri-

butes, such as the crown of thorns or the lily of the Annunciation. As ancient prophets of the coming of Christ, they served as proof of the idea that God had given the pagans many hints of the plan for the world's redemption in order to prepare them.

The Sibyls lived on past the Middle Ages. Michelangelo gave them prominence on the Sistine Chapel ceiling, and here Antoine Caron treats the story of one Sibyl in a painting of the sixteenth century. The Roman Senate has decided to approve the apotheosis, or deification, of the Emperor Augustus. He has gone to the Tiburtine Sibyl (from the river Tiber) and asked her whether he should accept. She answers by foretelling the birth of a child who will one day surpass all of the Roman gods. Just then the Virgin appears in the sky, holding the infant in her arms. The Roman citizens are engaged in a number of mysterious ceremonial activities, and only the Sibyl, book in hand, and the emperor have noticed the visitation from another world.

The view of Rome is an eccentric one. The city brings to mind a game

Antoine Caron. Augustus and the Sibyl. *c. 1575–80. Oil on canvas, 49 ¼ x 66 ⅞". Musée du Louvre, Paris*

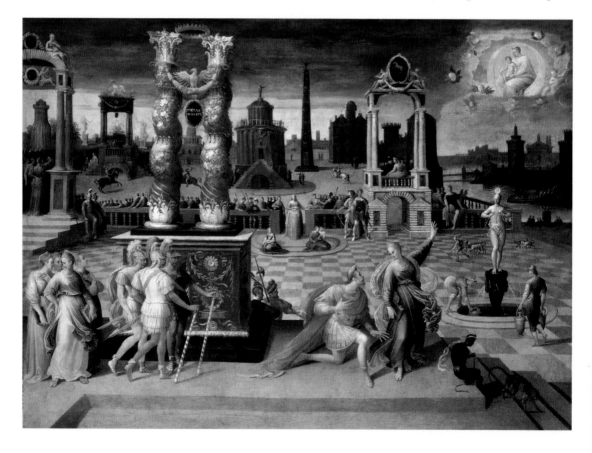

board studded with elaborate pieces, or a collection of very large, expensive paperweights and other desk ornaments. This is Mannerism (here in a French incarnation), an artistic movement that followed the High Renaissance. It is characterized by movement, complication, a striving for elegance and originality, and a great affection for ascending corkscrews. It is as if the Renaissance, wanting to keep going and going, managed to turn itself inside out.

The drapery and the long ribbons that billow, float, and twist about, however, are not just a Mannerist trait. The use of drapery to impart drama, movement, life itself, has been important to Western art all along. Abraham, for example, in our twelfth-century bronze (page 18) is given vitality and even authority by the living fabric that clothes him. Our craving for these effects is now taken for granted; we do not wonder why a fashion model is photographed in a fan-induced breeze, or why the ribbon on a Christmas wreath has been wired to flutter permanently. Until recently, an otherwise static conversation in a movie almost required the ascending drapery of cigarette smoke.

JUPITER AND IO
<p style="text-align:center;">∽</p>

There is more than one way to look at the love life of Jupiter, the ruler of the gods. His tendency to fall irresistibly in love with beautiful humans—usually but not always women—can give reign to rousing stories of lust, disguise, seduc-

Correggio. Jupiter and Io. *c. 1532. Oil on canvas, 64 ½ x 27 ¾". Kunsthistorisches Museum, Vienna*

tion, and strange consequences, or it can inspire the allegorically inclined to thoughts of God's union with the soul. Both views have been known to operate simultaneously.

As we have seen, the erotic, or sometimes the matrimonial, metaphor for mystical union is part of the Christian tradition, beginning with the allegorical interpretation of the Old Testament love

poem the Song of Songs and including the symbolic marriage of Saint Catherine to the infant Christ.

The parallels between Jupiter's love of human women and the Virgin's impregnation by the Holy Spirit were not entirely lost, even on medieval theologians—sometimes to their dismay. Again, they attributed this to the fact that the ancients had had their own revelation in the form of imperfect and debased versions of the purer truth that was to come. The idea of ancient *influences* on Christian thought was not acceptable.

For medieval thinkers, Jupiter represented Christ and his love-object the soul, which he carried off to Paradise. In Renaissance thought the meanings of god-human love stories were subtler and more complex, but similar. Love of the highest type freed the soul from the chains of the body, making union with the divine possible. Death, then, was closely allied with love, because it did the same, making the final union complete.

Io was the daughter of a river god. Jupiter, inflamed by her beauty, changed himself into a cloud and seduced her; alternatively, he covered the Earth with a cloud. In either case, the cloud was meant to fool his wife, Juno. Juno is always described as Jupiter's jealous wife, but heaven knows she had reasons. Juno was not fooled. As she approached, Jupiter changed Io into a white heifer, but Juno was still not fooled and she asked for the cow as a present. Then she sent a gadfly to torment poor Io, who wandered the Earth, swimming the Ionian Sea (named after her) and crossing the Bosporus (which means "cow pass"). She finally reached Egypt, was transformed again into a woman, and gave birth to Jupiter's son, Epaphus, who had many illustrious descendants.

The large urn in Correggio's painting is a reference to Io's father (page 153). River gods almost always have large urns, usually overturned, from which their rivers flow. It is a good solution to the problem of depicting a river god with his river, and the device was used widely.

The white cloth suggests that Io has been bathing. She leans against a clump of roots and mossy earth. Her warm, creamy flesh finds its opposite in Jupiter's cool, gray-green, misty presence. Jupiter's face can be seen, just barely, inside of his cloud, but it is the cloud that interests Io. It seems to be atmosphere personified, weather, or perhaps vaporous night itself. She embraces the huge foggy arm, completely entranced. The painting is all the more remarkable if one pretends one hasn't seen it and tries to imagine how to paint a woman making love with a cloud.

EUROPA

Europa was a princess of either Tyre or Phoenicia (accounts vary). Early one morning she awoke having dreamed that two continents, each in the form of a woman, wanted to possess her. One was Asia; the other had no name. She woke her maiden friends and they all went down to the seashore to pick flowers. Ju-

piter, idly looking down to the Earth, saw Europa and lost no time in going to the meadow, disguised this time as a beautiful white bull with large, gentle eyes. The maidens were enchanted with the bull. They put a garland of flowers on his head, and he knelt down as if to offer them a ride on his back. Europa climbed on and the bull was off before the others knew what had happened. Jupiter carried Europa out over the water while she clutched his horn and looked back at her friends. They landed on Crete, where Jupiter made love to Europa, who eventually gave birth to Minos and Rhadamanthus. Jupiter named Europe in her honor, though it seems she never went there.

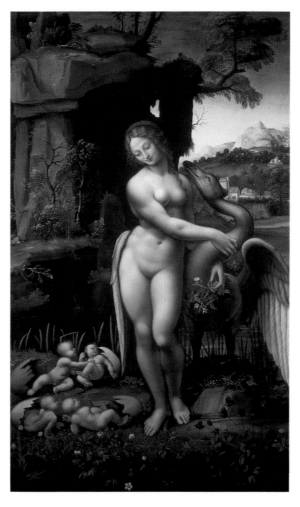

LEDA AND THE SWAN

Swans are large birds, but not quite as large as this one, painted by a follower of Leonardo. Somehow the bird and the woman make believable lovers, though Jupiter, who is the swan, must stand on a little hill, and still he cannot reach his

arm around Leda's shoulder, but only her hip. Leda is happy with their union, and with her newly hatched offspring, who are pairs of twins. The boys are gods—Castor and Pollux, the devoted brothers who will some day be known as the constellation Gemini. But the baby girls are another matter. One is Helen, who will become the most beautiful woman in the

Stefano della Bella.
Europa and the Bull
(from a pack of mythological playing cards). 1644. Etching. The Metropolitan Museum of Art, New York. Gift of Robert Hartshorne, 1918

Leonardo da Vinci (workshop). Leda and the Swan. *Early 16th century. Oil on canvas. Ministero Beni Culturali al Museo Leonardiano di Vinci*

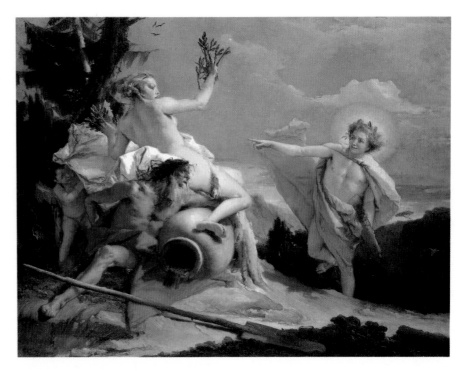

world and will therefore cause the Trojan War, just by being so beautiful men must fight over her. The other is Clytemnestra, destined to wed the Mycenean king Agamemnon; she will plot with her lover to kill her husband upon his return from the war in Troy. In the fruit of this coming together of the human and the godly, the boys represent Concordia, and the girls, obviously, Discordia.

APOLLO AND DAPHNE
∾

Apollo was a beautiful god, a musician whose skill could charm even animals; a god of light who shone like the sun. But isn't it Orpheus who is the musician? And isn't Sol, or Helios in Greek, the sun? It is not a good idea to expect a clear division of labor among the gods. If each god had only one important function and no two gods the same one, their stories would be duller than a corporate flow chart. The classical mythology that we have inherited is the creation of many centuries, and the gods came into the Greek and Roman pantheon from many cultures. In this melting pot of deities, overlaps and duplications abound, as do contradictions and conflicting versions of the same story.

Daphne was a nymph, daughter of the river god Peneus. Like the moon god-

dess Diana, she wanted only to roam the woods hunting; love held no interest for her. Even though she neglected her looks and her hair was a mess, Daphne was surpassingly beautiful. One day Apollo saw her. Ovid tells us that the first thought that crossed his mind was how lovely she would look in a nice dress with her hair properly arranged in a beautiful coif. The idea filled him with desire and he began to approach, trying not to startle her. But she jumped, ran like the wind, and Apollo followed. Daphne cried out to her father for help, and when she reached him, a strange sensation came over her. Her limbs stiffened; branches and leaves grew from her fingers. Before she knew what had happened she was covered with bark, her feet rooted to the ground. She was a laurel tree. Apollo, embracing the tree, declared that the laurel, or bay, would be his special emblem and that poets and victors of all kinds would henceforth be honored with a laurel wreath. With this history, it is interesting that the laurel wreath is given to the Christ in Majesty on page 92.

Daphne's transformation is just beginning in Tiepolo's vision of the story. The river god with his seaweed hair leans on his urn; his oar, another attribute of river gods, lies across his shin. The sprouting branches have progressed from Daphne's fingertips to her forearm. Apollo, genuinely sorry that he has caused this catastrophe, looks as shocked and helpless as a mortal. Anachronistically, he is already wearing the laurel wreath. In his halo we have come full circle. The light of the solar divinity that was the origin of the halo is returned to him.

APOLLO AND MARSYAS

Minerva invented the flute. She played it well and enjoyed making music until one day, while playing, she leaned over and looked at her reflection in a river. She thought she looked stupid with her cheeks all puffed out and threw the flute in the water, at the same time laying a curse on it. Marsyas, who was a Satyr and follower of Bacchus, the god of wine, happened by and retrieved the flute. The instrument so delighted him that he played it incessantly and thus became a consummate musician. Apollo was angered, not so much by Marsyas's skill as by his pride in it. He challenged Marsyas to a competition. Not surprisingly, Marsyas lost, and Apollo had him tied to a pine tree and flayed alive as punishment.

Though Marsyas may have been guilty of hubris, such cruel treatment from a usually beneficent god cries out for an allegorical explanation, and one is not lacking. First, the lyre, and all stringed instruments, represent the higher type of music—uplifting, intellectual, pure, and heavenly—and the flute, partly because of its phallic associations, signifies physically stirring, sensual, earthbound music, a category still condemned by some today, though the flute would hardly be the target of their scorn. As for Marsyas's gruesome death, it was taken to symbol-

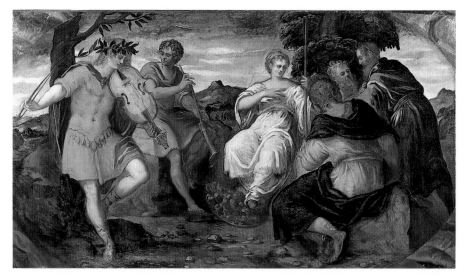

ize the purging of the outer, baser, physical self to liberate the intellect and the soul. The torture itself is suggestive of the rites of the ancient mystery cults, through which the initiate symbolically suffered and died and was then purged and made fit to be joined to his god and achieve immortality.

The flaying of Marsyas is a popular subject for sculpture, which usually shows the moment before the torture begins. In Tintoretto's painting we have a very beautiful example of mythology beginning to turn into wallpaper. The Satyr is a wholesome-looking shepherd, the lyre is a kind of viola, and the occasion is a concert perhaps, but not a deadly contest. The guests, an anonymous group (unless one of them is the patron for whose palace the work was painted), are probably meant to be an assortment of gods and a goddess. Minerva, or a muse

who served as judge in the contest, may be present, but specific subject matter was becoming less important to painters by this time, and mythology lent itself to less rigorous treatment than Christian subjects. Sometimes art historians are forced simply to identify such a painting as a "mythological subject," because no title is given and the clues are so vague.

GENERAL MAYHEM
જી

A love for action and excitement caused artists to turn often to two "historical" subjects that were actually legendary. One, the Rape of the Sabines, shows a crowd of male pre-Romans on horseback, abducting Sabine women for the lofty purpose of founding Rome. The other, which harks to a much earlier time, is the battle of the Lapiths and centaurs.

We have already met one or two centaurs, but they were civilized by their contact with saints. Most centaurs are really not civilized at all. Some Renaissance theories, based on the Roman poet Lucretius, maintained that centaurs were the result of the promiscuous mating of humans and animals that went on long ago, before the discovery of fire, farming, and family values. Many monsters were explained this way.

The Lapiths, who were civilized people, planned a big wedding. Since they were distantly related to the centaurs, they decided that they really should invite them. It was a big mistake, obviously born of being too civilized. Things went well at first but soon the centaurs began to get rowdy, and finally they went berserk, ravishing Lapith women, and, if Piero di Cosimo has it right, bashing people with wedding presents. A great battle ensued, finally won by the Lapiths, signaling the triumph of civilization over barbarity.

If, as you look at Piero's painting, you have some trouble knowing which side to be on, it is understandable. Prominently placed in the foreground is a lovely centaur lady, holding her dying centaur lover in her arms, making it clear that centaurs have feelings too.

The artist's sympathies are clearly mixed. Piero was fascinated with animals, and with savages. He liked things to run wild and would not let the plants in his garden be pruned. He ate when he felt like it instead of at mealtimes, and sometimes he painted with his hands. One wonders if he was invited to many weddings himself, and whether he cared.

Piero di Cosimo.
The Fight between
the Lapiths and the
Centaurs (detail).
c. 1500.
Poplar, 2'4" x 8'6⅜".
By courtesy of the
Trustees, The National
Gallery, London

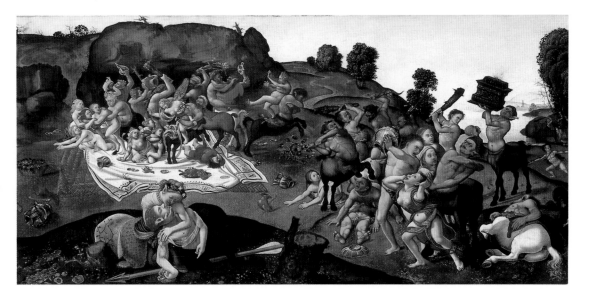

THE JUDGMENT
OF PARIS

Lucas Cranach the Elder. The Judgment of Paris. *c. 1528. Tempera and oil on wood, 40 ⅛ x 28". The Metropolitan Museum of Art, New York. Rogers Fund, 1928*

Eris, the goddess of strife, was the only one of the gods not invited to the wedding of the King Peleus and the Nereid Thetis. So she sought revenge. You really cannot win in this matter of wedding invitations. Eris tossed a golden apple, inscribed, "To the fairest," into the midst of the celebration. Three god-desses claimed the apple: Juno, Venus, and Minerva. Jupiter was asked to pass judgment but declined. One of the contestants was, after all, his wife. He asked Mercury, his messenger, to present the three to Paris, son of King Priam of Troy, who would make the decision.

Mercury, in an elaborate version of his usual winged cap, holds a globe of glass, instead of a golden apple, while Paris makes up his mind. It is true the three goddesses look very much alike, but that is not what Paris is thinking about. He has been weighing the relative value of the bribes they have offered. Juno will give him riches and empire, Minerva fame and military glory, and Venus will give him the love of the most beautiful woman in the world, the famous Helen, wife of Menelaus. The expression on his face supports the conclusion that he is not daydreaming about riches or fame. He chose Venus.

Thus, the Trojan War began. The powerful suitors who had lost Helen to Menelaus had taken an oath to defend his right to her and to destroy the city of any man who dared to violate that right. Paris put the inexorable machinery of war in motion and, even more ominously, he also gained the enmity of Juno and Minerva.

Weakness and want of virtue lay behind Paris's disastrous choice, and the subject therefore had allegorical as well as visual appeal. In simplified form, the story was said to represent a choice among the active, contemplative, and sensuous life. Once again, it allowed art-

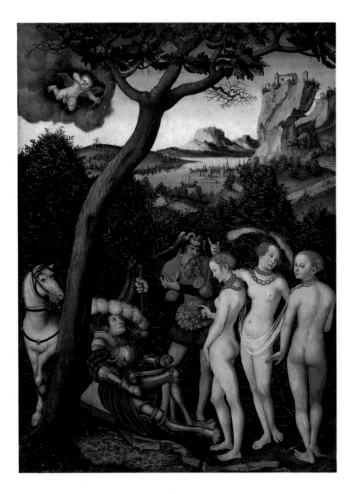

ists to treat the nude female form, which also explains the subject's great popularity. Cranach's nudes remind us that, as much as northern Europeans admired ancient art and culture, they had their own idea of female comeliness, which called for thin limbs and nice round stomachs.

LAOCOÖN
‹›

"Beware of Greeks bearing gifts" is the famous line of Laocoön (pronounced "lay-AH-co-wan"), a Trojan priest of Neptune who eyed the Greeks' wooden horse with suspicion. The Greeks had spread the word that the horse was an offering for Minerva, whose temple was inside the city walls. Laocoön thought differently, and when he was ignored, he hurled his spear at the horse in frustration. Two huge snakes then emerged from the sea and strangled Laocoön and his two sons. The Trojans took this as a sign of the god's anger at Laocoön's impious gesture and dragged the horse inside the city to present it at the temple. Greek warriors climbed out during the night, and the fall of Troy began.

Though the story is an interesting one, the great popularity among artists of the struggle with the snakes is not due to literary influence. During the Renaissance, a late Hellenistic sculpture of Laocoön and his sons wrestling with the serpents was uncovered in Rome. The discovery caused a sensation. The statue had been described by Pliny as one of the greatest works of art ever produced. Thus the European world had been aware, even during the Middle Ages, of its loss and, upon the discovery, knew what had been found. Casts and engravings spread rapidly, making a deep impression on artists and connoisseurs throughout the continent.

The original sculpture is a tightly bound unit of three writhing, seated figures connected by the twining snakes. El Greco has pulled the three figures apart, laying two on the ground and standing one of them up (page 162). Perhaps he found the original too coherent for its subject. The menace in his painting encompasses the sky, the landscape, and the view of his own walled city of Toledo, representing Troy. The subject—the defeat of an entire civilization because it would not listen to warning—calls for

Hagesandros, Polydoros, and Athenodoros. Laocoön and His Two Sons. *2nd century BC–1st century AD. Marble, height 96". Vatican Museums, Rome*

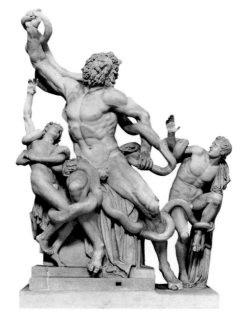

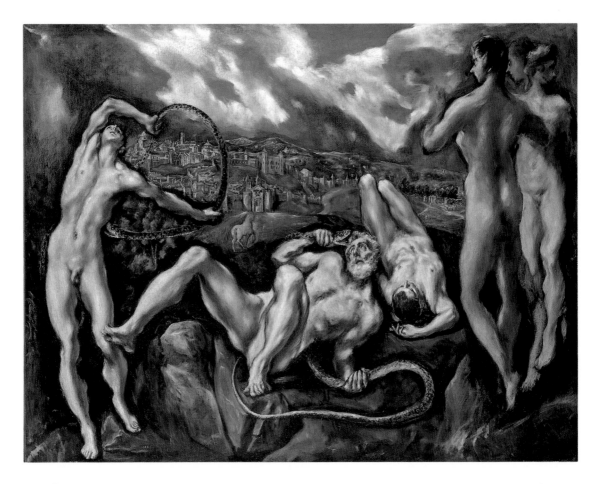

this treatment. The spectators on the right are probably deities, who, if they have helped cause the grim scene, nonetheless show little interest.

DRINKING

Bacchus, the god of wine, is familiar to most of us as either a boy or a young man, wearing a wreath of grape leaves and holding a goblet or wine bowl. Less famil-

iar is the old Satyr who was once his teacher, Silenus. Aside from the fact that we may know someone like him, what, we wonder, can be the great appeal of a pot-bellied, bearded, and balding old man who is always drunk? It is hard to say, except to speculate that Silenus provides comic relief. Bacchus, especially if we remember his past as the Greek Dionysus, represents the wine-religion, both beautiful and dangerous in its self-abandon. Silenus, on the other hand, seems to repre-

sent the other consequences of alcoholic excess: hilarity, foolishness, and stupor.

The Triumph of Silenus, a common theme, uses the word *triumph* ironically. As we see on this Majolica dish, the procession lacks dignity. A companion flourishes a mask, Renaissance symbol of false dreams. Silenus will never make it home without help; supported by a donkey and two Satyrs, he is bound to topple over a few times before the trip is over. The scene is one of pure folly.

EMBLEMS AND MOTTOES

Renaissance humanists indulged their fascination with hidden meanings in a craze for emblems. Unlike coats of arms, the family insignia that began to develop in the Middle Ages, emblems were not inherited; one could invent one's own. In the sixteenth century, books of emblem designs began to appear, composed by emblematists who took their imagery from medieval bestiaries, the Bible, and especially classical myths and legends. The idea was to be very learned, and to avoid the obvious. Lovers might even have emblems that only they could understand. A device that employed both a visual symbol and a phrase was called an *impresa*.

It was discovered that the Emperor Augustus had used as his motto, *Festina Lente*, "Make Haste Slowly." This struck a sympathetic chord in Renaissance thinkers, who were drawn to the

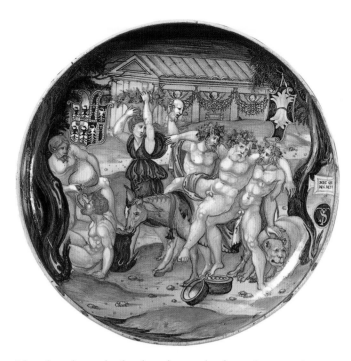

idea that the truly developed man (and they were not talking about women) knew how to maintain the tense balance between impetuosity and steady, prudent restraint or, we might say, between spontaneity and planning. It is not a highly complex idea, but was amplified to encompass a deep mystical truth contained in the coincidence of opposites.

The motto itself was pictured in various ways, some happier than others: a turtle with a sail, a butterfly on a crab, and, one of the most successful visually, an anchor and a dolphin. This compact, graceful emblem was designed by the renowned Venetian printer Aldus Manutius, the first publisher of small, portable books. He used it on his title page as a device some would now call a "logo," a

Urbino artist. The Triumph of Silenus. *c. 1530–35. Majolica plate, diameter 10 ¾". The Metropolitan Museum of Art, New York. Robert Lehman Collection, 1975*

usage that demonstrates that a word can be robbed of meaning as easily as it can be enriched.

PRUDENCE

We have already met Hope and Charity, two of the three theological virtues (Faith being the third). Their source is biblical, while the four cardinal virtues, Justice, Prudence, Fortitude, and Temperance, are derived from Plato's *Republic.* Moral allegories throughout the Middle Ages were simply portrayed as female figures, holding their identifying attributes and, sometimes, treading their immoral counterparts underfoot. During and after the Renaissance, artists turned more and more to classical sources. In many cases, Roman deities, heroes, and historical figures were recruited to play their own roles in

myth or legend while at the same time representing such ideas as reason, marital fidelity, and filial piety. But the old allegorical figures did not die out, and one of the favorites was Prudence.

Prudence, meaning wise behavior, took on some strange guises. In the Della Robbia roundel, she has kept her medieval attributes, the snake and the mirror. The snake comes from Jesus' advice to his disciples: "I send you forth as sheep in the midst of wolves: be ye therefore wise as serpents, and harmless as doves." The mirror is also a medieval convention and simply suggests that the wise can see themselves clearly. But Prudence now has a second face, a male one.

Janus was the two-faced god of beginnings, keeper of doors (from whom we derive *janitor*), who could see both past and future. It would make sense that Prudence have his double vision. But, both of Janus's faces were male. If we remember Aristophanes' story from the *Symposium,* we begin to suspect that this particular Prudence has regained the original integrity of the humans who were once both male and female, before they were split in half. To Renaissance thinkers, this hermaphroditic image suggested the person who can both see the spiritual and take care of the material, knows both the eternal and the temporal, the upper and the lower worlds.

For these philosophers, grotesque images were not to be avoided, since in their very strangeness they were likely to hold deep secrets. But the artist cannot help himself: he has managed somehow

to combine the woman's hair and the man's beard, joining the two faces in a creation that is as attractive as it is far-fetched. And the surrounding border, a descendant of Roman swags and garlands, weaves fruits, leaves, pinecones, and vegetables into a gorgeous wreath.

THE THREE GRACES
❧

There is no general agreement on the identity of the three Graces. In myths they were attendants to Venus and companions of the Muses. Sometimes they were called Splendor, Mirth, and Good Cheer; sometimes they were Beauty, Gentleness, and Friendship. There are no stories about them. They danced to Apollo's lyre and simply existed, being beautiful. Eventually, allegorical meanings that had adhered to them grew in importance, and these were many.

Classical writers described the Graces as representing liberality. One is the spirit of giving, another of receiving, and

Andrea della Robbia. Allegory of Prudence. c. 1475. Enameled terra-cotta, diameter 64 ½". The Metropolitan Museum of Art, New York. Joseph Pulitzer Bequest, 1921

yond, the ultimate truth. The wisdom of the ancients came from the same ultimate source as the Christian revelation. Everything is a metaphor for the hidden mysteries of the universe. There are three Graces, for example, because God is a Trinity and works in threes.

Raphael's *Three Graces* falls into another category. It signifies the reconciliation of opposites by a third unifying and transcendent force. These women are Chastity, Beauty, and Love. They show us that Beauty inclines Chastity toward Love. The Graces hold golden apples, associated with Venus, though they are more globes than apples. They wear almost nothing but evil-averting coral beads. Nudity usually signifies honesty in Renaissance art; Chastity's filmy little drapery is needed to help identify her, but it is transparent, so it suggests no subterfuge or artifice.

In painting the three Graces, an artist has one of the best opportunities to celebrate the beauty of women. In many cases three views, front, back, and profile, combine into an even more complete treatment. The subject also appears within paintings, sometimes in disguise, as in Lucas Cranach's *Judgment of Paris*, for example (page 160).

We have not exhausted the iconography of the three Graces. A picture can generate many more than a thousand words. But words did not keep these three beautiful women alive for so many centuries. They themselves did that.

the third of returning the benefit or giving thanks. *Gratia*, which we are translating as "grace," also means "thanks." In another take on the subject, the figure with her back to us (facing in the same direction we are facing) is giving, while the two that face us signify that what we give comes back to us twofold.

The Italian humanists developed a rich collection of commentaries upon the Graces. In one conception they are, from left to right, Beauty, Love, and Pleasure. Beauty comes to us from the gods; in receiving it we are drawn to the gods, and we respond with love. In return we are given pleasure—of the highest kind, a transcendent joy. How did this fit in with Christianity? Just fine. "The gods" are a metaphor for the Be-

POSTSCRIPT:
ANOTHER SQUARE HALO

It is possible to spend hours in a museum and, afterward, not remember one single picture frame. This might imply that frames have no effect on us and are of no importance whatsoever. This is not true. We do not consciously notice them because the museum's curators have given so much attention to their appropriateness. The sober, dark wood frames in a room full of Dutch paintings prepares us for the northern Protestant frame of mind, perhaps even the climate.

Frames can range from Gothic intricacy to
geometrical stateliness to exuberant,
cloudlike billowiness. They give
a painting its final definition,
its glow. Many are gold,
just like halos.

എ

SUGGESTED READING

A good, general reference book that covers both Christian and classical themes is James Hall's *Dictionary of Subjects and Symbols in Art* (New York, Harper and Row, revised edition, 1979).

Below is a short, personal selection of interesting and provocative books on very specific subjects. I have left out many important works of art history, but as your interest gains momentum these books will lead you to them. The nineteenth-century author Mrs. Jameson (the full name under which she published) is a rich source of lore. Some of her original volumes have been reprinted and are available in a good, large library, which may also have her early editions. There have been a number of translations and abridged versions of *The Golden Legend*, a medieval compilation of saint and miracle stories. I list here the most recent. Throughout the list, wherever paperback editions are in print, I have cited those.

Freedberg, David. *The Power of Images: Studies in the History and Theory of Response.* Chicago: The University of Chicago Press, 1991.

Hollander, Anne. *Seeing Through Clothes.* Berkeley: University of California Press, 1993.

Husband, Timothy, with the assistance of Gloria Gilmore-House. *The Wild Man: Medieval Myth and Symbolism.* New York: The Metropolitan Museum of Art, 1980.

Jameson, Anna. *Sacred and Legendary Art.* Reprinted from the edition of 1896. New York: AMS Press, Inc., 1970.

Mâle, Emile. *The Gothic Image: Religious Art in France of the Thirteenth Century.* New York: HarperCollins, 1973.

Mellinkoff, Ruth. *The Horned Moses in Medieval Art and Thought.* Berkeley: University of California Press, 1970.

Panofsky, Irwin. *Studies in Iconology: Humanistic Themes in the Art of the Renaissance.* New York: Harper and Row, 1972.

Steinberg, Leo. *The Sexuality of Christ in Renaissance Art and in Modern Oblivion.* New York: Pantheon Books, 1983.

Voragine, Jacobus de. *The Golden Legend.* Translated by William Granger Ryan. Princeton: Princeton University Press, 1993.

Warner, Marina. *Alone of All Her Sex: The Myth and the Cult of the Virgin Mary.* New York: Random House, 1983.

Wind, Edgar. *Pagan Mysteries in the Renaissance.* New York: W. W. Norton and Company, Inc., 1969.

INDEX

Italic page numbers refer to illustrations.

Abraham, 18–21, 33, 153; *18, 19, 20*
Abraham and the Three Angels, Abraham and Sarah (Second Master of San Zeno), 18–19, 153; *18*
Abraham Dismissing Hagar and Ishmael (Maes), 19, 20; *19*
Adam, 8; at the Creation of Eve, 12, 13; *13*; Expulsion from Paradise, 14, 43, 97; *14, 42*; Fall of, *10*; at the Harrowing of Hell, 78; *78*; skull of, 76
Adoration of the Child: by the Magi, 58, 71; by shepherds, 58; by the Virgin, 57; *56, 57*
Agnus Dei Displayed on Cross Between Emblems of the Four Evangelists (ivory book cover), 90; *90*
Agostino Novello, Saint, 139–40; *139*
Alesso di Andrea: *Hope*, 93; *93*
Alexander the Great, 21, 40–41, 147, 148–49
allegorical figures, 101–2, 164–65; *102, 165*; dress, 147; halos, 93; *93*
Allegory of Prudence (Della Robbia), 164–65; *165*
Altarpiece of Fra Agostino Novello (Martini), predella panel, 140; *139*
Altichiero da Zevio: *Saint George Liberates the Princess*, 102, 120; *119*
Angelico, Fra: *The Annunciation*, 43; *42*; *The Coronation of the Virgin*, 86; *87*; *The Last Judgment*, 85; *86*; *Saints Cosmas and Damian Healing the Deacon Justinian*, 121; *120*; *The Transfiguration*, 72; *72*; *The Visitation*, 45–46; *45*
angels, 11, 12, 147; Abraham's visitors, 18, 19; *18*; of annunciation, 18, 112; *see also* Gabriel; bald, 131; *110*; at the Baptism of Christ, 67; *67*; in battle for the soul of the dying, 106; *107*; at the Crucifixion, 76; descent to Hagar and Ishmael, 20; vs. devils, 112; fallen, *see* Satan; on the Flight into Egypt, 62; *62*; halos, 92; in Heaven, 86; *87, 88*; at the Nativity, 57; *55, 56, 57*; in Saint Ursula's dream, 134; *133*; stopping Abraham's sacrifice of Isaac, 21; *20*; at the Temptation in the Wilderness, 68; *69*; Tobias's guardian, 28–29; who warned the Three Kings, 59; *59*

animals, 16, 57, 90, 111, 126; Four Beasts of the Evangelists, 89–90; *90, 144, 145*; *see also* individual animal entries
Anna (Saint Anne; mother of Mary), 32–35, 64; *32, 33, 34, 35*
Anna (prophetess), 65; *66*
Annunciation, The (Angelico), 43; *42*
Annunciation (Joos van Cleve), detail of Moses (Cornelisz van Oostsanen), *21*
Annunciation, The (Lippi), 42; *40*
Annunciation, The (Martini), 42–43; *41*
Annunciation, The (Tintoretto), 43; *43*
annunciations: to Abraham and Sarah, 18; to Anna and Joachim, 18, 33; *32*; to Mary, 40–43, 45, 47; *40, 41, 42, 43, 44*; to Zacharias, 18, 112
Annunciation to Saint Anne and Saint Joachim, The (Strigel), 33; *32*
Anthony of the Desert, Saint, 122, 125–26, 127; *122, 123, 126*
Apocalypse, 52, 88–89
apocrypha, term, 24
Apollo, 121, 147, 156, 157–58, 165; *156, 158*
Apollo Pursuing Daphne (Tiepolo), 157; *156*
Apostles, 48, 83; *48*; *see also* disciples
Aquamanile in the Shape of Aristotle and Phyllis (Mosan bronze), 148; *149*
Archangel Gabriel and the Virgin of the Annunciation (David), 44; *44*
archangels, 11–12; *see also* Gabriel; Michael; Raphael
architecture, 40, 44; *39*; model buildings, 91–92, 93; *92, 93*
Aristotle, and Phyllis, 7, 148–49; *149*
Ars Moriendi, 106; *107*
Assumption of the Virgin, 48–49, 80; *48, 49*
Assumption of the Virgin, The (Daddi), 48–49; *48*
Assumption of the Virgin (Titian), 49; *49*
Augustinians, 137, 140; *137*
Augustus, Emperor, 151–53, 163; *152*
Augustus and the Sibyl (Caron), 152–53; *152*
aureole, 92; *see also* mandorla
Azarias, 28

Bacchus/Bacchantes, 147, 157, 162
Baptism of Christ, 67–68, 71; *67*

Baptism of Christ (A. Pisano), 67–68; *67*
baptisteries, 67, 147
Barbara, Saint, 92, 142–43; *141, 144*
Batlló Crucifix, 76; *76*
Beauty (a Grace), 166; *166*
beds, 29; *29*; communal, 59; *59*
Bella, Stefano della: *Europa and the Bull*, 155
benedictio Latina, 96; *96*
Bernard, Saint, 51
Bicci di Lorenzo: *Saint Nicholas Providing Dowries*, 137; *136*
birds: revived by Nicholas of Tolentino, 137–38; *137*; Saint Francis preaching to, 130; *129*; symbolism, 16, 43, 85; *see also* dove; eagle; ravens
Birth and Naming of Saint John the Baptist, The (Sano di Pietro), 112; *112*
Birth of the Virgin (Carpaccio), 33–34; *34*
bishops, 86, 98, 128; *98, 127*
Bosch, Hieronymus, 101, 108; *The Cure for Folly*, 100–101; *101*; *Death and the Miser*, 106–8; *107*
Bridget of Sweden, Saint, 57

Campin, Robert: *Virgin and Child Before a Firescreen*, 95; *94*
Caravaggio: *The Supper at Emmaus*, 80; *80*
Caron, Antoine: *Augustus and the Sibyl*, 152–53; *152*
Carpaccio, Vittore: *Birth of the Virgin*, 33–34; *34*; *The Dream of Saint Ursula*, 134; *133*
cartellini, 40, 81, 139; *81, 138*
Castor and Pollux, 155; *155*
Catherine of Alexandria, Saint, 50, 140–42, 143, 154; *51, 141, 145*
Catherine of Siena, Saint, 129
centaurs, 99, 122; *122, 123*; and Lapiths, 158–59; *159*
Charity, 93, 101–2, 151, 164; *102*
Charity (Reni), 102; *102*
Chastity, 109, 148; as a Grace, 166; *166*
cherubim, 15, 51; *14, 51*
cherubs, 38, 43, 49, 147; *38, 43, 49*
Christ Child: with coral necklace, 103; *103*; mystical marriage to Saint Catherine, 141, 142, 154; *141*; and Saint Christopher, 131; *110, 131*; *see also* Adoration of the Child;

Holy Family; Nativity; Madonna and Child
Christ in Limbo (Master of the Osservanza), 78; *78*
Christ in Majesty with Emperor Otto I (ivory relief), 91–92, 157; *92*
Christopher, Saint, 130–31; *110, 130*
Christ Pantocrator (Master of Tahull), 90–91; *91*
Christ's Entry in Jerusalem (Giotto), 72; *73*
Christus, Petrus: *Our Lady of the Barren Tree*, 33; *2*
churches, 19; models, 92; *92*
Cima da Conegliano: *The Incredulity of Saint Thomas*, 81, 94; *81; Saint Jerome in a Landscape*, 125
Claesz, Pieter: *Vanitas Still Life*, 106; *106*
classical influences, 44, 68, 85, 147–66
classical mythology, 12, 13, 151, 153–58, 160; Christian interpretations, 16, 41, 147, 154
clothing and fashion, 102–5, 147; *104, 105*
cloth of honor, 46, 95, 140; *46, 141*
Clytemnestra, 156; *155*
codpieces, 104–5; *23, 104*
Colantonio: *Saint Jerome in His Study*, 123–24; *124*
Cologne, 59, 134
columbine, symbolism, 38
Concordia, 156
Contest between Apollo and Marsyas, The (Tintoretto), 158; *158*
continuous narration, 113, 122, 147; *114, 122, 123*
coral beads, 103, 166; *103, 166*
Cornelisz van Oostsanen, Jacob: woodcut of Moses, *21*
Coronation of the Virgin, The (Angelico), 86; *87*
Correggio: *Jupiter and Io*, 154; *153*
Cosmas and Damian, Saints, 120–21; *120*
courtly love, 108–9
Cranach, Lucas the Elder: *The Judgment of Paris*, 160–61, 166; *160*
Creation of Eve, The (Master Bertram), 12–13; *13*
Creation of the World and the Expulsion from Paradise, The (Giovanni di Paolo), 14–15; *14*
Crivelli, Carlo: *Saint Lucy*, *135; Saint Michael*, 11–12; *11*
cross, 76; invention of, 96–98
crucifixes, 76; *76*

Crucifixion, 17, 21, 44, 72, 75–76, 86, 115–16; *75*
Crucifixion of Saint Peter (Masaccio), 118; *117*
Cupid, 109, 151; *150*
Cure for Folly, The (Bosch), 100–101; *101*
curtains, 18; *17;* lifted, 38; *38*

Daddi, Bernardo: *The Assumption of the Virgin*, 48–49; *48*
Damian, Saint, 120–21; *120*
Dance of Death, 105
Dance of Salome, The (Gozzoli), 113–14; *114*
Daniel, 27; Book of, 88
Dante, 9, 86, 87
Daphne and Apollo, 156–57; *156*
Daret, Jacques: *Nativity*, 57–58; *57*
Daumier, Honoré, 8
David, king of Israel, 63, 78; *78*
David, Gerard: *Archangel Gabriel and the Virgin of the Annunciation*, 44; *44; The Rest on the Flight into Egypt*, 60–62; *61*
Death, 86, 105, 106, 148; *88, 105, 107*
death, 47–49, 80, 105, 106–8, 154; *105, 106, 107*
Death and the Miser (Bosch), 106–8; *107*
Death and the Young Man (Housebook Master), 102, 105, 106; *105*
Della Robbia, Andrea: *Allegory of Prudence*, 164–65; *165*
demons, 28, 98, 106–7, 117, 125, 126; *107, 126*
denticular border, 68; *67*
Descent from the Cross, The (Weyden), 77–78; *77*
Descent of the Holy Ghost upon the Faithful (Fouquet), 83; *82*
Devil, 68, 69, 112, 139; *see also* Satan
Diana, 52, 157
Dionysus, 162; *see also* Bacchus
Dioscorus, 142
disciples: at the display of wounds to Thomas, 81; *81;* at the Last Supper, 73–74; *74;* at Pentecost, 84; *84; see also* Apostles; James; John the Evangelist; Judas; Peter; Thomas
Discordia, 156
dog-faced people, 99, 149
dogs, 28, 57, 134; *29, 133*
Dominic, Saint, 72, 130; *72*
Dominicans, 72, 130
donkey, 60, 62, 72, 123; *62, 73*
Donne, John, 16–17
donor figures, 47, 140; *30, 46, 141*
Dormition of the Virgin, The (Multscher), 48; *48*

dove, symbol of the Holy Spirit, 38, 84–85, 90; *85;* in Annunciation scenes, 41, 42, 43; *40, 42, 43, 44;* at the Baptism of Christ, 67; *67*
dragons, 99, 119–20, 132; *119, 132*
drapery, 17, 90–91, 118, 153; *15, 91, 118, 152*
dream bubbles, 24; *23*
Dream of Saint Ursula, The (Carpaccio), 134; *133*
dreams: false, 163; of Innocent III, 130; *129;* interpreted by Joseph, 23–24; *23;* of Saint Catherine, 141; of Saint Ursula, 134; *133*
drinking/drunkenness: of Noah, 17–18; *17;* of Silenus, 162–63; *163*
Duccio: *The Temptation of Christ on the Mountain*, 68, 69; *69*
Dürer, Albrecht: *Triumphal Procession of Maximilian I*, 105; *104*
Dying Man Tempted to Impatience, The (German), 106; *107*

eagle, of Saint John, 89; *90, 145*
early Christian art, 27, 75–76, 83, 84, 85
Earth, 14–15, 93; *14*
Eden, expulsion from, 14–15, 43; *14, 42*
egg, symbolism, 35, 72
Egypt: Flight of the Holy Family into, 60–63, 113; *61, 62;* Joseph in, 22–24
Egyptian influences, 21, 51, 151
Elijah, 72; *72*
Elizabeth, Saint, 60, 64, 67, 112; *112;* Visitation to, 45–46; *45*
emblems, 163–64; *164*
Emmaus, Supper at, 78–80; *80*
Entombment of Christ, 23, 78
Entry into Jerusalem, 34, 72–73, 148; *73*
Epiphany, festivals of, 71
Eris, 160
Eucharist: institution of, *see* Last Supper; prefigurations, 16, 62, 71; symbols, 76, 145
Europa and the Bull (Bella), 154–55; *155*
Eustace, Saint, 138–39; *138*
Evangelists, *see* John; Luke; Mark; Matthew; Beasts of, 89–90; *90, 144, 145*
Eve: Creation of, 12–13; *13;* Expulsion from Paradise, 14, 43; *14, 42;* at the Fall, *10;* at the Harrowing of Hell, 78; *78;* redemption in Mary, 31
Expulsion from Paradise, 14–15, 43; *14, 42*
Expulsion of Joachim (Giotto), 32; *32*
ex-votos, 140
Eyck, Jan van: *The Last Judgment*, 86; *88*

eyes, of Saint Lucy, 135
Ezekiel, 89

Faith, 93, 164
Fall of Man, *10*; Golgotha site, 76; Mary's
 exemption, 31, 41, 46
Fall of Man, The (Masolino), 13; *10*
fashion fads, 102–5
feast days, 44, 65, 73
Federico II, duke of Urbino, 148; *146*
Felix, Saint, 121
Fight between the Lapiths and the Centaurs,
 The (Piero di Cosimo), 159; *159*
fish: symbolism, 29; of Tobias, 28, 29
flame: attribute of Charity, 101; symbol
 of the Holy Spirit, 83, 95; *84, 94*
Flanders, painting, 24, 106
Flight into Egypt, 60–63, 80, 113; *61, 62*
Flight into Egypt, The (Spanish), 62; *62*
flute, 157
Fortitude, 93, 164
Fortune, 148; Wheel of, 101
fountain, in Garden of Love, 109; *109*
Fouquet, Jean: *Descent of the Holy Ghost*
 upon the Faithful, 83; *82*; *Madonna and*
 Child with Angels, 50–51, 103; *51*
frames, 167
Franciscans, 130
Francis of Assisi, Saint, 124, 127–30; *127,*
 128, 129
Freud, Sigmund, 12

Gabriel, 12; annunciations: to Anna, 33; *32*;
 to Mary, 41, 42–43, 45; *40, 41, 42, 43, 44*;
 relic of, 96
Gaddi, Agnolo: *The Trinity*, 84–85; *85*
Garden of Love, The (Nuremberg Manufac-
 tory), 108–9; *109*
Garofalo, Benvenuto Tisi da: *Saint Nicholas*
 of Tolentino Reviving the Birds, 137
George, Saint, 119–20, 132; *119*
Ghirlandaio, Domenico: *Tobias and the*
 Angel, 28–29; *28*
Giotto: *Christ's Entry in Jerusalem*, 72; *73*;
 Expulsion of Joachim, 32; *32*; *Jonah and the*
 Great Fish, 16; *The Kiss of Judas*, 74–75; *75*;
 Meeting of Joachim and Anna at the Golden
 Gate, 33; *Nativity*, 55, 58; *55*; *Saint Francis*
 Receiving the Stigmata, 129
Giovanni di Paolo: *The Creation of the World*
 and the Expulsion from Paradise, 14–15; *14*
glory, 15, 92; *14*
God, 84, 85; in Adoration scene, *56*; at the

Assumption of the Virgin, *49*; at Crea-
 tion, 14, 15; *14*; halos, 15, 92, 94; *14, 93*;
 hand of, 14, 83; *82*; Lamb of, 90, 92, 113;
 90; three persons, 84–85; *85*; *see also* Holy
 Spirit; Jesus Christ; Trinity
God the Father (Romano), *93*
Gogh, Vincent van, 7
Golgotha, 76, 77
Gothic art, 19, 68, 93, 102, 147
Gozzoli, Benozzo: *The Dance of Salome*,
 113–14; *114*
Graces, Three, 165–66; *166*
grapes, symbolism, 16, 62
Greco, El, 38; *Laocoön*, 161–62; *162*; *The*
 Pentecost, 83–84; *84*
Greece, *see entries at* classical
Gregory the Great, Saint, 85
grisaille, 44; *44*
Guardian Angel, cult of, 29
Gubbio, wolf of, 128–29; *128*

Hagar, 19–20; *19*
Hagesandros, Polydoros, and Athenodoros:
 Laocoön and His Two Sons, 161; *161*
hair, 13, 99, 100, 116; *116*
halos, 92–95, 167; animals with, 90; of Apol-
 lo, 157; *156*; of the beheaded, 114; black, 47,
 73, 95; *95*; of disciples, 74; *74*; frames as,
 167; of God, 15, 92, 94; *14, 93*; of Jesus, 74,
 92, 94; *74*; of Mary, 38; *38*; of saints, 92, 93,
 118; *81, 117*; shapes, 92–93; *93*; subliminal,
 95; *94*; *see also* mandorla
Ham Seeing Noah Naked (mosaic), 17–18; *17*
hands, covered, 65, 90, 92; *66, 90, 92*
Harmony, 151
Harrowing of Hell, 78; *78*
hats, 19, 22, 123, 135
Heaven, 85–86, 147; *86, 87, 88*; color, 50;
 saints in, 86, 111; *87*
Helen of Troy, 8, 155–56, 160; *155*
Helena, Saint, 97; *98*
Helios, 92, 156
Hell, 86–87, 147; *88*; Harrowing of, 78; *78*
hermaphroditic images, 164–65; *165*
hermits, 108, 122, 141; *108, 122, 123*
Herod Antipas, 59–60, 113; *60*
Herodotus, 99
Holofernes, 25
Holy Family, on the Flight into Egypt,
 60–63, 113; *61, 62*
Holy Innocents, Massacre of, 59–60; *60*
Holy Kinship (follower of the Saint Veronica
 Master), 63–64; *64*

Holy Spirit (Holy Ghost): at the Annuncia-
 tion, 41, 42, 43; *40, 42, 43, 44*; at the Bap-
 tism of Christ, 67; *67*; descent at Pente-
 cost, 83–84; *84*; Jupiter compared to, 154;
 seven gifts of, 38; symbols of: flames, 83,
 85, 95; *84, 94*; red, 50; *see also* dove; and the
 Trinity, 84–85; *85*
Holy Week, 73
Hope, 93, 101, 164; *93*
Hope (Alesso di Andrea), 93; *93*
horns, symbolism, 21–22, 69; *21, 22, 70*
hortus conclusis, 50
hospitality, 18, 79
Housebook, 105
Housebook Master: *Death and the Young*
 Man, 102, 105, 106; *105*; *Wild Woman and*
 Children on Stag, 100
human figure, 147–48; elongated, 102
humanists, 149, 163, 166
Hypatia, 142

iconography, 7, 149–50
icons, 68, 81
idolatry, 143
Immaculate Conception, 31, 33, 52; *53*
Immaculate Conception, The (Tiepolo), *53*
impresa, 163
Incarnation, 57, 68, 77; symbols, 43, 72
Incredulity of Saint Thomas, The (Cima da
 Conegliano), 81, 94; *81*
Innocent III, pope, 130; *129*
in-situ paintings, 37–38
invention of the cross, 96–98
Io, 154; *153*
Isaac, 18, 19–20, 33; sacrifice of, 20–21; *20*
Isaiah, Book of, 15, 38, 57, 63
Ishmael, 19–20; *19*
Isis, 51
Israelites, 22, 25; *see also* Jews

Jacobello del Fiore: *Saint Lucy Resisting*
 Efforts to Move Her, 134
James, Saint, 72, 74, 80; *72*; *see also* disciples
Janus, 164
Jerome, Saint, 21, 63, 123–25, 147; *124*;
 temptations of, 125, 126; *125*
Jerusalem, *see* Entry into; Temple at
Jesse, Tree of, 63; *63*
Jesus Christ, 16, 55–81, 151; Baptism, 67–68,
 71; *67*; birth (Nativity), 55–58; *55, 56, 57*;
 Crucifixion, 17, 21, 44, 72, 75–76, 86, 115–
 16; *75*; Descent from the Cross, 77–78; *77*;
 display of wounds to Thomas, 80–81; *81*;

Entombment, 23, 78; Entry into Jerusalem, 34, 72–73, 148; *73;* on the Flight into Egypt, 60, 61, 62, 113; *61, 62, 113;* foretellings and prefigurations of, 16, 18, 21, 23, 24, 41, 147, 152; halo, 74, 92, 94; *74;* Harrowing of Hell, 78; *78;* Holy Kinship, 63–64; *64;* and John the Baptist, 45, 67, 113; *67, 113;* Kiss of Judas, 74–75; *75;* Last Judgment, 86; *86, 88;* Last Supper, 73–74, 117; *74, 94;* in Majesty, 91–92, 157; *92;* at the Marriage Feast at Cana, 71; *71;* and Mary, 31, 48; *48; see also* Madonna and Child; and Mary Magdalene, 114, 116; *115;* nude representations, 67–68; as Pantocrator, 90–91, 92; *91;* physical appearance, 81, 118; *54;* Presentation in the Temple, 64–67; *66;* Resurrection, 16, 23, 44, 79–80; Supper at Emmaus, 78–80; *80;* symbols of, 22, 29; Temptation in the Wilderness, 68–69; *69, 70;* Transfiguration, 71–72; *72;* in Tree of Jesse, 63; in the Trinity, 84; *85; see also* Christ Child; Lamb of God

jewelry: healthy, 102–3; on nudes, 27; of the Virgin Mary, 50, 67

Jews: 19, 21, 22, 57; *18, 21, 22;* traditions and beliefs, 12, 39, 65

Joachim, Saint, 32–33; *32, 33*

Johannes de Hildesheim: *The Three Kings in Bed*, 59; *59*

John, Gospel of, 71, 88

John VII, pope, 93; *93*

John on Patmos (Memling), 88–89; *89*

John the Baptist, Saint, 18, 33, 60, 64, 112–14; Baptism of Christ, 67, 84–85; *67;* birth and naming of, 45, 112; *112;* at the Harrowing of Hell, 78; *78;* with the Madonna and Child, 113; *113*

John the Divine, Saint, 52, 88–89, 90; *89*

John the Evangelist, Saint, 74, 88, 143–45; *145;* beast of, 89; *90, 145;* at the Crucifixion, 76; at the Descent from the Cross, 78; *77;* at Gethsemane, 80; at the Last Judgment, 86; *88;* at the Last Supper, 74; *74;* at the Transfiguration, 72; *72;* at the Wedding at Cana, 71; *71; see also* disciples

Jonah and the Great Fish (Giotto), 16

Joos van Cleve: *Annunciation*, detail of Moses (Cornelisz van Oostsanen), *21*

Joseph, Saint (husband of Mary), 55–56, 63; on the Flight into Egypt, 60, 61, 62; *61, 62;* Marriage, 39–40; *39;* at the Nativity, 55–56, 57; *55, 57;* at the Presentation in the Temple, 65; *66*

Joseph (son of Jacob), 23–24; *23*

Joseph Interprets the Dreams of His Fellow Prisoners (Master of the Story of Joseph), 24, 105; *23*

Joseph of Arimathaea, Saint, 77; *77*

Juan de Flandes: *The Temptation of Christ*, 69; *70; The Wedding Feast at Cana*, 71; *71*

Judas Iscariot, 47, 81, 84, 114; Kiss of, 74–75; *75;* at the Last Supper, 73–74, 117; *74*

Judgment of Paris, The (Cranach the Elder), 160–61, 166; *160*

Judith and Holofernes (Mantegna), 24–26; *25*

Jungian interpretations, 31, 151

juniper, halo of, 95; *95*

Juno, 154, 160; *160*

Jupiter, 153–56, 160; *153, 155*

Jupiter and Io (Correggio), 154; *153*

Justice, 93, 164

Kiss of Judas, The (Giotto), 74–75; *75*

lactating figures: Charity, 101–2; *102;* Mary, 51, 101; *51;* Venus, 151; *150*

lamb: Joachim's offering, 32; *32;* of John the Baptist, 113; *113*

Lamb of God, 90, 92, 113; *90*

Lamentation theme, 78

landscapes: Flight into Egypt, 63, 113; *61, 113;* Saint Jerome's desert, *125*

Lanzani, Polidoro: *Madonna and Child and the Infant Saint John in a Landscape*, 113; *113*

Laocoön (El Greco), 161–62; *162*

Laocoön and His Two Sons (Hagesandros, Polydoros, and Athenodoros), 161; *161*

Lapiths and centaurs, 158–59; *159*

Last Judgment, The (Angelico), 85; *86*

Last Judgment, The (Eyck), 86; *88*

Last Supper, 40, 73–74, 96, 117; *74, 94*

Last Supper (Leonardo da Vinci), 95; *94*

Last Supper (Ugolino di Nerio), 74; *74*

laurel: Christ's wreath, 91; *92;* Daphne's metamorphosis, 157; *156*

Leda and the Swan (workshop of Leonardo da Vinci), 155–56; *155*

Leonardo da Vinci, 95; *Last Supper*, 95; *94; Virgin and Child with Saint Anne*, 35; workshop, *Leda and the Swan*, 155–56; *155*

lilies, symbolism, 38, 41, 46, 152

Limbo (Purgatory), 78; *78*

lions: cubs, 16; digging the grave of Saint Paul the Hermit, 122; *123;* of Saint Jerome,

123, 124, 125; *124, 125;* winged, of Mark, 89; *90, 144*

Lippi, Fra Filippo: *The Annunciation*, 42; *40*

Lochner, Stephan: *Saints Mark, Barbara, and Luke*, 143; *144; Saints Matthew, Catherine of Alexandria, and John the Evangelist*, 143; *145*

Lorenzetti, Ambrogio: *Presentation in the Temple*, 65; *66*

Lorenzo di Credi: *Portrait of a Lady*, 95; *95*

love: courtly, 108–9; erotic, 153–54; Garden of, 108–9; *109*

Love, 50, 148; as a Grace, 166; *166*

Lucifer, 11; *see also* Satan

Lucretius, 159

Lucy, Saint, 134–35; *134, 135*

Luke, Gospel of, 45, 65

Luke, Saint, 118, 143; *118, 144;* painting of Mary, 118; *118, 144;* winged ox, 89, 90, 118; *90, 118, 144*

Madonna, 49–52; of Humility, 50; *50;* in Immaculate Conception portrayals, 52; *53;* of Mercy (della Misericordia), 51–52, 134; *52;* del Parto, 46–47; *46, 47;* in Sacred Conversations, 97, 140; *141; see also* Mary

Madonna and Child (Virgin and Child): appearance to Augustus and the Sibyl, 152; *152;* in a barren tree, 33; *2;* with coral necklace, 103; *103;* before a firescreen, 95; *94;* in Holy Kinship group, 64; *64;* with the infant John the Baptist, 113; *113;* Madonna Enthroned type, 49–50; *30;* Maria Lactans type, 51, 101; *51;* objects clutched by Jesus, 62; with Saint Anne (*Selbdritt* type), 34–35; *35;* with Saint Catherine, 50, 140; *50, 141; see also* Holy Family; Nativity

Madonna and Child (Niccolò di Pietro), 49–50; *30*

Madonna and Child and the Infant Saint John in a Landscape (Lanzani), 113; *113*

Madonna and Child with Angels (Fouquet), 50–51, 103; *51*

Madonna del Parto (Piero della Francesca), 47; *47*

Madonna del Parto with Two Devotees (Venetian school?), 46–47; *46*

Madonna of Charity (Miralheti), 52; *52*

Madonna of the Rose Garden, The (Stefano da Verona), 50; *50*

Maes, Nicholas: *Abraham Dismissing Hagar and Ishmael*, 19, 20; *19*

Magdeburg Cathedral, 92; *92*

Magi, 58–59; *see also* Three Kings

Malchus, 74–75; *75*

man, winged, of Matthew, 89, 90; *90, 145*

mandorla, 49, 72, 90, 92; *49, 72, 91*

Mannerism, 153

Mantegna, Andrea: *Judith and Holofernes*, 24–26; *25*

Manutius, Aldus, emblem of, 163–64; *164*

Margaret, Saint, 131–32; *132*

Maria Lactans theme, 51, 101; *51*

Mark, Saint, 96, 143; *144*; beast of, 89; *90*

marriage, mystic, *see* mystic union

Marriage Feast at Cana, 71; *71*

Marriage of the Virgin (Raphael), 38–40; *39*

Mars and Venus United by Love (Veronese), 151; *150*

Marsyas, 157–58; *158*

Martha, Saint, 114, 132

Martini, Simone: *The Annunciation*, 42–43; *41*; predella panel, *Altarpiece of Fra Agostino Novello*, 140; *139*

Martyrdom of Saint Sebastian (Master of the Playing Cards), *121*

Mary (Virgin Mary), 8, 31–52, 98; *30*; Annunciation to, 18, 40–43, 45, 47; *40, 41, 42, 43, 44*; Assumption, 48–49, 80; *48, 49*; Birth, 33–34, 40, 45; *34*; childhood, 35–38; *36–37, 38*; Coronation, 50, 86; *87*; at the Crucifixion, 76; cult, 8, 31; death, 47–49; at the Descent from the Cross, 78; *77*; devotional images, 143; Dormition, 48; *48*; on the Flight into Egypt, 60–61, 62, 113; *61, 62, 113*; halos, 38, 92, 95; *38, 94*; Immaculate Conception, 31, 33, 52; *53*; impregnation, 41–43, 154; *40, 41*; and Infant John the Baptist, 112, 113; *113*; at Jesus' Presentation in the Temple, 65; *66*; jewelry, 50, 67; *66*; at the Last Judgment, 86; *88*; Luke's likeness of, 118; *118, 144*; Marriage, 38–40; *39*; at the Marriage Feast at Cana, 71; *71*; milk, 51; *51*; at the Nativity, 55, 57; *55, 56, 57*; parents, 18, 32–34; *32, 33, 34*; at Pentecost, 84; *84*; prefiguration, 15; pregnancy, 46–47; *46, 47*; Presentation in the Temple, 35–36; *36–37*; Purification, 65; as Queen of Heaven, 31, 46, 50; *30*; seven sorrows, 38; and Thomas, 48–49, 80; *48*; at the Transfiguration, 72; *72*; in Tree of Jesse, 63; tunic, 97; virginity, 9, 35, 40–41, 63; Visitation to Elizabeth, 45–46; *45*; wedding ring, 39, 50, 96; *see also* Madonna; Madonna and Child

Mary Magdalene, 71, 78, 84, 114–16, 142; *77, 84, 115, 116*

Mary Magdalene (Pistoiese Master), *116*

Marys, 63–64, 76; at Pentecost, 84; *84*

Masaccio: *Crucifixion of Saint Peter*, 117

mask, symbolism, 163

Masolino da Panicale: *The Fall of Man*, 13; *10*

Massacre of the Innocents, The (B. Pisano), 60; *60*

Master Bertram: *The Creation of Eve*, 12–13; *13*

Master Francke: *Nativity*, 57, 58; *56*

Master of the Lehman Crucifixion: *Noli Me Tangere*, 116; *115*

Master of the Osservanza: *Christ in Limbo*, 78; *78*

Master of the Playing Cards: *Martyrdom of Saint Sebastian*, 121

Master of the Story of Joseph: *Joseph Interprets the Dreams of His Fellow Prisoners*, 24, 105; *23*

Master of Tahull: *Christ Pantocrator*, 90–91; *91*

Matthew, Saint, 145; *145*; beast of, 89, 90; *90*

Matthias, Saint, 84; *84*

Maxentius, Emperor, 142

Medici family, 121

Meeting of Joachim and Anna at the Golden Gate (Giotto), 33

Meeting of Saint Anthony and Saint Paul, The (Sassetta), 122; *122*

Memling, Hans: *John on Patmos*, 88–89; *89*; *Mystic Marriage of Saint Catherine*, 140, 142, 143; *141*; *Saint Veronica*, 81; *54*

Mercury, 160; *160*

Metamorphoses (Ovid), 147

Michael, 11–12, 14, 86; *11, 14, 88*

Michelangelo: *Moses*, 21; Sistine Chapel ceiling, 8, 152

Middle Ages: art, 15, 18, 24, 26, 44, 55, 93–94, 147, 164; beds, 29, 59; beliefs and ideas, 16, 46, 60, 63, 95, 98–99, 100, 103, 105, 108–9, 147

Minerva, 157, 158, 160, 161; *160*

miracle paintings, 139–40; *139*

Miralheti de Montpelier, Jean: *Madonna of Charity*, 52; *52*

mirror, 164; *165*

model buildings, 91–92, 93; *92*

monarchs, 86, 92; *92*; clothing, 104, 105; *see also* Three Kings

monsters, 98–99; *99*; in Hell, 86–87; *88*

Montefeltro Altarpiece (Piero della Francesca), detail, *103*

moon crescent, symbolism, 52

mosaics, 18; *17, 93*

Moses, 21–23, 72, 78, 97, 151; *21, 22, 72*

Moses (Michelangelo), 21

Moses Striking the Rock (French miniature), 22–23; *22*

mottos, 163–64; *164*

Multscher, Hans: *The Dormition of the Virgin*, 48; *48*

Muses, 165

music, 86, 157

mystery plays, 46, 55, 59

Mystic Marriage of Saint Catherine (Memling), 140, 142, 143; *141*

mystic mill, 15–16, 17, 21; *15*

Mystic Mill, The (French), 16, 17; *15*

mystic union, 141–42, 153–54

Nativity, 55–58; *55, 56, 57*

Nativity (Daret), 57–58; *57*

Nativity (Giotto), 55, 58; *55*

Nativity (Master Francke), 57, 58; *56*

Neoplatonists, 149

Niccolò di Pietro: *Madonna and Child*, 49–50; *30*

Nicholas of Bari, Saint, 135–37; *136*

Nicholas of Tolentino, Saint, 137–38; *137*

Nicodemus, 77; *77*

Noah, 85; drunkenness of, 17–18; *17*

Noli Me Tangere (Master of the Lehman Crucifixion), 116; *115*

nudes, 13; *10, 13, 14*; female, 27, 161, 166; *26, 160, 166*; Jesus, 67–68; male, 18; *17*; Sebastian, 121; *121*

nuns, habits of, 103

Old Testament themes, 11–29; apocryphal, 24–29; Christian use of, 15–16, 41, 88, 101, 153–54

Otto I, Emperor, 92; *92*

Our Lady of the Barren Tree (Christus), 33; *2*

Ovid, 147, 157

ox, 57; of Luke, 89, 90, 118; *90, 118, 144*

palm, symbolism, 62

Palmesel (Swiss), 73; *73*

Palm Sunday, 73

Pantocrator, 90–91, 92; *91*

Paradise, *see* Eden; Heaven

Paris, France, 83; *82*

Paris, Judgment of, 160–61; *160*

Passion, 50, 72, 81

Patinir, Joachim: *Saint Anne with the Virgin and Child*, 34–35; *35*; *The Temptation of Saint Anthony*, 125, 126; *126*

Paul, Saint, 93, 117–18
Paul of Thebes, Saint, 122; *122, 123*
Pentecost, The (El Greco), 83–84; *84*
Peter, Saint, 41, 80, 83, 116–18; crucifixion, 118; *117;* at Gethsemane, 74–75; *75;* at the Last Supper, 74; *74;* at the Transfiguration, 72; *72*
Petrarch, 148
Philip, Saint, 74; *74*
Phyllis and Aristotle, 7, 148–49; *149*
physicians: Cosmas and Damian, 120–21; *120;* quacks, 101; *101*
Piero della Francesca: *Madonna del Parto,* 47; *47; Montefeltro Altarpiece* (detail), *103; Triumph of Duke Federico II,* 148; *146*
Piero di Cosimo: *The Fight between the Lapiths and the Centaurs,* 159; *159*
Pietà theme, 78
Pilate, Pontius, 75, 76, 77
pilgrims, 80
Pisanello, Antonio: *The Vision of Saint Eustace,* 139; *138*
Pisano, Andrea: *Baptism of Christ,* 67–68; *67*
Pisano, Bonanno: *The Massacre of the Innocents,* 60; *60*
Pistoiese Master: *Mary Magdalene,* 116
plague, 108, 121
Plato, 13, 40–41, 93, 141, 164
Plotinus, 149
Pope John VII (mosaic), 93; *93*
Portrait of a Lady (Lorenzo di Credi), 95; *95*
Potiphar, 23, 24; wife of, 23
Presentation in the Temple: of Jesus, 64–67; *66;* of Mary, 35–36; *36–37*
Presentation in the Temple (Lorenzetti), 65; *66*
Presentation of the Virgin (Titian), 35–38; *36–37*
processions, 73, 148; *104*
Prodigies (Schedel), *99*
Protestants, 39, 88, 111
Prudence, 93, 164–65; *165*
Psalms, Book of, 34, 78
Purgatory (Limbo), 51, 78, 147; *78*
Purification, 65
putti, 38, 147
Pythagoras, 40–41

quatrefoil, 68; *67*

Rape of the Sabines, 158
Raphael (archangel), 12, 28, 29; *28*
Raphael (painter): *Marriage of the Virgin,* 39–40; *39; Saint Margaret,* 132; *132; The Three Graces,* 166; *166*

ravens, 116, 122; *123*
Reformation, 88, 98, 111
Regula, Saint, 121
relics and reliquaries, 59, 95–96; *96*
Reliquary Arm of Saint Valentine (Swiss), 96; *96*
Renaissance: art, 13, 15, 18, 24, 29, 38, 55, 67, 72, 94, 95, 100, 149–50, 151, 153, 164; ideas and concepts, 147, 148, 149–51, 154, 163, 164
Reni, Guido: *Charity,* 102; *102*
Republic (Plato), 93, 164
Rest on the Flight into Egypt, The (David), 60–62; *61*
Resurrection, 16, 44, 79–80, 121; prefiguration, 23; symbols, 35, 43, 72
Retable of Saint Christopher, 131; *110*
Revelation, Book of, 52, 88–89; *89*
river gods, 154, 157; *156*
Roch, Saint, 121
rock: Peter as, 117; symbolism, 22
Roman Catholicism, 29, 31, 39, 48, 52, 111
Romanesque art, 7, 19, 147
Romano, Antoniazzo: *God the Father,* 93
Rome, 88, 152–53, 158; *152;* catacomb paintings, 27, 51, 58; *see also* entries at classical
rose, symbolism, 38, 50
Ruth, 16

Sacred Conversations, 7, 96–97, 140, 143; *141*
Sacrifice of Isaac, The (Second Master of San Zeno), 21; *20*
Saint Anne with the Virgin and Child (Patinir), 34–35; *35*
Saint Anthony, Padova, museum at, 140
Saint Anthony Abbot and Saint Paul the Hermit (Velázquez), 122; *123*
Saint Christopher (German), *130*
Saint Francis and the Wolf of Gubbio (Sassetta), 128–29; *128*
Saint Francis Receiving the Stigmata (Giotto), *129*
Saint Francis Renounces His Earthly Father (Sassetta), 127–28; *127*
Saint George Liberates the Princess (Altichiero da Zevio), 102, 120; *119*
Saint Helen: Vision of the Cross (Veronese), 98; *97*
Saint Jerome in a Landscape (Cima da Conegliano), *125*
Saint Jerome in His Study (Colantonio), 123–24; *124*
Saint John in Lateran, Rome, 130

Saint Lucy (Crivelli), *135*
Saint Lucy Resisting Efforts to Move Her (Jacobello del Fiore), *134*
Saint Luke Painting the Virgin (German), 118; *118*
Saint Margaret (Raphael), 132; *132*
Saint Michael (Crivelli), 11–12; *11*
Saint Nicholas of Tolentino Reviving the Birds (Garofalo), *137*
Saint Nicholas Providing Dowries (Bicci di Lorenzo), 137; *136*
saints, 11, 93, 98, 111–45; attributes, 111, 143–44; beheaded, 96, 114, 118, 120–21, 132, 142; *114;* with Christ Pantocrator, *91;* devotional images, 143; halos, 93, 94; *81;* in Heaven, 86, 111; *87;* relics, 96; temptations, 125–26; *125, 126*
Saints Cosmas and Damian Healing the Deacon Justinian (Angelico), 121; *120*
Saints Mark, Barbara, and Luke (Lochner), 143; *144*
Saints Matthew, Catherine of Alexandria, and John the Evangelist (Lochner), 143; *145*
Saint Veronica (Memling), *81; 54*
Saint Veronica Master, follower of: *Holy Kinship,* 64; *64*
Saint Vitus's dance, 143
Salome (daughter of Herodias), 113–14; *114*
Salome (midwife to Mary), 55
Samson and Delilah, 26
Sano di Pietro: *The Birth and Naming of Saint John the Baptist,* 112; *112*
Santa Claus, 135
Santiago di Compostella, 80
San Zeno, Verona, doors, 19; *18, 20, 98*
San Zeno Frees the Princess of a Demon (Second Master of San Zeno), 98; *98*
Sarah (wife of Abraham), 18, 19, 20, 33; *18*
Sarah (wife of Tobias), 27–28; *29*
Sassetta: *The Meeting of Saint Anthony and Saint Paul,* 122; *122; Saint Francis and the Wolf of Gubbio,* 128–29; *128; Saint Francis Renounces His Earthly Father,* 127–28; *127*
Satan, 11–12, 21, 98, 117, 126, 131, 145, 147; as Saint Margaret's dragon, 132; *132;* at the Temptation in the Wilderness, 68, 69; *69, 70;* under foot of Michael, 11; *11*
Satyrs, 99, 147; Marsyas, 157–58; *158;* Silenus, 162–63; *163*
Sbazios, 96
Schedel, Hartmann: *Prodigies,* 99
Sebastian, Saint, 121; *121*

Second Master of San Zeno: *Abraham and the Three Angels, Abraham and Sarah*, 18–19, 153; *18; The Sacrifice of Isaac*, 21; *20*
Selbdrift, 34–35; *35*
seraphim, 15, 38, 51; *38, 51*
Sermon on the Mount, 64–65
serpents: of the Fall, 13, 52; *10, 53;* in Hell, 86; *see also* snakes
Sheba, queen of, 97–98
shell, symbolism, 80
shoes, pointed, 102; *105*
Sibyls, 147, 151–52; *152*
Siege on the Castle of Love, 109
signatures, 40
Silenus, 162–63; *163*
Simeon, 65; *66*
Simon Magus, 41, 117
Sistine ceiling (Michelangelo), 8, 152
sky, golden, 68–69; *69*
snakes: of Prudence, 164; *165;* of Saint John, 145; *145*
Solomon, 97
Song of Songs, 142, 154
soul: battle for, 106; *107;* symbol, 85; union with Christ, 142; weight, 12
Spanish art, stripes, 90; *91*
speech banners, 33, 57; *32, 56*
stag, of Saint Eustace, 138–39; *138*
Starnina: *Thebaid*, 108; *108*
Stefano da Verona: *The Madonna of the Rose Garden*, 50; *50*
stigmata, 129; gloves, *128*
still life, 80; *80; vanitas* type, 106; *106*
Stoicism, 147
Strigel, Bernhard: *The Annunciation to Saint Anne and Saint Joachim*, 33; *32*
Strozzi, Zanobi, 85
Supper at Emmaus, The (Caravaggio), 78–80; *80*
Susanna and the Elders (Tintoretto), 27; *26*
swords, 104; *104*
Symposium (Plato), 164

Temperance, 93, 164
Temple in Jerusalem, 36, 39–40, 68, 112; *39;* Expulsion of Joachim, 32; *32;* Presentation of Mary, 35–36; *36–37*
Temptation of Christ, The (Juan de Flandes), 69; *70*
Temptation of Christ on the Mountain, The (Duccio), 68, 69; *69*

Temptation of Saint Anthony, The (Patinir), 125, 126; *126*
temptations of saints, 125–26; *125, 126*
Thebaid (Starnina), 108; *108*
Third Master of San Zeno: *San Zeno Frees the Princess of a Demon*, 98; *98*
Thistle (donkey), 62; *62*
Thomas, Saint: as the doubter, 48–49, 80–81; *81;* at the Last Supper, 74; *74; see also* disciples
Thomas Aquinas, Saint, 85
Three Graces, The (Raphael), 165–66; *166*
Three Kings, 58–59, 97; *58, 59*
Three Kings, The (German), 59; *58*
Three Kings in Bed, The (Johannes de Hildesheim), 59; *59*
Tiepolo, Giovanni Battista: *Apollo Pursuing Daphne*, 157; *156; The Immaculate Conception*, 53
Tintoretto: *The Annunciation*, 43; *43; The Contest between Apollo and Marsyas*, 158; *158; Susanna and the Elders*, 27; *26*
Titian: *Assumption of the Virgin*, 49; *49; Presentation of the Virgin*, 35–38; *36–37*
Tobias, 27–29; *28, 29*
Tobias and Sarah (Cologne School), 28–29; *29*
Tobias and the Angel (Ghirlandaio), 28–29; *28*
Tobit, 27–28, 29; Book of, 27–29
Toledo, 161; *162*
tower, of Saint Barbara, 92, 142, 143; *141, 144*
Transfiguration, 71–72; *72*
Transfiguration, The (Angelico), 72; *72*
Tree of Jesse (woodcut), 63; *63*
trees, *see* juniper; laurel
Trinity, symbols of, 18, 84–85, 142, 166; *85;* triangular halo, 92; *93*
Trinity, The (Gaddi), 84–85; *85*
triumphs, 148, 163; *146, 163*
Triumphal Procession of Maximilian I (Dürer), 105; *104*
Triumph of Duke Federico II (Piero della Francesca), 148; *146*
Triumph of Silenus, The (Urbino plate), 163; *163*
Trojan War, 156, 160, 161
trompe l'oeil effects, 44
True Cross, 96; Legend of, 97–98

Ugolino di Nerio: *Last Supper*, 74; *74*
Uriel, 12
urn, of river gods, 154, 157; *153, 156*
Ursula, Saint, 133–34; *133*

Valentine, Saint, reliquary arm, 96; *96*
Vanitas Still Life (Claesz), 106; *106*
Velázquez, Diego: *Saint Anthony Abbot and Saint Paul the Hermit*, 122; *123*
Venus, 151, 160, 165, 166; *150, 160*
vera eikon, 81
Veronese, Paolo: *Mars and Venus United by Love*, 151; *150; Saint Helen: Vision of the Cross*, 98; *97*
Veronica, Saint, 81, 118; *54*
Victory, 147, 148; *146*
Virgil, 149
Virgin and Child Before a Firescreen (Campin), 95; *94*
Virgin and Child with Saint Anne (Leonardo da Vinci), 35
Virgin Birth, 9, 40–41; symbol of, 35
virginity, 63, 131; symbol of, 52
Virgin Mary, *see* Mary
Virtue and Vice, 101
virtues, 93, 164; *see also* Charity; Hope; Prudence
Vision of Saint Eustace, The (Pisanello), 139; *138*
visions, 31, 98; of Ezekiel, 89; of Saint Bridget, 57; of Saint Eustace, 139; *138;* of Saint Francis, 129; *129;* of Saint Helena, 97, 98; *97;* of Saint John the Divine, 88–89; *89;* of Saint Luke, 118; *118*
Visitation, The (Angelico), 45–46; *45*
Vitus, Saint, 143

Wedding Feast at Cana, The (Juan de Flandes), 71; *71*
wedding rings, 39, 50, 96, 141
Weyden, Rogier van der: *The Descent from the Cross*, 77–78; *77*
wheel: of Fortune, 101; of Saint Catherine, 142; *141, 145*
Wholen, Fundort: *Wild Man*, *100*
Wild Man (Wholen), *100*
wild persons, 99–100; *100*
Wild Woman and Children on Stag (Housebook Master), *100*
wolf of Gubbio, 128–29; *127*

Young Virgin, The (Zurbarán), *38*

Zacharias, 112; *112*
Zeno, San, 98; *98*
Zeus, 12, 13; *see also* Jupiter
Zurbarán, Francisco de: *The Young Virgin*, *38*

ACKNOWLEDGMENTS

My husband and excellent traveling companion, Norman Snyder, gave me inspiration and useful criticism. He brought his artistic training to our conversations while making his Jewish unfamiliarity with certain Christian lore a great asset. He was a curious, enthusiastic audience for the stories of saints and the Virgin that so fascinate me.

Over the years, my sons, Adam Fisher and Jacob Fisher, have spent more time with me in museums than active boys can be expected to. They continued to ask questions, even knowing how long the answers might be. Most gratifying of all, they have always expressed pleasure in my accomplishments.

Bradford Kelleher, a wonderful boss, has also been a generous literary advisor. Linda Scovill offered astute and valuable guidance. Katy Homans, the masterful designer of this volume, is also a longtime friend who really makes me want to write books.

For many kinds of assistance, mostly spiritual, sometimes practical, I am happy to thank Sue Chandler, Joan Stein, Marcia Due, Jerry Thompson, Leslie Katz, Phyllis Alden, Erik Wensberg, Joanne Lyman, Bertha Rogers, Douglas Sardo, Gwen Buehrens, Nancy Arnesen, Michael George, Paolo Veronesi, Dodie Catlett, Brother Benedict Simmonds, Ruth Bogin, and Jane Cooper. I am grateful to friends across the ocean who looked things up for me, specifically Herbert Krauer, my link with Saints Felix and Regula in Zurich, and Enrico Battei, my contact with Saint George in Verona. And for highly expert and sympathetic work in the editing and production of the book I thank Harriet Whelchel, Roxana Marcoci, Shun Yamamoto, and Deborah Zeidenberg.

Four wonderful institutions have my ongoing gratitude. They are The Metropolitan Museum of Art, The MacDowell Colony, The New York Society Library, and The Virginia Center for the Creative Arts.

One can almost forget that works of art are objects. They must be protected from wars, rescued from floods, rid of vermin, shielded from pollution. Our century has seen many heroic efforts on their behalf. This book is dedicated to all those who have sandbagged church walls, rolled up Rembrandts and hidden them in caves, wiped the mud from Florentine treasures, fanned the leaves of manuscripts dry, and, less dramatically, those who keep an eye on art objects every day and never stop worrying about them.

—S.F.